P9-DEQ-994

The Comox Valley

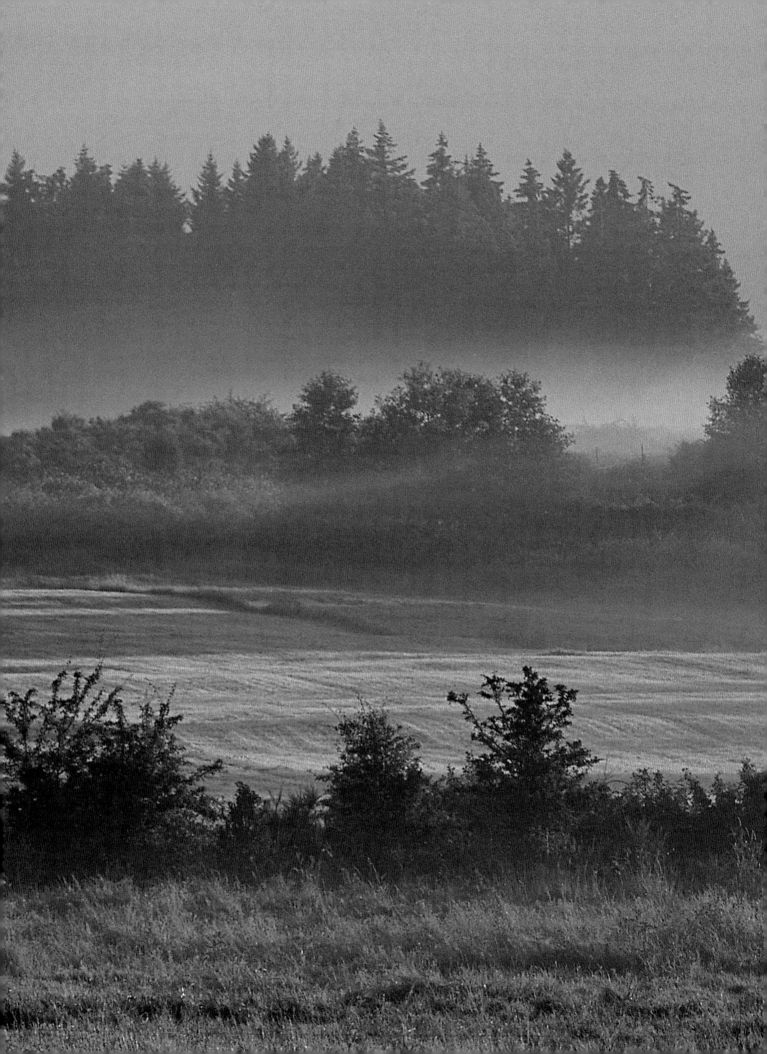

The Comox Valley

COURTENAY, COMOX, CUMBERLAND AND AREA

BY PAULA WILD WITH RICK JAMES

PHOTOGRAPHY BY BOOMER JERRITT

Harbour Publishing

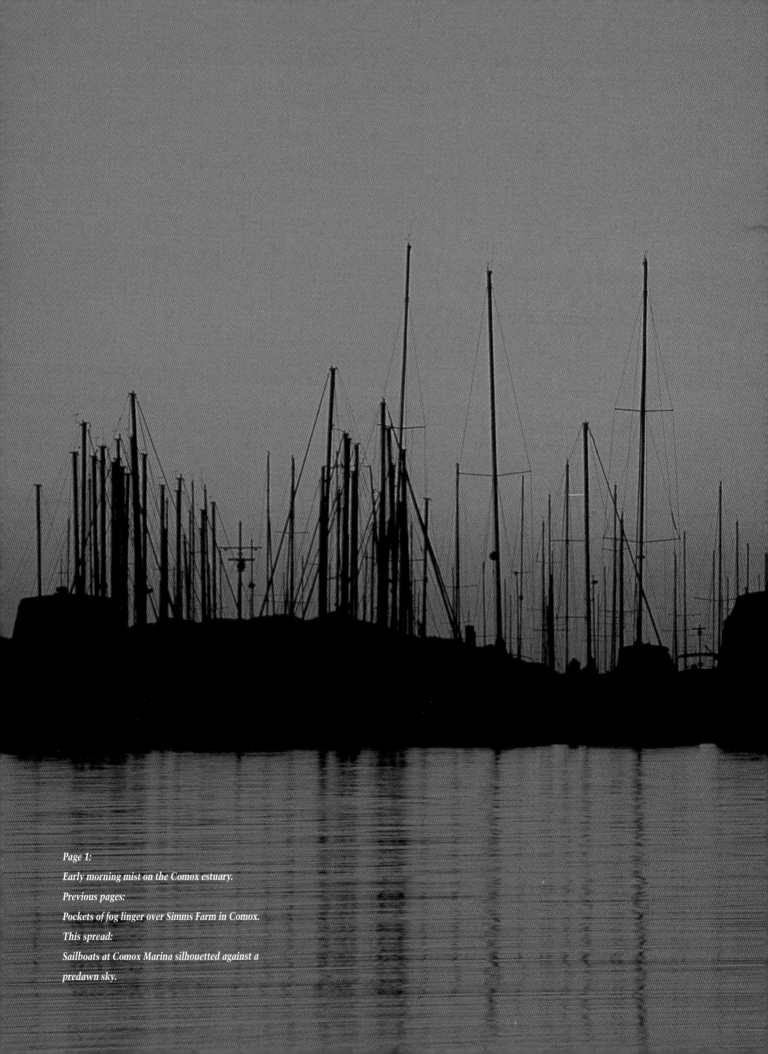

Page 1:
Early morning mist on the Comox estuary.
Previous pages:
Pockets of fog linger over Simms Farm in Comox.
This spread:
Sailboats at Comox Marina silhouetted against a predawn sky.

Contents

Text Copyright © 2006 Paula Wild and Rick James
Photographs © 2006 Boomer Jerritt, except where noted

2 3 4 5 — 10 09 08 07

All rights reserved. No part of this publication may be reproduced, stored in a retrieval system or transmitted, in any form or by any means, without prior permission of the publisher or, in the case of photocopying or other reprographic copying, a licence from Access Copyright, www.accesscopyright.ca, 1-800-893-5777.

Harbour Publishing Co. Ltd.
P.O. Box 219, Madeira Park, BC, V0N 2H0
www.harbourpublishing.com

Text design by Roger Handling, Terra Firma Digital Arts
Printed and bound in China

Harbour Publishing acknowledges financial support from the Government of Canada through the Book Publishing Industry Development Program and the Canada Council for the Arts, and from the Province of British Columbia through the BC Arts Council and the Book Publishing Tax credit.

Library and Archives Canada Cataloguing in Publication

Wild, Paula
The Comox Valley : Courtenay, Comox, Cumberland and area / Paula Wild and Rick James; photographer, Boomer Jerritt.

Includes bibliographical references and index.
ISBN 13:978-1-55017-408-3
ISBN 10:1-55017-408-8

1. Comox Valley (B.C.) —History. 2. Comox Valley (B.C.) —Pictorial works.
I. James, Rick, 1947— II. Title.

FC3845.C64W54 2006 971.1′2 C2006-903335-8

..

This book is dedicated to all the individuals and organizations that have donated countless hours of time and labour to protect and preserve the Comox Valley's green spaces and waterways. And to those, past and present, who have generously donated their property for public use so that these special places may be enjoyed by future generations.

—Paula & Rick

I dedicate this book to my wife, Heather, and children, Josh and Megan, for their behind-the-scenes support. Between missed dinners and weekends spent shooting, they have always supported me and sacrificed much to allow me to do my work. I am also grateful to my parents who taught me early on the importance of self-reliance and gave me the confidence to make life decisions that may not always follow the easiest path.

—Boomer

Acknowledgements

Thanks to the many people who provided support and encouragement during the creation of this book. Your interest, friendship and kind words are greatly appreciated. We are particularly grateful to those who shared stories, answered questions and agreed to have their photographs taken; without you this book would not exist. We would also like to acknowledge the generosity of all businesses and individuals who contributed images for possible use in the book.

Boomer extends a special thanks to Doug and Donna Kerr of Studio One and Fuji Film for their generous donation of film and processing. He would also like to acknowledge his relationship with *Infocus Magazine* and Comox Valley Tourism; working with them has given him the opportunity to meet many people and visit many places.

Paula is especially grateful to Susie Quinn and Hope Spencer for their research and anecdotes. They never failed to answer the call for help. And to Krista Kaptein of the Comox Valley Naturalists for her last-minute assistance. We all appreciate the support of Colonel Jon Ambler, 19 Wing Commander, Wing personnel and the Comox Air Force Museum, particularly museum volunteer, Lieutenant Colonel (retired) David Stinson, for going above and beyond the call of duty.

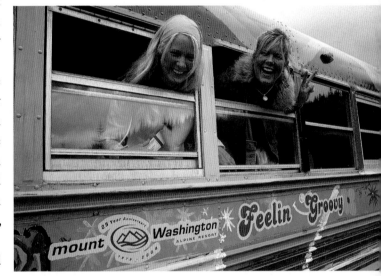

Many people read drafts, provided background information and otherwise contributed to this project. People who took the time to assist include: Frank Hoveden of the Comox Valley Naturalists Society, Nancy Greene, Catherine Siba and Pat Trask of the Courtenay & District Museum, Robert Huber of the Marmot Recovery Foundation, Melinda Knox of the K'ómoks Band, Andy Everson, Janette Glover-Geidt, Sharon Niscak of the Comox Archives & Museum, Barb Lempky of the Cumberland Museum, Harold Macy, Bettyanne Hampton of the Comox Valley Youth Music Centre, Tony Berniaz, Ruth Masters, Marilyn Jensen, Ramona Johnson, Joan Collins, Carol Neufeld, Mary-Jane Douglas, Betty Brooks, Margaret and Bus Griffiths, George Sawchuk, Jim Palmer of the Morrison Creek Streamkeepers, Jack Minard of the Tsolum River Restoration Society and Tony Martin of the Comox Valley Arts Gallery. If any names have been omitted, please forgive the oversight.

—Paula, Rick & Boomer

The Comox Valley offers year-round recreational activities.

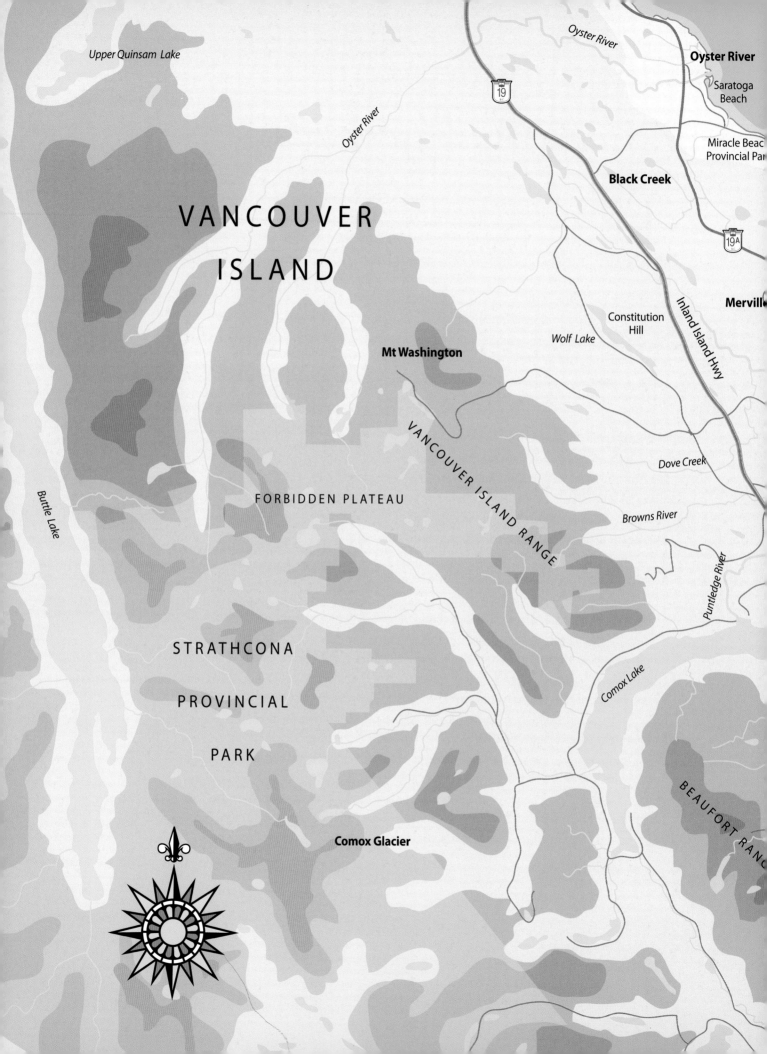

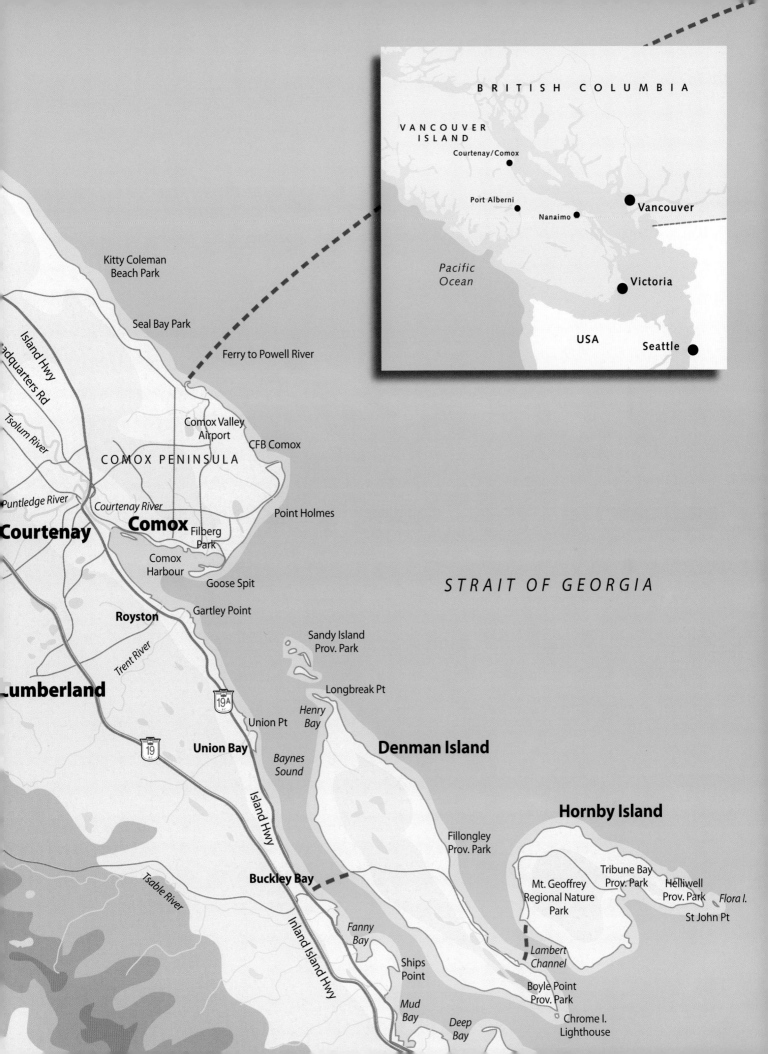

BRITISH COLUMBIA

VANCOUVER
ISLAND

Courtenay/Comox

Port Alberni

Nanaimo

Vancouver

*Pacific
Ocean*

Victoria

USA

Seattle

Kitty Coleman
Beach Park

Seal Bay Park

Ferry to Powell River

Island Hwy

Headquarters Rd

Tsolum River

Comox Valley
Airport

CFB Comox

COMOX PENINSULA

Puntledge River

Courtenay River

Courtenay

Comox

Filberg
Park

Point Holmes

Comox
Harbour

Goose Spit

STRAIT OF GEORGIA

Gartley Point

Royston

Trent River

Sandy Island
Prov. Park

...umberland

Longbreak Pt

19A

*Henry
Bay*

Union Pt

Union Bay

19

*Baynes
Sound*

Denman Island

Hornby Island

Island Hwy

Fillongley
Prov. Park

Tribune Bay
Prov. Park

Mt. Geoffrey
Regional Nature
Park

Helliwell
Prov. Park

Flora I.

St John Pt

Buckley Bay

Tsable River

*Fanny
Bay*

*Lambert
Channel*

Inland Island Hwy

Ships
Point

Boyle Point
Prov. Park

*Mud
Bay*

*Deep
Bay*

Chrome I.
Lighthouse

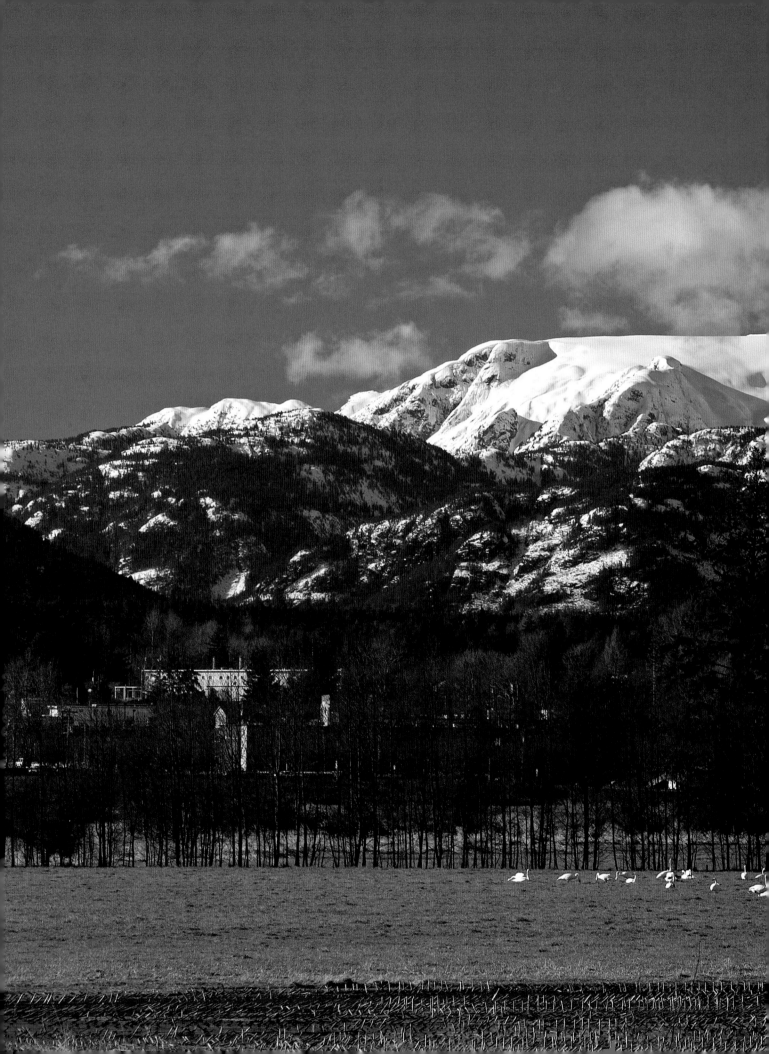

Chapter 1
Origins

Previous pages: The Comox Glacier and snow-covered peaks of the Vancouver Island Range loom over the Comox Valley.

ou won't find the name Comox Valley on any map, but the place exists all the same. Situated on the east coast of Vancouver Island, the valley is pretty well the mid-point between the rural community of Port Hardy at the northern end of the island and Victoria, the capital of British Columbia, to the south.

On the West Coast, people tend to think of valleys as being formed by rivers that spill from mountain to sea in a line fairly perpendicular to the coast. The Comox Valley, however, is defined by the Tsolum River, which runs parallel to the shoreline for much of its length. Residents commonly refer to the Comox Valley as the area between Black Creek and Fanny Bay and including Denman and Hornby islands, reflecting their strong social and economic ties.

The valley's wide, generally flat plain consists of sediments and gravel deposited by glaciers during the last ice age. It's nestled between the Vancouver Island Range, the rugged mountains that form the spine of Vancouver Island, and the northern waters of the Strait of Georgia. Bordering the valley to the west are glaciers, snow-capped mountains and delicate subalpine meadows. To the east, this rugged terrain gives way to hillsides covered in stands of second- and third-growth timber and pockets of swampy land that becomes pungent with the aroma of skunk cabbage in spring. The valley floor culminates in a mix of sand and rock beaches facing the more or less sheltered waters between Vancouver Island and the BC mainland.

The Comox Valley is horse country. Here riders explore one of the many trails on Mt. Washington.

A feel for the lay of the land can be had by hiking up Forbidden Plateau or riding one of the chairlifts at Mt. Washington Alpine Resort to take in the view. A simpler way is to walk or drive down Ryan Road, where the valley, the Comox Glacier and the path of the Puntledge River flowing from Comox Lake are all visible. Seen from the air, glacier-fed Comox Lake is

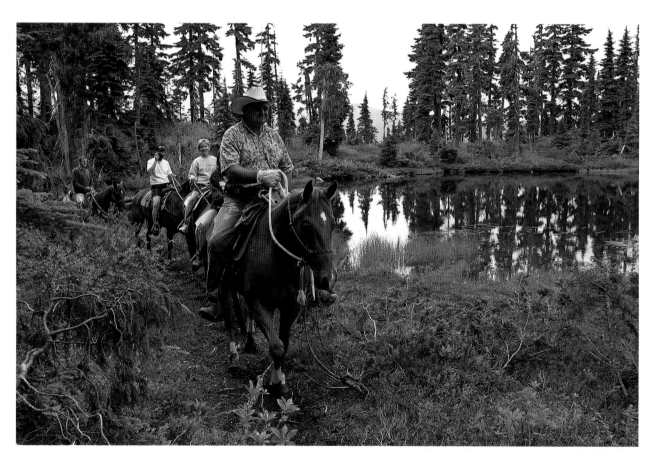

the biggest splash of blue. This body of water and the mountains around it feed a network of rivers and creeks that flow toward the sea. Along the way they pass farms, small rural communities and larger urban centres. Two of these rivers, the Tsolum and Puntledge, join forces to create the 3-kilometre-long Courtenay River, which empties into Comox Bay.

Comox Bay is the real heart of the Comox Valley. Its waters are home to a variety of fish and other marine creatures; it also serves as a protected harbour for commercial fishing and pleasure boats. And, thanks to the buffer provided by nearby Denman and Hornby islands, the relatively shallow waters extend as far south as Deep Bay, creating a unique estuary-marine ecosystem. Numerous streams deposit nutrients and sediment into these waters, providing ideal growing conditions for a variety of marsh and sea vegetation.

This environment, which in the early 21st century still retains a largely natural shoreline, is internationally recognized as a significant feeding area for resident and migratory waterbirds in BC. It's estimated that over the course of a year, the valley may be home to as many as 175 species of birds with a particularly high concentration of scoters, harlequin ducks and trumpeter swans during the winter months.

In fact, the valley's bird habitat is so rich that in the past it drew Theed Pearse, Hamilton Mack Laing, Allan Brooks and other well-known birders to the area. In North American

Noted illustrator Allan Brooks painted many local birds while living in the Comox Valley, including this watercolour of an American kestrel.

Photo courtesy Elizabeth Brooks and Jocie Ingram

Aviation has a strong presence in the valley, thanks to Canadian Forces Base 19 Wing Comox. This Lockheed CP-140 Aurora is used for coastal surveillance.

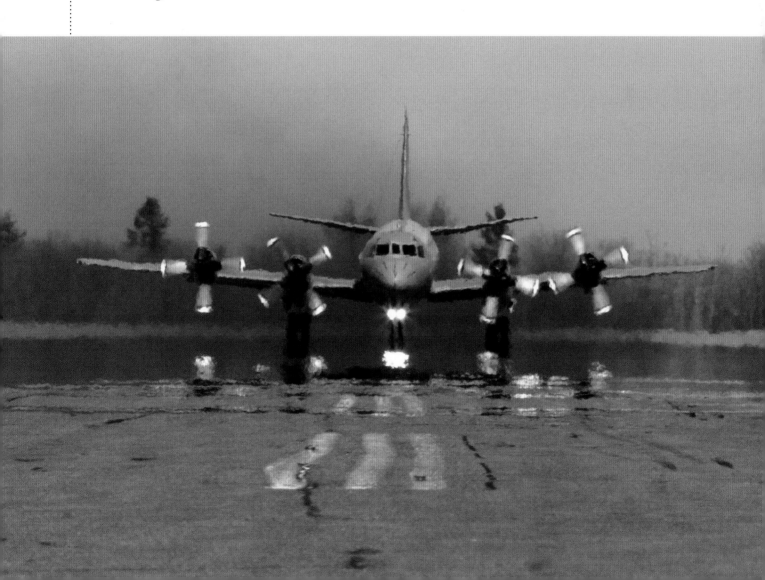

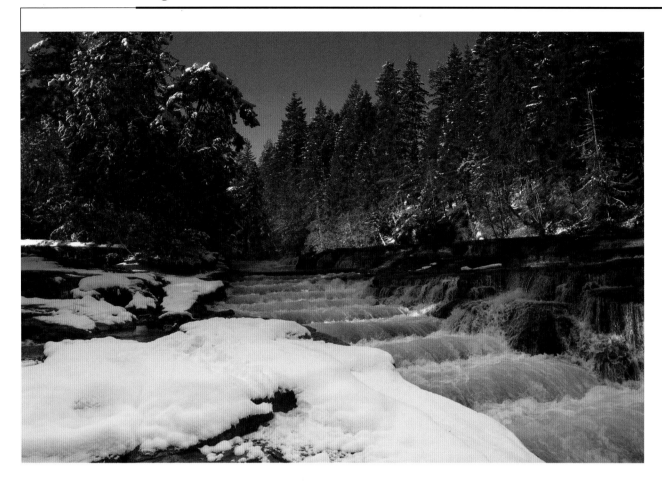

Stotan Falls on the Puntledge River is one of the valley's beauty spots. The middle channel is a fish ladder migrating salmon swim up each fall to spawn.

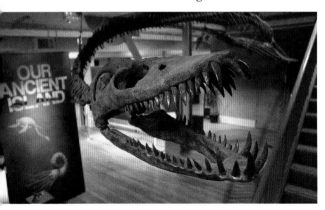

The Courtenay Museum is home to the fossilized remains of a 13-metre elasmosaur found along the Puntledge River.

birding circles, Brooks, an accomplished painter, was known as the "pope of ornithology." Like the birds he studied, he wintered in Comox from the late 1920s to his death in 1946. Throughout his life, Brooks conducted research for museums and illustrated many articles and books including *Birds of Western Canada* and *Birds of Canada*.

The combined expanse of Comox Harbour and Baynes Sound is a waterbird's idea of a gourmet roadside diner. Around late February or early March, huge schools of herring converge in these protected waters to spawn. These small fish provide a lucrative fishing industry (herring roe is a delicacy in Japan) as well as a readily available source of protein for migrating birds before they complete their journey north to breed. The arrival of the herring also stimulates a feeding frenzy for gulls, eagles, seals and sea lions.

But the valley didn't always look like this. Millions of years ago it, like much of eastern Vancouver Island and the Gulf Islands, was a huge saltwater lagoon inhabited by large and often ferocious-looking marine reptiles. Over time the ground has been pushed upward by forces deep within the earth to reveal the seabed that was present around 80 million years ago. In 1988 Mike Trask and his 11-year-old daughter Heather were walking along the Puntledge River when Trask noticed a rock as big as his fist sticking out of the flat shelf he was standing on. The rock was grey, like the surrounding shale, but smooth and shaped like a small loaf of bread.

This unusual formation turned out to be a fragment of the fossilized remains of an 80-

million-year-old elasmosaur. The fossil was nearly complete. It was the first of its kind found on the Pacific side of the Canadian Rockies and the oldest elasmosaur discovered to date on the west coast of North America. When alive, the Puntledge elasmosaur was about 13 metres long and weighed approximately 4 tonnes. Its fossilized remains and fully reconstructed skeleton are on display at the Courtenay & District Museum.

Three years after Trask discovered the elasmosaur, a new genus and species of mosasaur, a massive crocodile-like reptile known as the T. Rex of the sea, and probably related to modern-day snakes, was found on the Puntledge River. A couple of years later, on nearby Trent River, three turtles and a ratfish were found. Ratfish fossils are extremely rare as the animal is primarily made up of cartilage.

Even in the 21st century, strange and amazing creatures continue to inhabit the Comox Valley. The Vancouver Island marmot, one of the rarest and most endangered mammals in Canada, lives in the subalpine meadows of Mt. Washington. Morrison Creek, a tributary to the Puntledge River, has the distinction of being the only home in the world to a rare and unusual species of lamprey—an eel-like creature that has been in existence for over 300 million years. And a summer dive in the waters near Hornby Island offers the possibility of viewing elusive six-gill sharks.

Not the least of the valley's attractions is its spectacular oceanfront. Goose Spit, a long finger of sand guarding the seaward side of Comox Bay, attracts nature lovers year-round and is particularly popular during the summer months.

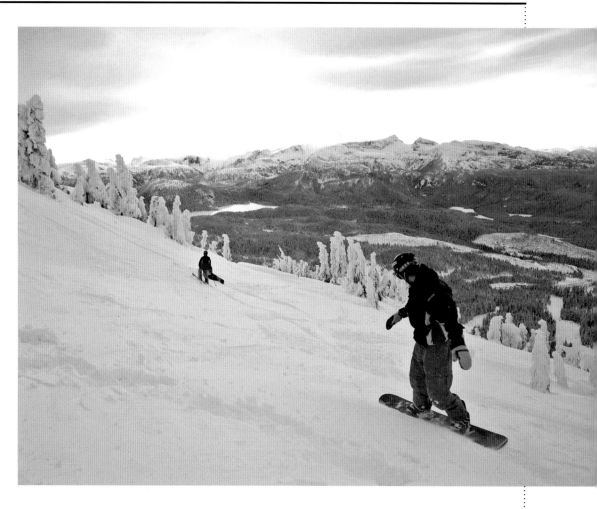

Mt. Washington, a 30-minute drive from Courtenay, offers year-round alpine adventure including skiing, hiking, and mountain biking.

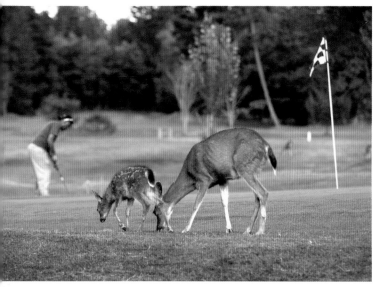

There are months when valley residents can play golf, ski or sail—all on the same day.

The natural paradise of the Comox Valley also attracts people. They're drawn by the region's beauty, diverse recreational opportunities and reputation as a vibrant centre for the arts. The temperate climate appeals to farmers, gardeners and those who enjoy golfing, hiking, kayaking and other year-round outdoor pursuits. And because of the area's unique geography, it takes less than an hour to drive from sandy beach to mountain peak. Countless numbers of painters, potters, musicians and other creative souls find inspiration in the diversity of the landscape and the cadence of its seasonal rhythms.

The Comox Valley is connected to the rest of Vancouver Island by the Old Island Highway and a limited-access, four-lane expressway. It's linked to the BC mainland and Washington State by ferries at Little River, Nanaimo and Victoria. And, although the population as of 2004 was estimated at just under 62,000, the Comox Valley Airport has the second-longest runway in BC and is capable of handling jumbo jets. But many people forgo travel by land or air in favour of a leisurely boat cruise along the inland waters that separate Vancouver Island from the mainland.

Farming has been a vital part of Comox Valley life since early settlers arrived in 1862. Photo by Rick James

At twilight a lone kayaker gazes toward Comox from the end of Goose Spit. The area's sheltered waterways, lakes and rivers make it a paddler's paradise.

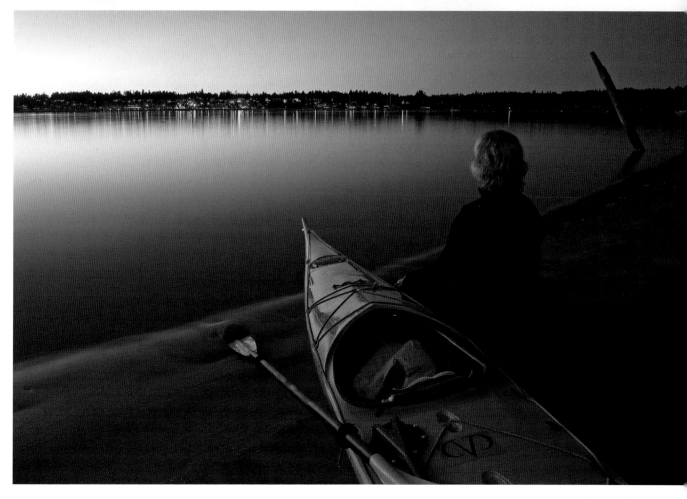

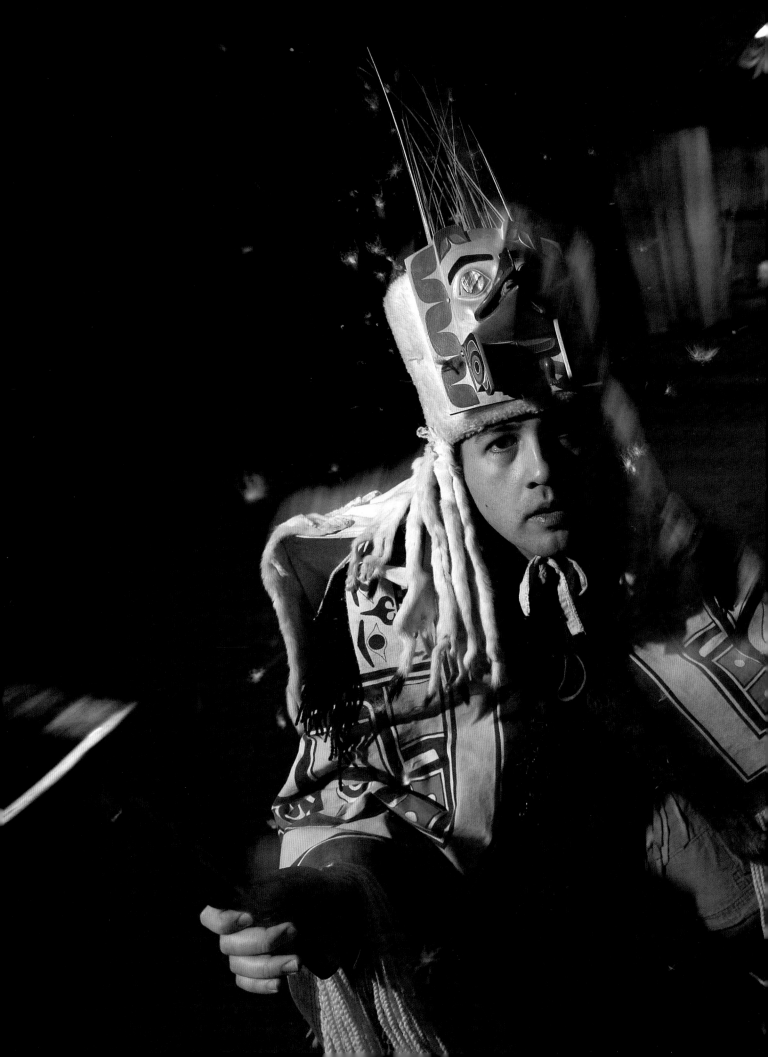

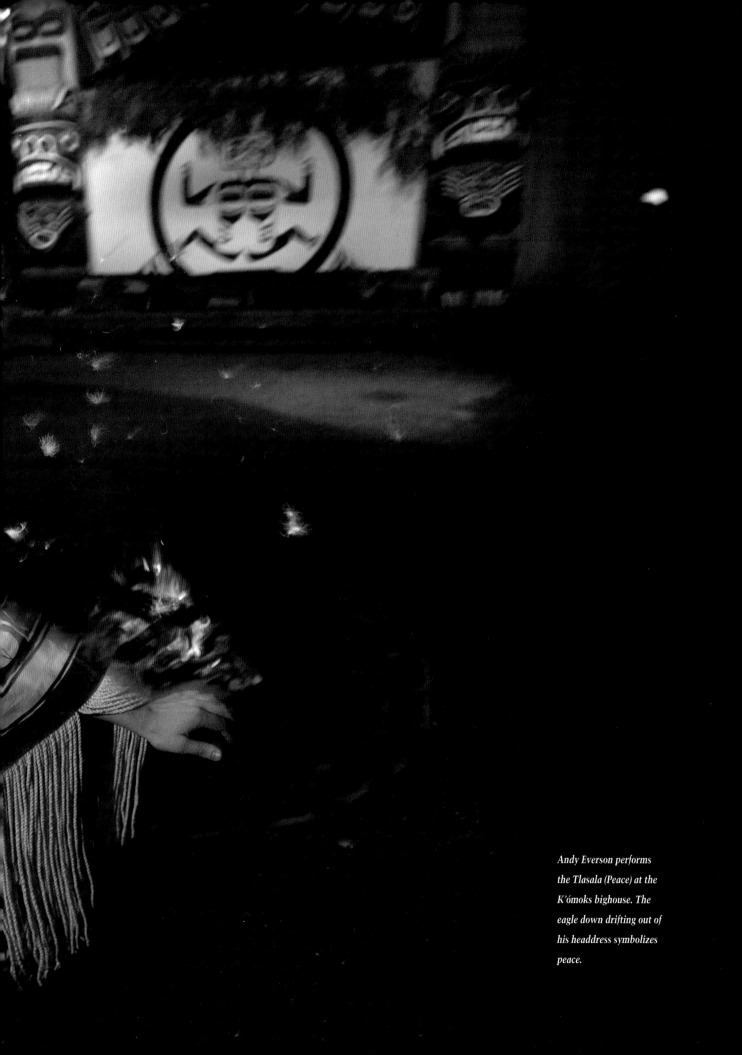

Andy Everson performs the Tlasala (Peace) at the K'ómoks bighouse. The eagle down drifting out of his headdress symbolizes peace.

*Opposite: The front of the
I-Hos Gallery features the
two-headed sea serpent that
is an important crest of the
K'ómoks Band.*

The First People

Many thousands of years ago an old chief was warned that a flood would sweep through the valley where his people lived. The Creator told the chief to prepare four canoes and great lengths of cedar rope, and to pick the strongest and best-looking people from the village. When the flood came the chosen people got into the canoes. Whenever someone who hadn't been selected tried to get into a canoe, the craft magically moved away.

The flood waters filled the village, destroying it and all who remained there. The canoes floated higher and higher up the mountains until there was no land to be seen anywhere. Eventually a large white whale appeared and the people attached their ropes to it. When the water receded, the whale landed on a mountain, ensuring that the people remained in their territory. Ever since that time, they have referred to the glacier that overlooks the Comox Valley as Queneesh, or White Whale.

—As told to Andy Everson

Although early inhabitants of the Comox Valley did not leave written records, signs of their presence are everywhere. It's not unusual for a beach or a field to reveal soil heavily mixed with pieces of broken white shell and fire-cracked rock, clear evidence of middens. Or for road and other excavation work to yield ancient stone tools or even human bones. There are petroglyphs, too, but these rock carvings are often hidden in out-of-the-way places.

Archaeological finds indicate that there has been continuous human activity in the Comox Valley for at least 4,000 years. Although there have been no major archaeological

*K'ómoks men Sean Frank
and Chief Norman Frank
enjoy a traditional salmon
barbeque at the bighouse.
The K'ómoks band is small
in numbers but strong in
spirit.*

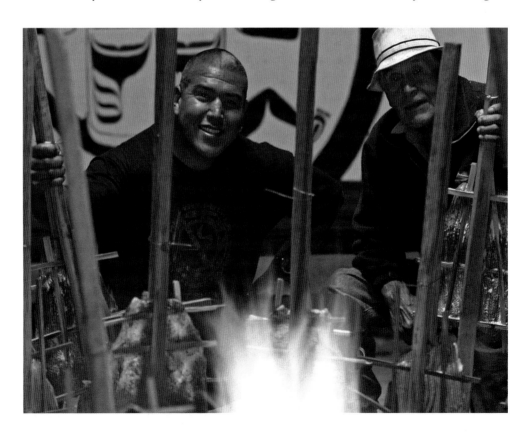

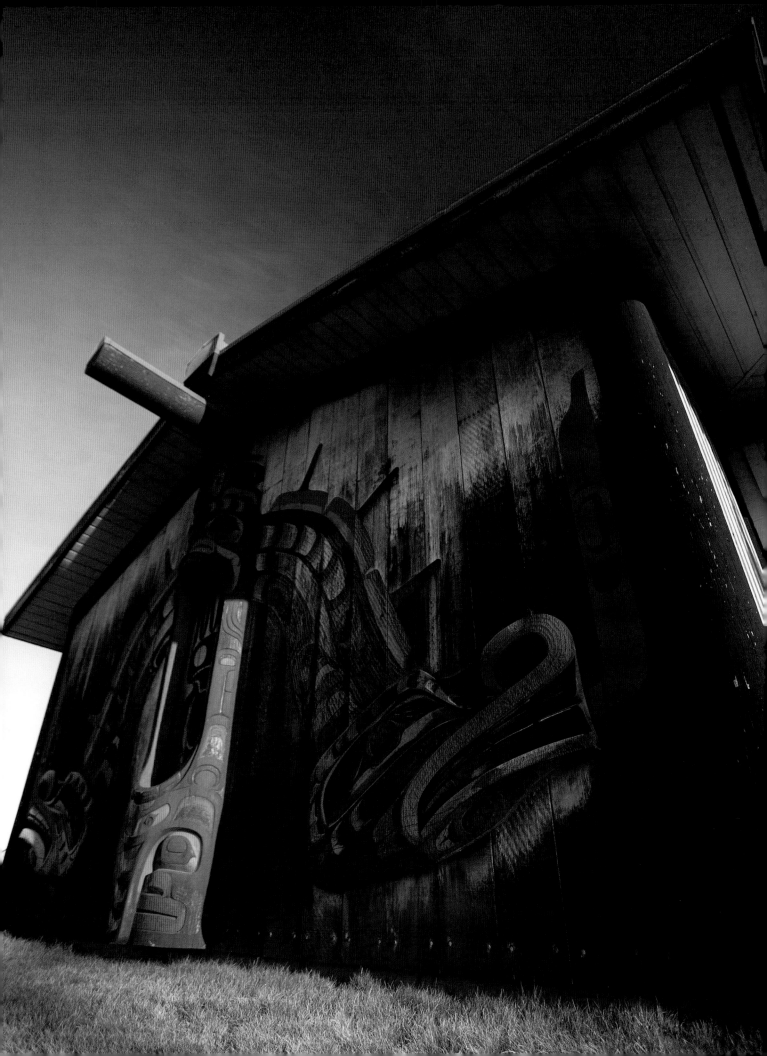

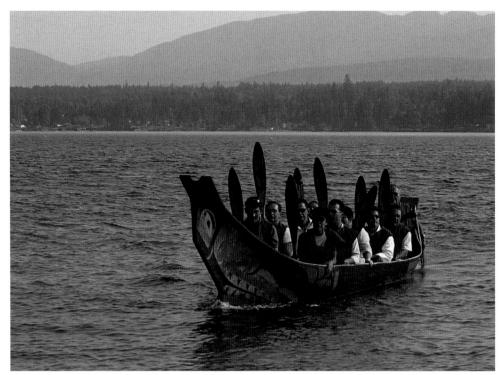

The mythical I-Hos sea serpent has been painted on the K'ómoks Band's traditional canoe.

Photo by Pauline Mitchell, courtesy Ramona Johnson

First Nations gather from near and far to celebrate their culture at the annual Pow Wow.

investigations, numerous small digs have been conducted, many by Katherine Capes. One of Canada's early woman archaeologists, Capes worked at the Canadian Museum of Civilization in Quebec and returned home each summer to visit friends and family. The most unusual sites she worked on were three low-lying mounds, two near the Tsolum River and one adjacent to the Mission Hill/Sandwick midden. Even though two of the mounds had charcoal-filled pits, none of them contained any cultural material aside from a single piece of a broken slate point. The purpose of the mounds remains a mystery to this day.

Historians and anthropologists believe that the Pentlatch may have been the first people to live in the valley. Their original territory ran from around Cape Lazo on the Comox peninsula south to Parksville and included Denman and Hornby islands. Their neighbours to the north, the Island K'ómoks, occupied villages along the Salmon River near today's Sayward (a tiny community on the coast of Vancouver Island, north of Campbell River) and other locations south to Cape Lazo, as well as on Quadra Island. *K'ómoks* is an anglicized version of a Kwakw'ala term translating as "plentiful," "rich" or "wealthy." Both the Pentlatch and K'ómoks spoke dialects of the Coast Salish language.

In the days before European settlement, intertribal war among coastal First Nations was common. Just to the north of Kelsey Bay lived the Lekwiltok, a particularly fierce group of Kwakwa̱ka'wakw who regularly raided other First Nations villages to capture people to use and sell as slaves. Chief Joe Nim Nim, the last of the full-blooded Pentlatch, died in 1940. In a 1922 interview published in the *Comox Argus*, Nim Nim, who claimed to be 100 years old at the time, recalled several battles.

Nim Nim said he was a small child when the Pentlatch village near today's Condensory Bridge was attacked. His mother escaped carrying Nim Nim on her back and hid in the woods until the fight was over. A few years later some Nuu-chah-nulth travelled overland from Port Alberni and raided the same village. This time the Pentlatch were in a position to

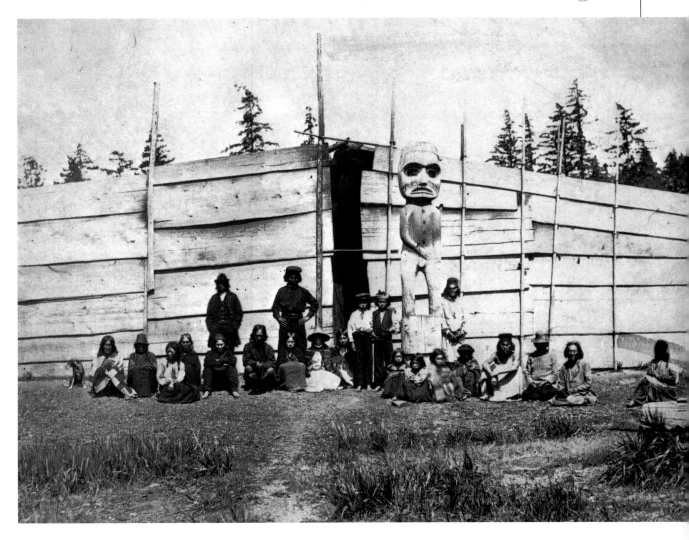

fight back and managed to kill most of the intruders. The last battle Nim Nim remembered took place on Denman Island when he was in his teens. By this time he was old enough to take part in the fight against the marauders from Alert Bay. Although Nim Nim didn't get a scalp, he nearly lost his but was saved by some friends at the last moment.

To defend themselves, the Pentlatch established an outlook post on a bluff near the present Manor Drive in Comox. Here they had a good view of canoes entering the harbour. Nearby, hidden in the forest, they erected a fortified shelter. The walls were long, narrow trees dug into the earth on an angle so they leaned outward. This made it impossible for enemy warriors to scale the walls and, during battle, Pentlatch warriors could run up the inside of the trees to throw spears and rocks at their attackers. The stockade contained a longhouse filled with enough food and water to sustain them through the longest siege. Enemies killed during battle were decapitated and their heads driven onto the tops of the barricade walls. Many years later, long after the need for a fort had passed and the structure had fallen into ruins, a group of young boys playing in the area found several skulls. They took great delight in using them as balls until some adults discovered what was going on.

Over time the warlike Lekwiltok pushed the K'ómoks south into Pentlatch territory. Eventually, when warfare and disease had almost destroyed the Pentlatch, they amalgamated with the K'ómoks. Life was good when they were not under attack. An impressive collection

A massive longhouse of split cedar planks, typical of the K'ómoks village in the late 1800s. BC Archives AA-00456

Chief Joe Nim Nim (below) was the last of the full-blooded Pentlatch. Courtenay & District Museum and Archives 984.117.1

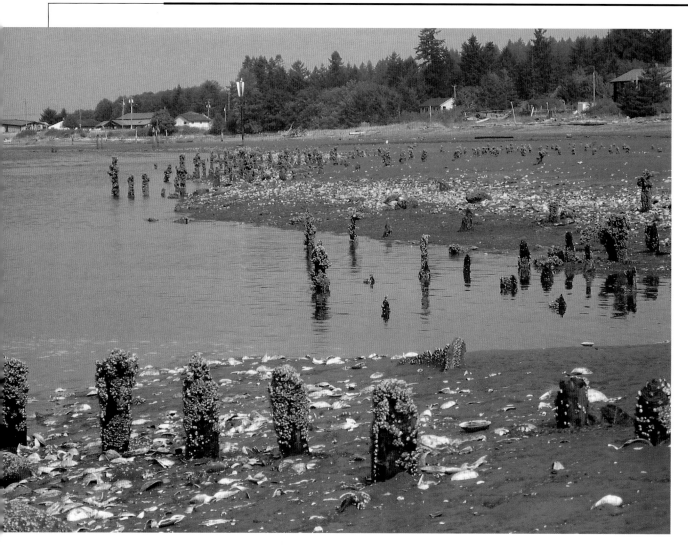

The broken-off stakes poking up out of the mud in Comox Bay are the remains of ancient First Nations fish traps. The amount and scope of the traps indicate that they fed a large number of people over a long period of time. Photo by Nancy Greene

of totem poles and longhouses lined the north shore of Comox Bay, the site of a major village. The longhouses were unique for their excavated earth floors, enclosed sleeping partitions and separate sheds for smoking fish and meat. The Pentlatch and K'ómoks thrived on the ocean's gifts of fresh salmon, clams and seals, as well as the land's abundant game such as deer and elk. The forest also provided red cedar, which was used for everything from canoes and house planks to clothing, rope, tools, household items and ceremonial regalia.

Numerous plants were harvested for food and medicinal purposes. Just as there were certain people who knew the best places to hunt and fish, there were those who knew which plants to use and how to use them. For instance, only the outer rind of wild rosehips were eaten, as consuming the seeds resulted in "an itchy bottom." Near the Tsolum River, inland from Point Holmes and on Hornby Island, the Natives managed large Garry oak meadows by periodically burning the underbrush. This provided excellent growing conditions for berries and fields of camas, a low-growing plant with edible bulbs.

In the spring, summer and fall the people hunted, fished and harvested food, which they smoked and dried for use throughout the winter. They spent the colder, wetter months inside their longhouses carving and weaving, as well as holding feasts and potlatches. Records of important events were kept orally so, instead of sending out wedding invitations or birth announcements, they invited guests from far and wide to special ceremonies where important

information was shared. Gifts were given to those attending the potlatches, and by accepting the presents, people indicated that they acknowledged and agreed with what they had been told.

Comox Bay was an integral part of life for the Pentlatch and K'ómoks, and its importance was highlighted in 2002. That fall Comox Valley resident Nancy Greene and her husband David McGee went for a walk on the mud flats at low tide. From inside the wide arc of the bay there is a good view of the valley and the mountains that rim it. But what caught Greene's eye was the large number of stick-like objects poking up a few centimetres out of the mud. Recalling archaeology classes she had taken, Greene suspected that the "sticks" were remnants of old fish traps.

After receiving permission from the K'ómoks Band, Greene enlisted the help of volunteers and began surveying the bay. They worked at low tides, using a Global Positioning System unit and other tools to chart and record clusters of stakes. When Greene transferred the findings onto virtual maps, large, distinct fish traps in heart- and chevron-shaped patterns were revealed. Greene estimated that the site contained at least 100,000 stakes; radiocarbon dating on a few of them indicated wood ranging from 175 to nearly 1,300 years old.

What Greene had documented was the remains of an enormous system of fish traps— possibly the largest on the West Coast. Nothing like it had ever been seen at any other archaeological site on the BC coast. Band members and other individuals had known about the fish traps but no one had ever surveyed them. Now it was obvious that the highly sophisticated system had been in operation over a long period of time and that it was capable of feeding a very large number of people. In fact, this collection of fish traps is so massive that it could very well prod experts into reconsidering their estimates of First Nation populations before European settlement.

Chief Joe Nim Nim claimed that 10,000 First Nations occupied the Comox Valley before

K'ómoks Band member Ramona Billie and husband to be, Charlie Johnson, cross Comox Road for their beachfront wedding. In the background paddlers of the I-Hos canoe serve as crossing guards. Photo by Pauline Mitchell, courtesy Ramona Johnson

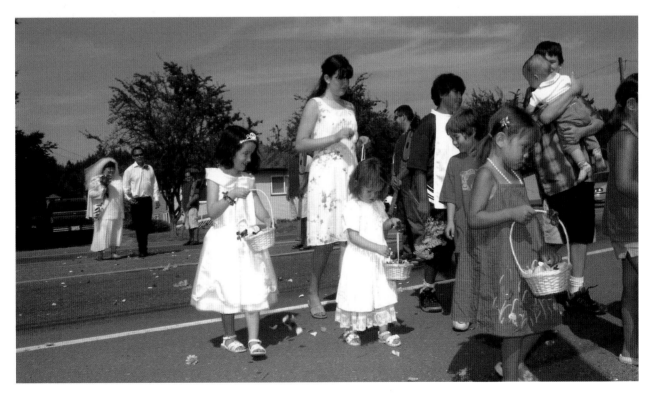

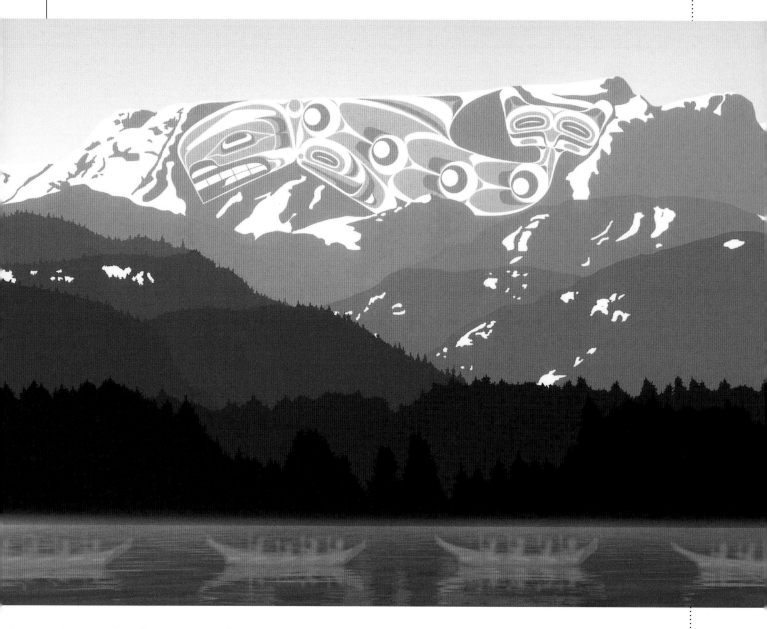

Heritage, a print by Andy Everson illustrates the close relationship between the K'ómoks Band and the Comox Glacier, which the K'ómoks call Queneesh or White Whale.

contact. The late Wilson Duff, anthropologist and author of *The Indian History of British Columbia*, estimated that in 1862, one-third of Vancouver Island Native people died as a result of a smallpox epidemic that started in Victoria and spread north. The 1876 census shows just how devastating disease and intertribal war was for Comox Valley First Nations. The K'ómoks population is listed at 88 and the Pentlatch at 21.

By 1865 all Pentlatch and K'ómoks, who had begun to intermarry with the Lekwiltok, were living at the village on Comox Bay. Serious white settlement had been taking place for a couple of years, and, as elsewhere, the influx of settlers brought massive change to the indigenous population. Different styles of dress, housing and religion were introduced, as was a wage-based economy. In addition to being devastated by new diseases, First Nations people also faced the very real possibility of losing their language and culture. Their traditional use of the land was also curtailed as areas along the north side of Comox Bay, at the tip of Goose Spit and near the confluence of the Tsolum and Puntledge rivers were designated as reserves. As an elderly First Nations woman told Robert Brown of the Vancouver Island Exploring

Expedition in 1864, "Ah, sir, you will see a fair country for white men, but the better for the whites, the poorer for the Indians."

Although the K'ómoks Band only numbered 277 in 2006, they are determined to retain their cultural identity and strengthen their economy. The carving of a 12-metre traditional style canoe in 1994 symbolically reconnected them to their heritage. The canoe, the first to be carved in more than 80 years, was named I-Hos after the two-headed serpent painted on its sides. One year later, the I-Hos Gallery opened. This distinctive cedar building on the Comox Bay reserve features carved images of the white whale Queneesh and I-Hos, important crests of the K'ómoks people. The gallery is a showcase for some of the finest First Nations art, jewellery and carvings found in the Pacific Northwest.

The K'ómoks Band's I-Hos Gallery carries a fine selection of First Nations art, jewellery and carvings.

In 2004 Pentlatch Seafoods, a company owned by the K'ómoks Band, began harvesting clams and oysters from valley beaches and distributing clam seed. This job is for hardy souls who don't mind being bent over in all types of weather or starting or finishing work at 3:00 a.m., depending on the tides. But aside from headlamps replacing torches, the work isn't that different from what the Pentlatch and K'ómoks were doing long ago. Another band initiative was the 2005 opening of a campground and the Nim Nim Interpretive Centre near Condensory Bridge in Courtenay. This is the spot where old Chief Nim Nim spent his last days, close to the Puntledge River and his favourite fishing pool.

Many families have worked hard to keep the K'ómoks culture alive but a common problem among Native communities is that young people leave the reserve for a post-secondary education and end up finding good jobs elsewhere. Artist Andy Everson felt it was essential to return. Born in Comox in 1972, Everson's roots include ties to Tlinglit, Kwakiutl, K'ómoks and Pentlatch ancestors. He was named Nagedzi after his grandfather, the highly respected Chief Andy Frank, and his grandmother, Margaret Frank, starred in the famous Edward Curtis film *Land of the War Canoes*.

After obtaining a master's degree in anthropology from the University of British Columbia, Everson returned to Comox to form Copper Canoe Consulting, a research and multimedia production company that promotes and supports the growth of First Nations government, culture and business. He encourages First Nations children to get a good education, but by basing his business on the reserve, he also lets them know they can use their knowledge at home. Everson has strong connections to family, place and heritage and expresses his cultural identity through his artwork and dancing. "Our culture is embedded in our DNA," he explains. "It's deep inside us, right to the core. It's not just something we learn."

The tranquil waters of the
Courtenay Slough provide
safe moorage for boats.

Chapter 2
Courtenay: The Hub of the Valley
with Merville and Black Creek

Stickers or Quitters

Fertile soil and easily cleared land attracted many early settlers to the Comox Valley.

With its fertile soil, mild climate and protected harbour, it's no surprise that the Comox Valley was being eyed as a settlement as far back as the mid-1800s. Early forays into the country led to reports of abundant wildlife, pristine streams and large stands of timber, as well as thousands of acres of "prairies" paralleling the Tsolum River. Following the end of BC's gold rush in the early 1860s, Victoria was swamped with men looking for other ways to earn a living. To reduce the strain on the new city's infrastructure, James Douglas, then governor of the colonies of Vancouver Island and British Columbia, began promoting the Comox and Cowichan valleys as agricultural settlements. The offer of land at $1 an acre and a free boat ride to their new home enticed many to make the move.

George Mitchell farmed the flats near the K'ómoks village in the 1850s and is credited with being one of the earliest settlers. But serious settlement, the kind that would shape and change the valley, started in 1862. In August that year, Reginald Pidcock, Reginald Carwithen, John Bailey and Harry Blaksley landed their small boat a short way up the Tsolum River. That October, HMS *Grappler*, a gunboat, delivered the first contingent of "official" pioneers from Victoria. Although a couple of men brought wives and families, most were single.

View over Courtenay (foreground) with the Courtenay River meandering into Comox Bay, Comox on the left and the narrow bulwark of Goose Spit beyond.

Nearly all the settlers landed at Comox Bay. A few preempted land near the tidal flats and today's Town of Comox, but the majority chose to live in what they called the lower prairies (along the Tsolum River and Headquarters Road) or the upper prairies (near the Old Island Highway). Here they found stands of Garry oak and large meadow-like areas covered with long grass and dotted with thickets of berry bushes and wild roses.

Early on, a group of Anglicans constructed a rough building called Mission House at the base of the hill close to the present intersection of Headquarters and the Old Island Highway.

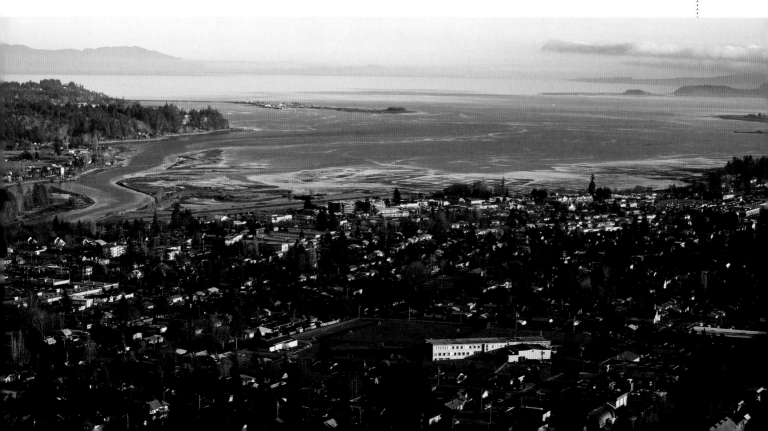

The "mission" served as church and meeting hall for everyone living on the upper and lower prairies. Around 1871 a larger church was needed so parishioners gathered to select a site. They weren't far up the hill, however, when portly Florence Green called a halt to catch her breath. Everyone agreed to build the church there and call it St. Andrew's. Not long afterwards, a Presbyterian church was constructed at the top of the hill and named St. Andrews.

Eric Duncan, author of *Fifty-Seven Years in the Comox Valley*, left the Shetland Islands in 1877 to join his uncle on his lower prairie farm. When he arrived, the first thing he noticed was "droves of Yorkshire pigs, branded and running loose, eating salmon in rivers, camping in woods under trees and rooting up the roadway." At that time, people living on the prairies had to walk or row a boat to Comox to collect their mail. In 1889, permission for a post office at Mission Corner was granted and Duncan became postmaster. Since Mission was already the name of another BC post office, the new one was christened Sandwick, after the Duncan farm and the Shetland parish it was named for.

A 1922 *Comox Argus* newspaper article referred to early settlers as "stickers or quitters." The stickers were independent, no-nonsense types who toughed out the hard times to create homes and communities, while the quitters went back to wherever they'd come from. The Shetland Islanders proved to be true stickers. In addition to farming and writing, Eric Duncan was known for his thriftiness, penchant for hard work and adherence to simple values. Once, while walking home from Courtenay, he was offered a ride in an automobile. "No thanks," he's said to have replied, "I'm in a hurry."

Duncan, who died in 1944 at age 85, was also one of the valley's first vegetarians. His recipe for a long life was to drink a third of a quart of fresh milk at each meal along with boiled oatmeal porridge and one raw apple for breakfast and whole wheat bread with butter and another apple for lunch. After a full day of farm chores he sat down to potatoes boiled with carrots or onions and one more apple. He adhered to this diet seven days a week, year-round. "I do not alter one iota for holidays," he said. "Why should a man punish his stomach just because it is Christmas?"

Crusty pioneer Eric Duncan came out from the Shetland Islands in 1877 and later wrote the book Fifty-Seven Years in the Comox Valley.
Courtenay & District Museum and Archives 979.81.1

A farm in the Comox Valley's earliest settlement, Sandwick. The name came from the Duncan family seat in the Shetland Islands.
BC Archives A-04523

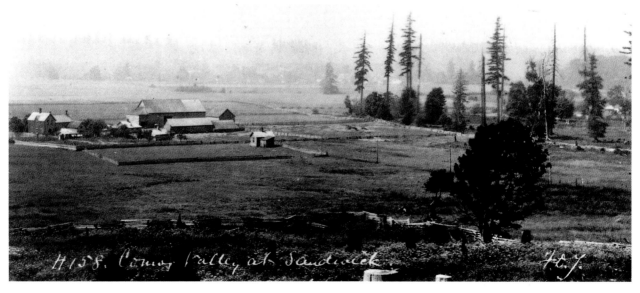

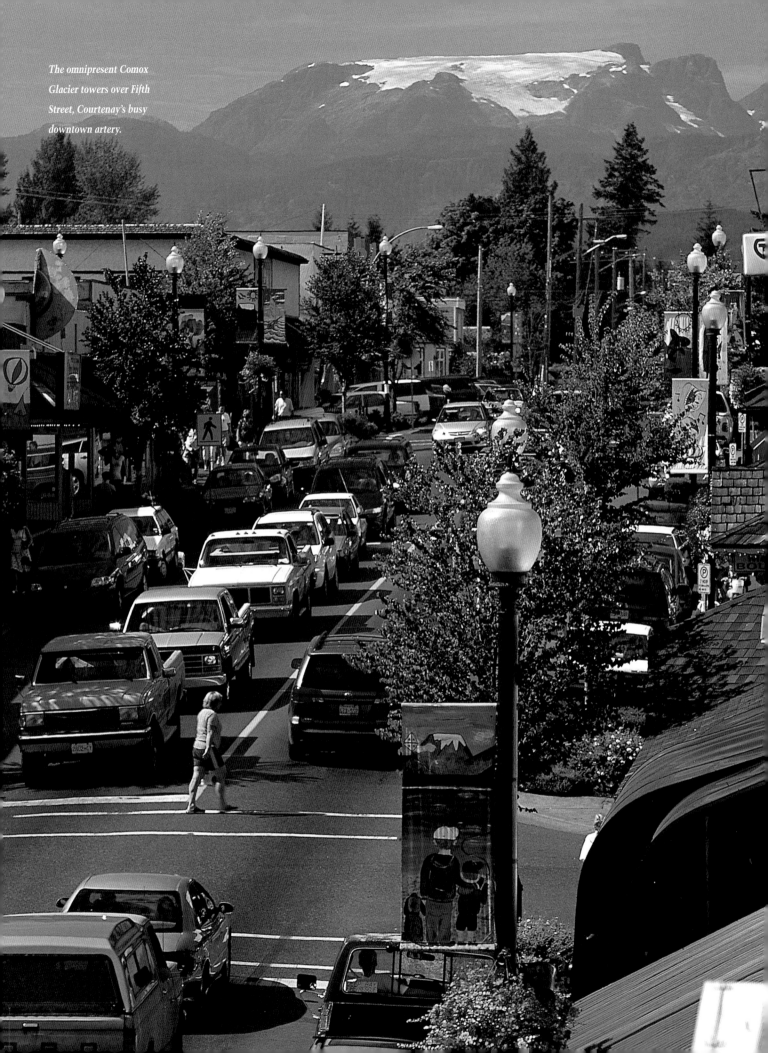

The omnipresent Comox Glacier towers over Fifth Street, Courtenay's busy downtown artery.

As the nucleus of valley settlement, Sandwick had the first school, church, golf course and library (in someone's house, perhaps the Duncans'), as well as the first agricultural hall, located at the top of Mission Hill. Today, the only physical reminders of Sandwick's past are the two churches, Sunnydale Golf Club and a cairn near the corner of Headquarters and the Old Island Highway marking the landing spot of Pidcock and his three buddies. People who've been around for a while still use the term Mission Hill, but most of the prairie farms have been carved into small acreages and subdivisions. By 2006 the valley's last major stand of untouched Garry oak, Vancouver Island's most threatened ecosystem, had been reduced to a small area near the Comox Valley Sports Centre.

Following in the footsteps of Eric Duncan, Sandwick residents are known as a feisty lot. In 2002 many balked at being annexed by the City of Courtenay. About a week before the matter was to be voted on during civic elections, Courtenay announced the annexation a *fait accompli*. Outraged at the speedy takeover, especially since some people had voted in advance polls in a riding they no longer belonged to and then left on holidays, the Sandwick Community Committee took the matter to the Supreme Court. But the annexation was declared legal and so the Sandwick stickers became the Courtenay complainers.

In the past, Cumberland and Union Bay were the commercial centres of the valley, but now Courtenay is the main mover and shaker in the economic and cultural scene. The city straddles the Courtenay River, sprawling inland in an irregular shape. Business areas have grown up to the east and west of the river, but for a while it was touch and go as to which side would claim the title of downtown.

The clock outside Graham's Jewellers has been a landmark in downtown Courtenay since 1951.

That's hard to believe now, with a lively city centre on the west side filled with fashionable boutiques and a varied selection of places to eat and sip java. But even though the main influx of settlers arrived in 1862, it was more than a decade before anyone opened a business on the west side of the river. When Reginald Pidcock, one of the first four to land at what was named Sandwick, tired of farming, he built a sawmill near today's Eighth and Cliffe. With help from the community, he dug a ditch and diverted water from a small Puntledge River tributary to power the mill. A bridge over the river was built close by.

Around 1885, Pidcock found himself in financial difficulties and offered Joseph McPhee half his land if he'd bail him out. A deal was struck and a few years later McPhee, known as the father of Courtenay, announced that he was going to build a townsite by the bridge. He called his town Courtenay after the river, which in turn had been named in honour of a British naval officer, Captain George William Conway Courtenay.

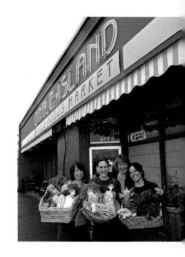

In the meantime, Williams Lewis had his own townsite underway on the east side of the river. Built around 1890, the Courtenay Hotel, now a stripper bar affectionately called the CoHo by regular patrons, was the centre of a business community that eventually included a boarding house, bike repair shop, restaurant and ice cream parlour. A blacksmith shop opened around the same time as the hotel and it was said that "Old" Johnny McKenzie could shoe or mend just about anything. He also liked to hand out free advice, such as "Never trust anyone who is a Conservative" and "Pick yourself up if you fall." Men enjoyed whiling away the time

Edible Island is a popular outlet for organic foods in Courtenay.

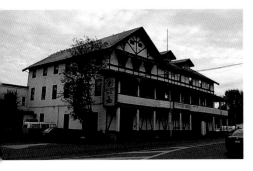

The Courtenay Hotel, one of the city's oldest buildings, was built around 1890. Photo by Rick James

in the shop while McKenzie worked. About mid-morning, he'd send someone across to the hotel for a two-bit pail of beer. When the beer arrived, McKenzie would stick a red-hot iron into the pail. Everyone agreed this gave the beer an unusual aroma and taste. Regular imbibers were considered part of the in crowd.

Back on the west side of the river, McPhee had sold a few lots and opened a store near the bridge. When his townsite didn't develop as quickly as he'd hoped it would, he planted a thousand-tree orchard a few blocks away and sold the fruit in his store. Around 1912, he subdivided the orchard, and numerous large homes replaced most of the fruit trees. Many of these houses still stand in what's known as the Old Orchard area.

One of the earliest businesses to join McPhee on the west side was the three-storey Riverside Hotel built in 1889. The low wall that ran in front of this imposing structure became a favourite spot for a group of old men to sit and discuss politics and comment on the attributes of women walking by. The Riverside burned down in 1968, but two businesses established on Union Street (now Fifth) and operating under early names are Searle's Shoes and Rickson's Menswear (formerly Rickson's Variety).

A fire in 1916 destroyed many downtown buildings, but two significant ones still stand. One of them, the two-storey brick building on the corner of Cliffe and Fourth, was constructed in 1925 as a post office and customs house. Now owned by the City of Courtenay, it is recognized as a structure of historical significance and houses the Courtenay & District Museum.

The art-deco Palace Theatre is one of Courtenay's most recognizable heritage buildings.

Just down the road on Cliffe stands the Native Sons Hall, likely the largest free-standing

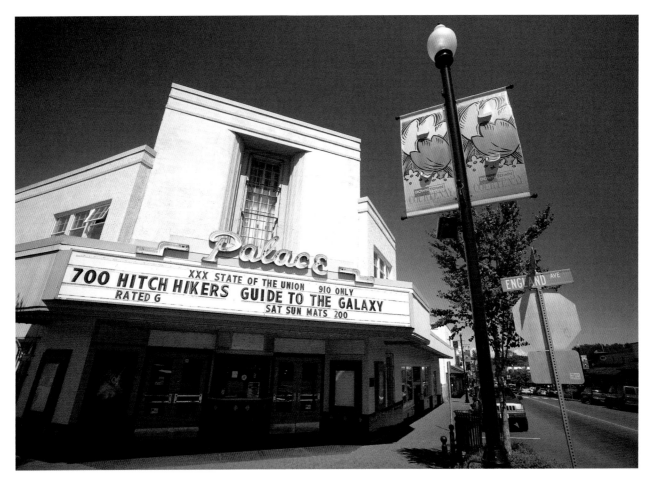

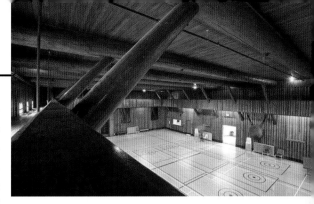

log building in the world. The mandate of the Native Sons, founded in Victoria in 1921, was to promote the interests of Canada and Canadians. In 1928 Courtenay's Native Sons Assembly No. 3 built a hall that contains enough lumber to build 64 four-room bungalows. Part of what makes the hall unique is that the 500 cedar logs that form the outside of the building are placed vertically instead of horizontally. Inside, beneath a 7-metre ceiling, is a grand ballroom featuring an 18x27 metre sprung floor of eastern maple edged with oak.

Built as a community hall in 1921, the Native Sons Hall is probably the largest free-standing log building in the world and is still used for recreational classes, dances and weddings.

Dorothy Stubbs, a longtime valley resident and newspaper columnist known by her middle name, Isabelle, wrote: "From the time it was built, the Native Sons Hall was the centre of sports and social life." Hundreds of basketball games were held there, as well as wedding receptions, political rallies, high school graduations and roller-skating events. When the local Native Sons chapter slowed down, the League of Canadian Daughters looked after the building, and the City of Courtenay took it over in 2000. Declared a heritage site in 1987, the Native Sons Hall is still the site of exercise classes, weddings, dances and other activities.

Another unique downtown building is the art deco-style Palace Theatre. It was originally called the E.W. Bickle Theatre after its owner, Edward W. Bickle, an astute businessman who owned various newspapers and theatres in the valley. The theatre opened in November 1940 and was said to be "a monument to the latest in projection, sound gear and patron comfort." The first movie shown was *Boom Town* staring Clark Gable, Spencer Tracy, Claudette Colbert and Hedy Lamarr.

The Fifth Street Bridge, Courtenay's most prominent landmark, spans the Courtenay River between west Courtenay and the Comox Peninsula.

Craftsman-style bungalows of Courtenay's Old Orchard neighbourhood predate the West Coast contemporary style of North Island College.

In the old days, supplies to Courtenay arrived via a scow up the river. But around 1905, Canadian Pacific Railway bought the Esquimalt and Nanaimo Railway Company and by 1914 had extended the line from Parksville to Courtenay. With a direct link to Victoria, Courtenay quickly became the commercial centre of the valley and was incorporated as a city the next year. Once the railway line was punched through, the west side of the river became the official downtown.

As the valley grew, the performing and visual arts became a vital part of its character. Now the region boasts countless artist and craft studios, numerous art galleries and various theatre venues. In addition to being available in theatres and galleries, art, music and drama frequently spill over into restaurants, parks and shops. Touring and local performers present events ranging from serious highbrow stuff to off-the-wall, I've-never-seen-anything-like-this-before productions. Many performing and visual arts organizations have been active for decades, and a variety of festivals and events take place year-round.

The valley's natural beauty, as well as its cultural heritage, stimulates writers, musicians and artists alike. Many appreciate the slower pace of life compared to cities like Vancouver. And the proximity to nature is a bonus. Often inspiration is only a drive, walk or glance out the window away.

As painter Bev Byerley puts it, "We have it all here—mountains, ocean, rivers, old-growth forests …. Having spent most of my life in the Comox Valley, I feel like I know every crack in the pavement and have seen the landscape from every viewpoint, but I'm still amazed at how

the very familiar is constantly shaped and reshaped by light and cloud. I love translating these images with paint and canvas."

With several art galleries, a performing arts theatre, a museum, a library and the multi-organization Comox Valley Centre for the Arts all located in the downtown core, there is no doubt that Courtenay is the heart of the valley's arts and culture scene. As far back as 1910, the downtown area was home to an opera house that could seat 500. When that burned down in 1917, the Gaiety Theatre was built, and when that too succumbed to fire a couple of years later, it was rebuilt and eventually purchased by E.W. Bickle.

Around 1935, Bickle built another theatre next door to the Gaiety on the corner of Fifth and Cliffe, calling it the Bickle Theatre. Although the Gaiety was primarily a live theatre venue and the Bickle a movie house, live performances were held at both. In *All About Us*, Isabelle Stubbs wrote, "There was no dressing rooms, no rest room facilities … Costumes were changed where one stood. Of necessity, lard pails became 'conveniences,' guards were posted, there was an unspoken agreement that no one ever saw what was not supposed to be seen."

Although it still operated as a movie theatre in 1950, the Bickle Theatre was used less often after the more lavish E.W. Bickle Theatre (now the Palace) was built a few blocks up Fifth Street. It may seem strange that Bickle would establish two theatres within a few blocks of each other, but he had a reputation for operating on a large scale. Legend has it that one morning, annoyed about not having any bacon for breakfast, he ordered 50 pigs; and that another time, after waiting to use the bathroom, he purchased 30 toilets. For a while the old Bickle Theatre ran as an auction house, but according to Lawrence Burns, it was pretty well derelict in 1968 when the Riverside Hotel burned down. "The theatre was only eight inches away from the hotel," said Burns, who as deputy fire chief was in charge of fighting the blaze. "A lot of people said we should have just let it burn."

Then, in the early 1970s, Mayor George Hobson launched his Total Community Participation Project. Hobson invited 60 people to a special breakfast meeting, but word of the gathering leaked out and some 200 showed up. The restaurant ran out of food and had to send out for more. In the meantime, Hobson outlined his idea to create a civic square in the centre of Courtenay where the Riverside Hotel had been and to buy the adjacent Bickle Theatre and renovate it. Volunteers raised money, scrubbed down the old theatre and pried gum off the bottoms of seats. When the theatre reopened, it was named the Civic Theatre. In 1984 it was rechristened the Sid Williams Civic Theatre. Extensive renovations and upgrading beginning in 1998 transformed the "Sid" into the modern facility it is today.

Frederick Sidney Williams was a special kind of guy. He loved to hike and ski, was an exceptional boxer and served on Courtenay City Council for more than 20 years. He was also involved with the building of the Memorial Pool and many other community projects. But most people probably remember "Sid" as an actor. According to Isabelle Stubbs, Sid first appeared onstage in a 1922 production of *The Toymaker*. Throughout his life he performed countless roles, including guest appearances on the television program *The Beachcombers*. Undoubtedly, Sid's most famous character was that of Century Sam, an old gold prospector

Named after legendary thespian Sid Williams, the downtown Courtenay civic theatre provides a venue for community and professional performances.

Sid Williams' most famous role was that of the old prospector Century Sam.
Courtenay & District Museum and Archives Stubbs 246

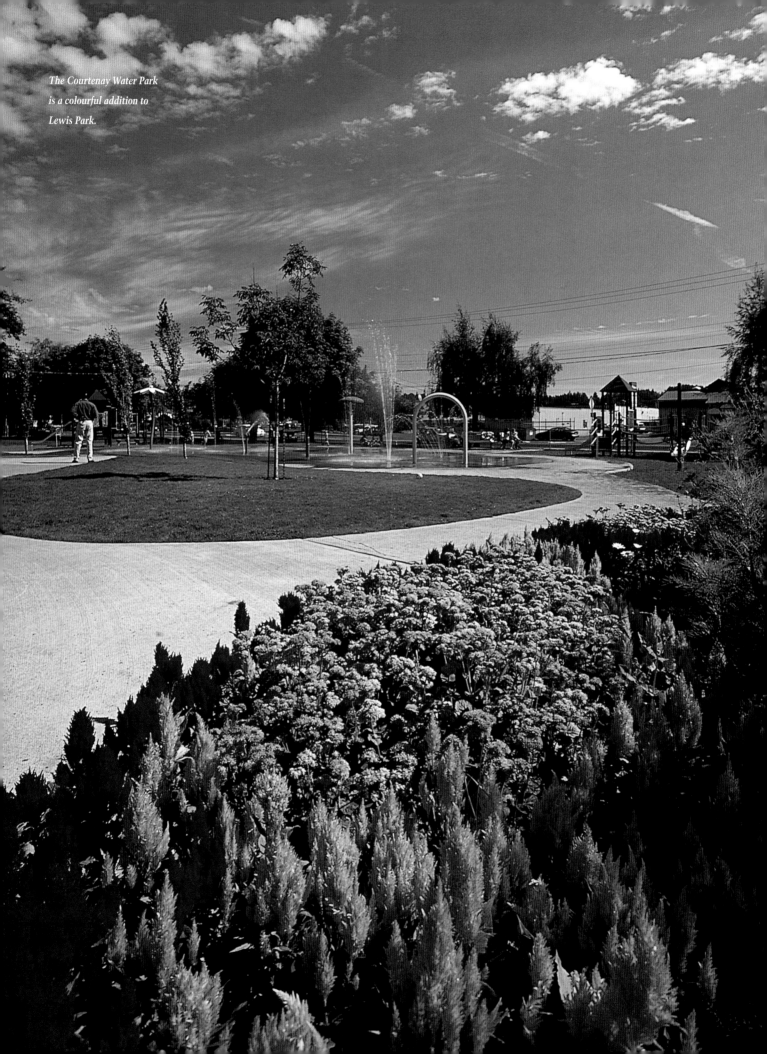

The Courtenay Water Park is a colourful addition to Lewis Park.

who came back to life in 1958 and toured the province to celebrate BC's Centenary. But Sid wasn't concerned about being on centre stage; he was just as happy painting scenery or moving props. Among his many accolades and honours, the most notable are being made Freeman of the City of Courtenay and becoming a Member of the Order of Canada.

Since he was always willing to don a costume, Sid frequently played Santa at Christmas events. And once he was asked to play the role in real life. When word got out that a young Courtenay boy had less than a year to live and wanted a bike for Christmas, funds were raised and a bike was bought. Sid agreed to deliver it as Santa. To his amazement, the boy didn't even look at the bike. Instead, he leapt into Sid's arms, threw his arms around his neck and cried, "Santa, you came! I knew you would!" During his performing years Sid had made many people laugh and cry, but this was the first time his own tears got the best of him.

Over the years Courtenay has grown phenomenally. Acres of subdivisions have been joined by condo developments, and city boundaries extend into formerly rural areas. In the early 1990s Courtenay was the fastest-growing municipality in BC, and by the mid-1990s it had the dubious honour of being the fastest-growing city in Canada. People from the Lower Mainland, Prairie and eastern provinces and the US love the views, the easy access to recreation and the more affordable real estate.

Not everyone likes growth, however, and valley residents are always ready to speak their minds and sign petitions. Roads, bridges, big-box stores and changing boundaries all provide opportunities for some verbal push and shove. For example, the Fifth Street Bridge had been upgraded several times, but by the late 1970s it was evident that more than one crossing of the river was needed. But where to put it? Various proposals were put forward, and after heated arguments that included name-calling and even threats, the provincial government said the

Above: A boy enjoys the Courtenay Water Park. Below: Bystanders crowd the Fifth Street Bridge to watch the Ducky 500 Race.

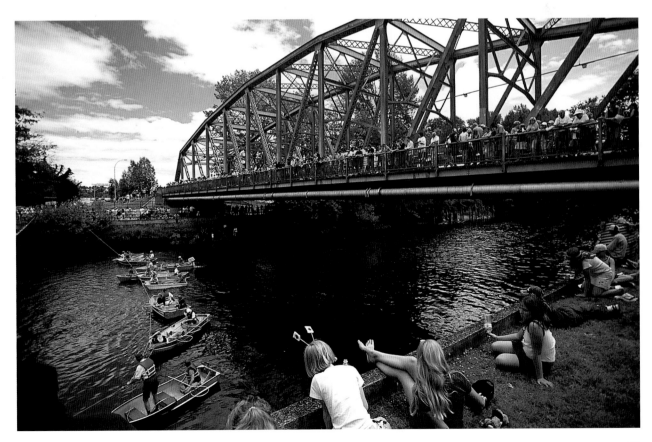

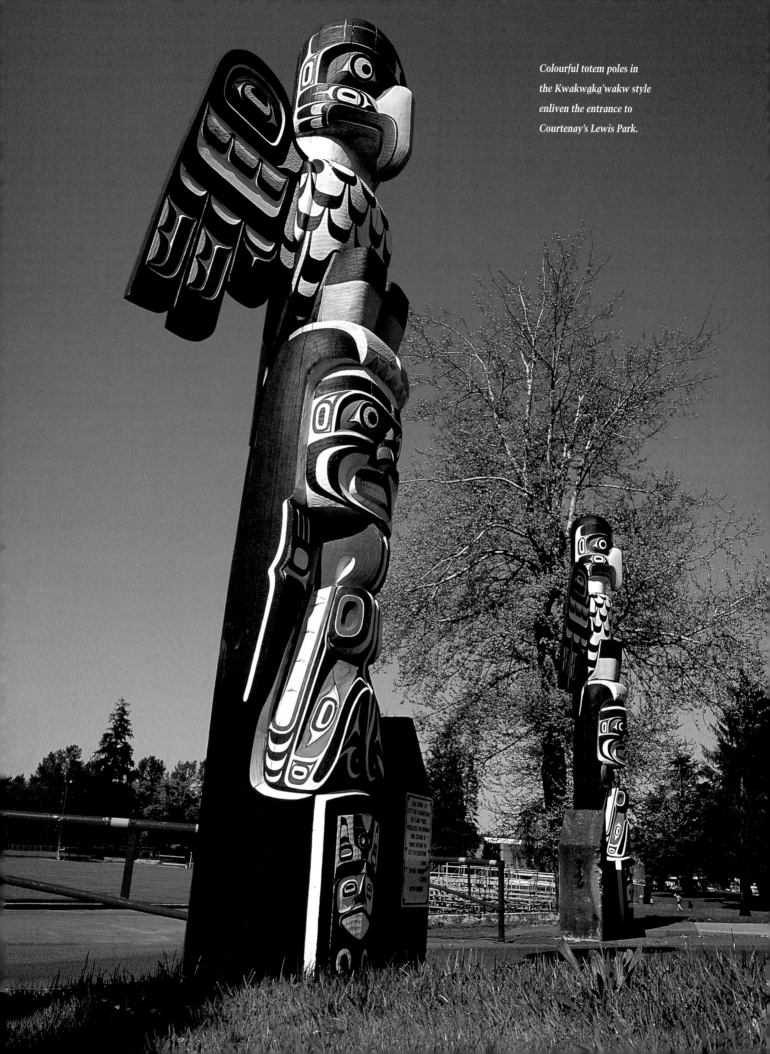

Colourful totem poles in the Kwakwaka'wakw style enliven the entrance to Courtenay's Lewis Park.

bridge was going in at 17th Street. As well as providing an alternate route to the east side of the river, this bypass also allows through-traffic using the Old Island Highway to avoid downtown Courtenay.

Despite all its growth, Courtenay has retained some notable green spaces. Immediately to the east of the Fifth Street Bridge are two jewels, Lewis and Simms parks. According to the late Jack Hames, a newspaper columnist and long-time valley resident, Lewis Park used to be nothing more than a cow pasture with a roughed-out ball field in which baseball players had to watch their step and their slides. Although cows haven't wandered the area for a good while, once a year or so, the park becomes "Lewis Lake" when heavy rains and high tides fill the fields with spawning salmon and seagulls rather than ball players and picnickers.

Across the street, also at the foot of the bridge, is Simms Millennium Park. A walkway has been built linking Lewis and Simms parks to the Courtenay Marina Airpark a couple of kilometres away. At the Airpark, a paved path separates the airport runway from the Courtenay River. Walkers share the path with wheelchairs, strollers and rollerbladers, while small planes practise their takeoffs and landings on one side and seals and kayakers travel the river on the other.

Courtenay has also made good use of its proximity to the Puntledge River. Puntledge Park is a few kilometres upstream from downtown. The main entrance takes visitors over an arched bridge that crosses Morrison Creek, believed to be the stream that Pidcock diverted for his mill. In the fall it's easy to see salmon as they swim up this shallow waterway to lay their white, pea-sized eggs in the gravel.

Morrison Creek is home to a mysterious species of lamprey, an eel-like creature about the size of a pen. Although lamprey have been around for more than 300 million years, the Morrison Creek species is unique in that there are two kinds—parasitic and non-parasitic, the only such genetically linked duo known in the world. The non-parasitic version lives for only a few months as an adult and doesn't eat during that time. Its counterpart, however, survives for about a year by attaching itself to passing fish and sucking their blood. Just enough is known about this genetic anomaly to class it as endangered.

Everyone enjoys soaking up the rays in Simms Millennium Park.

With the Courtenay River on one side and a runway for small planes on the other, the walkway at the Courtenay Marina Airpark is a pleasant and scenic place to take a stroll.

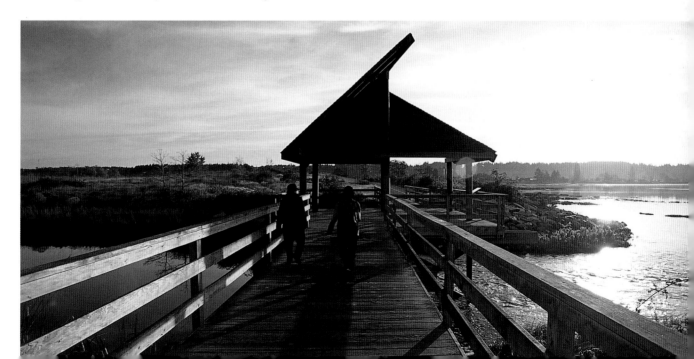

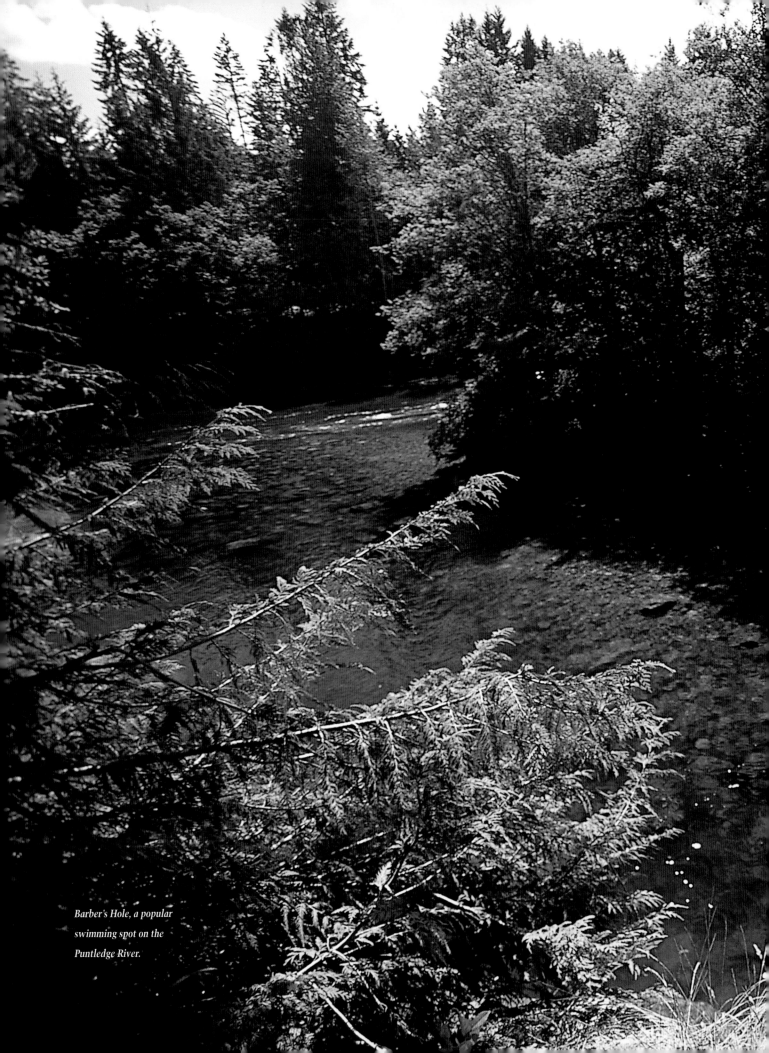

Barber's Hole, a popular swimming spot on the Puntledge River.

North of Courtenay, particularly in the Merville and Black Creek areas, much of the land is protected from development by the Agricultural Land Reserve. Photo by Rick James

The Big Fires

Many homesteaders at the Merville soldiers' settlement had barely moved into their homes when disaster struck in the summer of 1922. The land around them was covered with dry slash, bits of wood and stumps left behind from logging. For days a huge fire north of Merville had cast a pall of smoke over the area, and on July 6 a strong wind swept the fire toward the community.

In Merville and Its Early Settlers 1919–1985, Lester Hodgins, son of Joseph and Grace Hodgins, wrote: "The house was our last protection against that stinging shower of sparks which poured down on the clearing which was a sea of flames: everything seemed to be burning, even the fenceposts."

The Comox Argus reported, "Like a wolf on the fold the bush fire that had been raging in the bush north of Merville swept down … and wiped out 26 houses, leaving approximately a hundred people homeless and in most cases destitute."

In July 1938 another major fire started north of Campbell River and burned southward for two weeks, stopping only a few kilometres inland of Courtenay. Consuming 30,000 hectares of land, it went down in history as "The Great Fire" and remains one of the largest in BC history, though it didn't destroy as much private property as the Merville fire of 1922.

Merville: Gumboot Country

Merville is about a 15-minute drive up-valley from downtown Courtenay. According to residents, Canada Post's definition of the region—both sides of the Old Island Highway between Coleman and Howard roads—is debatable. When asked about boundaries, one resident replied, "Merville is infinite." Another answered, "Merville is a state of mind."

On the northeast side of Merville, gravel and sand beaches give way to the Strait of Georgia. From there it's possible to see the Coast Mountains on most days. Landmarks on the other side of the highway include Dove Creek, the Inland Island Highway and the steep hump of Constitution Hill with the long, skinny Wolf Lake behind it. The Tsolum River winds through much of Merville and the 3.2-hectare Tsolum Spirit Park, nestled along one of its larger bends, is also known as the "two beers and a pizza" park. That, according to then regional director Harold Macy, was the estimated annual cost to each resident in a two-year tax bite. Tsolum is a community nature park created collaboratively by local residents and the Regional District of Comox–Strathcona. A portion of the Comox Logging & Railway grade is now a trail, and for many years students at Tsolum School looked after the area. The school was recently and unexpectedly closed.

Merville's rural atmosphere has earned it the nickname "Gumboot Country."

The flat land of the Merville area supports some of the Comox Valley's enduring farms.

Opposite: A quaint wooden bridge crosses the Oyster River.

Merville didn't get its name or many settlers until after World War I, when the Government of British Columbia initiated a plan to assist returning veterans. The Land Settlement Board allowed men to obtain land in certain areas as long as they agreed to use it for agricultural purposes. Some 5,600 hectares of logged-off land was purchased from the Canadian Western Lumber Company, and by May 1919, 75 veterans and their families had set up temporary tents and tarpaper shacks near the present Merville Store. They called their settlement Merville ("village by the sea") after a French village where many Canadians had fought during the war.

Although the land was classed as agricultural because of the soil, logging had left many enormous stumps. In *Land of Plenty: A History of the Comox District*, Dick Isenor noted that these obstacles "were like huge molars with the roots penetrating deep into the gravel and sand to the hardpan beneath." Men tackled the stumps with donkey engines and dynamite, but the work wasn't easy. As Lester Hodgins wrote in *Merville and Its Early Settlers 1919– 1985*, "Merville was the land of big trees ... often six feet across at the base and 200 feet high and some have been as large as a room at the base. The area had been logged off around 1908 ... the remaining stumps, snags and rotting logs were all grown over with a tangle of

The Comox Valley's natural beauty and laid-back lifestyle has attracted a thriving arts community. Brian Scott is well known for his colourful paintings depicting Comox Valley scenes.

brush and second growth. Sometimes it took almost a box of blasting powder to rip a single stump from the ground and it could leave a hole behind the size of a well. Earth, stones and roots would go flying through the air—at least one man died while blasting stumps."

The Prince of Wales was invited to officially open the settlement's two-room school in the fall of 1919. To celebrate the occasion, men clearing a nearby field gave him a 21-stump salute and Gladys "Nina" King played some tunes on a piano sitting in the back of a wagon.

In addition to dealing with stumps, the settlers also had to contend with what seemed like a never-ending supply of rocks in the ground they hoped to use as fields. Even the quality of lumber available to build their homes presented a challenge. "If you don't believe that two parallel lines can eventually meet, just buy a 12-foot length of two by four from Erskine and May," Barney Beaumont recalled (*Merville and Its Early Settlers*). Many of the wives, war brides from England, found life in the "village by the sea" far different than they had expected.

Although the soldiers are long gone, Kitty Coleman Park is a legacy from their settlement. The area around Kitty Coleman Creek was part of the 5,600 hectares bought for use by returning veterans. During the fire of 1922 some families found sanctuary at Kitty Coleman beach; in better times it was a popular summertime getaway. The beach and surrounding mature forest were designated a provincial park in 1944. Two years later the Kitty Coleman Beach and Fishing Club boasted 130 members, and around 120 boats were berthed in the creek. This is also the place where Rex Field, inventor of the famous Buzz Bomb, tested the sport fishing plugs he initially carved from broom handles.

In the mid-1960s, another out-of-the-ordinary group settled in Merville. Led by a Belgian named Jacques Winandy, a dozen or so Benedictine monks established a hermitage at Headquarters, the abandoned logging camp on the Tsolum River. They were scholars

Acclaimed novelist Jack Hodgins is one of Merville's most distinguished alumni. His 1999 novel, Broken Ground, *revisits the settlement's dramatic past, including the devastating forest fire of 1922. Photo by Darren Stone*

There's always plenty of action at Saratoga Speedway in Black Creek.

and theologians seeking a quiet, contemplative life, and each built a small dwelling and was responsible for earning his own living. The homes were close to one another but the monks led solitary lives, spending much of each day in silence and prayer. After about five years the hermitage began to feel too much like a community, so the monks disbanded. Some took up more conventional lives; others created their own private hermitages.

Today, only a few descendants of the original settlers remain in Merville and the forest has reclaimed many of the fields they so laboriously cleared. Aside from a small commercial area at the corner of Merville Road and the Old Island Highway, Merville is a quiet area consisting of forests, small farms and homes on larger properties. Many people enjoy the fact that they can look out their windows and not see any signs of civilization. The rural nature of the region is best summed up by a sign in the Merville postal outlet that reads "Welcome to Gumboot Country."

Black Creek: Kodak as You Go

A little farther up-island from Merville is Black Creek. Although determining the borders of this community can be as tricky as defining those of Merville, most people acknowledge that it includes the land from Howard Road to Oyster River and from the saltchuck to the four-lane Inland Island Highway. The area is named after the murky waters of Black Creek, which drains out of a peat bog.

Young Jack Hames considered the area incredibly beautiful. In *Field Notes: An Environmental History* he recalled that, "You knew before you got there that you were coming to something scenic as there was a sign that read 'Picture ahead, Kodak as you go.' It was a single-track road with giant timber standing guard … Maidenhair ferns and moss carpeted the forest floor to water's edge."

Rainforest driveways of Merville and Black Creek areas sometimes resemble long green tunnels.

Opposite page: A sport fisherman makes an early morning cast from the beach near the Oyster River mouth.

Cougar Smith

The Smith family moved to Black Creek in the late 1880s, not because of tall timber or white sand but as the result of financial difficulties back home in England. Although they survived the cold snap of '89 by huddling around the wood stove wrapped in blankets, many of their cattle starved to death. It was the job of nine-year-old John to round up the unfenced herd, and that's how he learned to track animals. Five years later he shot his first cougar, unaware that he was launching a career as a bounty hunter and world-famous big-game guide.

At that time, cougars and wolves were a menace to livestock on Vancouver Island. Farmers didn't have time to track the troublesome beasts, so they hired John. Word got around and it wasn't long before Smith was on call 24 hours a day to deal with problem predators. Soon big-game hunters were hiring him as a guide. He was 20 when he received a letter addressed to "Cougar" Smith of Vancouver Island and a legend was born.

Following World War I, Smith was paid by the provincial game department to hunt cougars, wolves and bears. After he had shown a dead animal to a government official, he might sell the carcass to merchants in Cumberland's Chinatown, the skin to a taxidermist and the skull to a museum. He kept the cougar tails for himself and was renowned for his cattail soup. As his reputation grew, Roderick Haig-Brown, Hamilton Mack Laing and other writers often accompanied him on hunting expeditions to research their novels and magazine articles, increasing his fame.

It's ironic that the dark waters of Black Creek lead to an inviting low-tide expanse of white sand. Here, 22 kilometres up-island from Courtenay, is the 135-hectare Miracle Beach Provincial Park. As well as a waterfront playground and summer interpretive centre, the park contains wooded trails through second- and old-growth forests of ancient Douglas fir and Sitka spruce. A huge fire swept through the area in 1938, stopping just short of what is now the park. Some say that this is how the name "Miracle" was chosen.

In the early 1930s, after Comox Logging & Railway had logged off the great stands of Douglas fir, the Comox Colonization Society advertised 12,000 acres for sale in 100-acre parcels at $5 to $7 per acre (in today's currency, 40 hectares for about $70,000). The Schulz family was the first to respond to the ad, and when they sent letters about their new home to prairie newspapers, other Mennonite families joined them. Working communally, the Mennonites cleared land, built homes and established dairy and fruit farms. Around the 1950s some of the original properties were subdivided; non-Mennonite people began moving into the area, families mingled and cultural differences began to blur.

Today Black Creek is a mix of residential neighbourhoods and farms and retains an active Mennonite community. Every May, Mennonites from all over Vancouver Island meet in Black Creek to raise funds for the Mennonite Central Committee World Relief Fair, which supports a different project each year. At the heart of the commercial centre, which includes a gas station, store and mini-golf course, are the Black Creek Café and Market and the nearby Miracle Beach Country Junction. The turnoff to Miracle Beach is the halfway point between Courtenay and Campbell River.

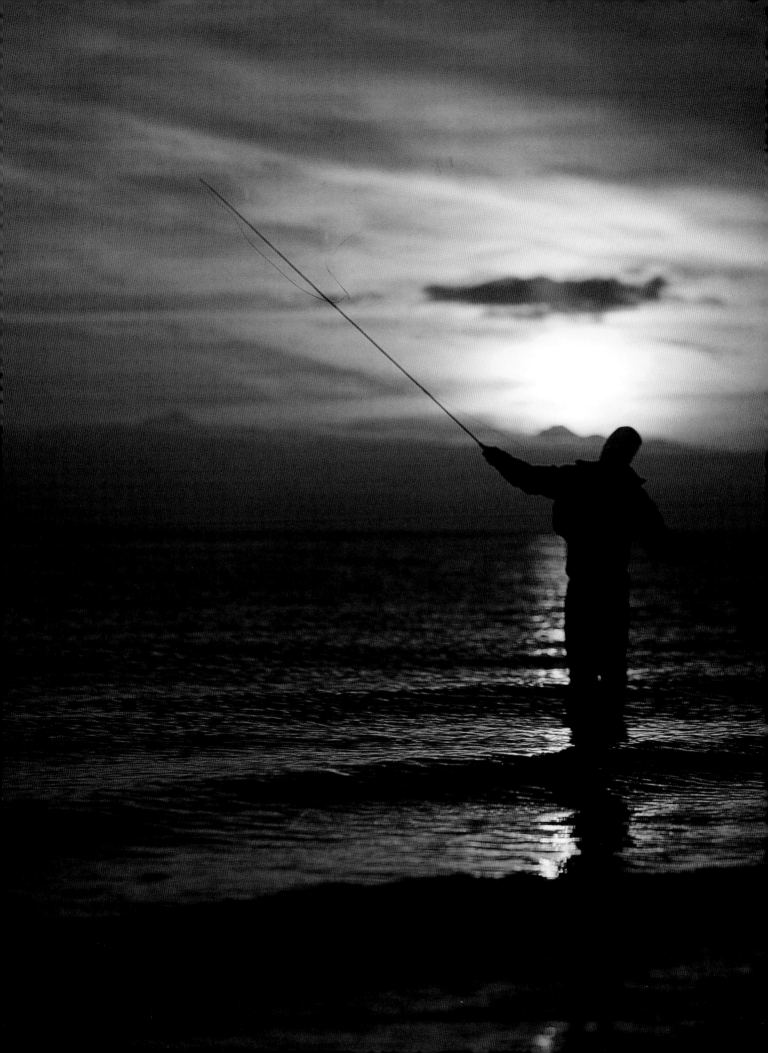

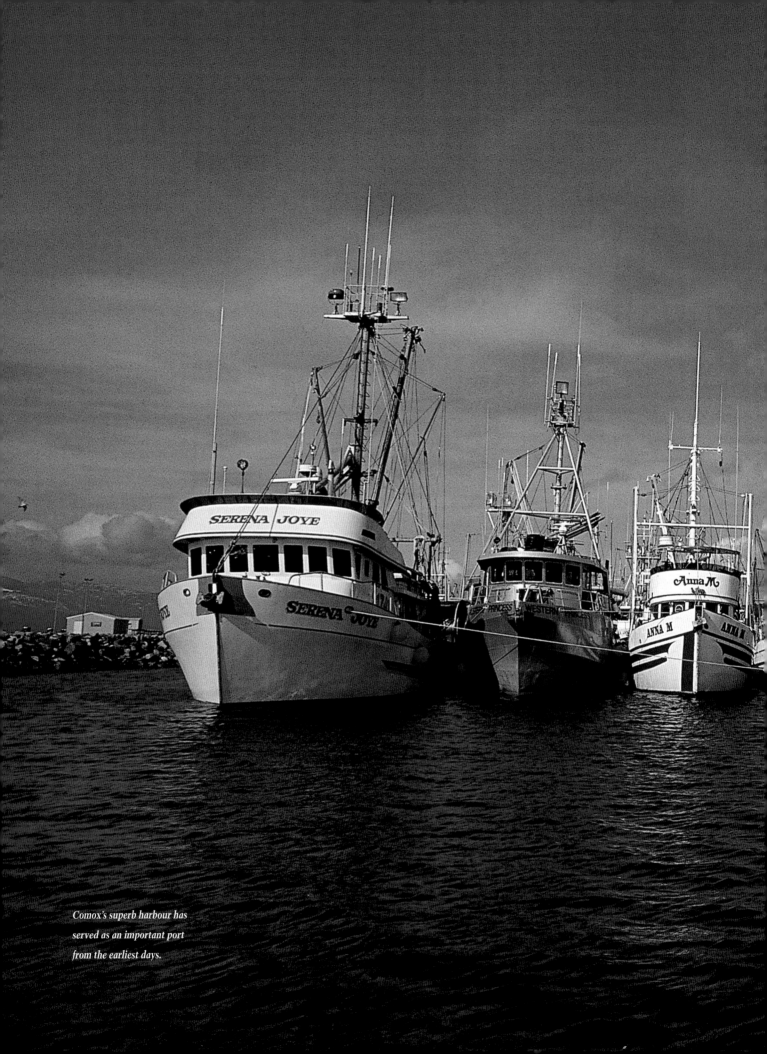

*Comox's superb harbour has
served as an important port
from the earliest days.*

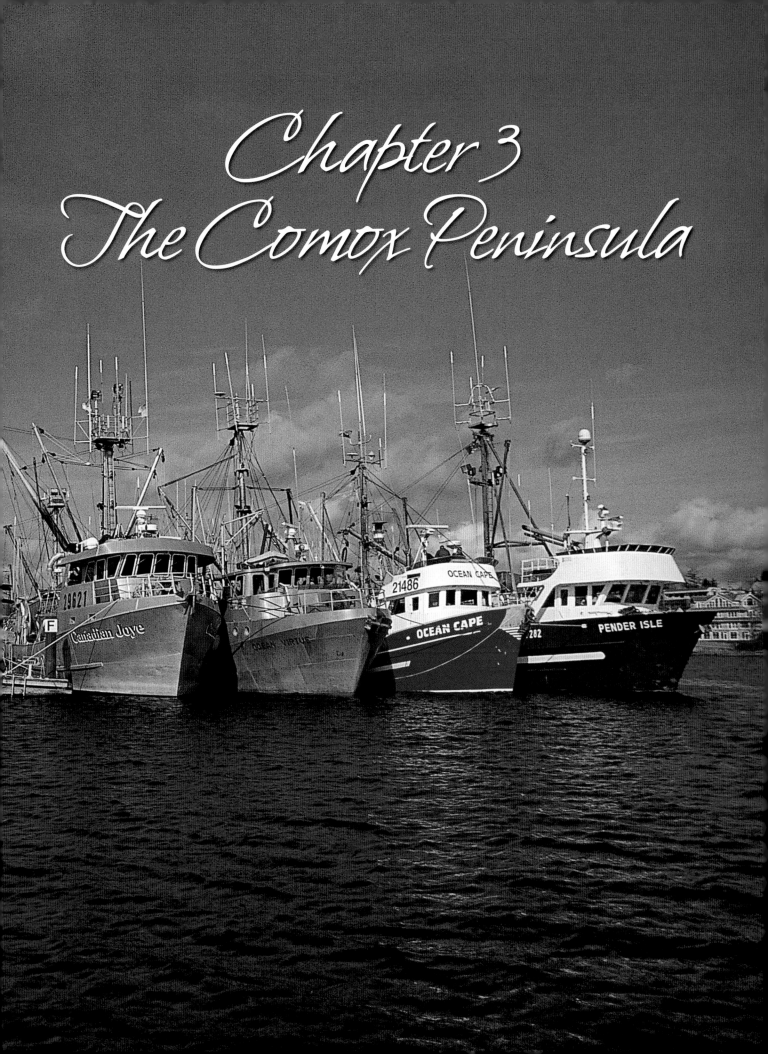

Chapter 3
The Comox Peninsula

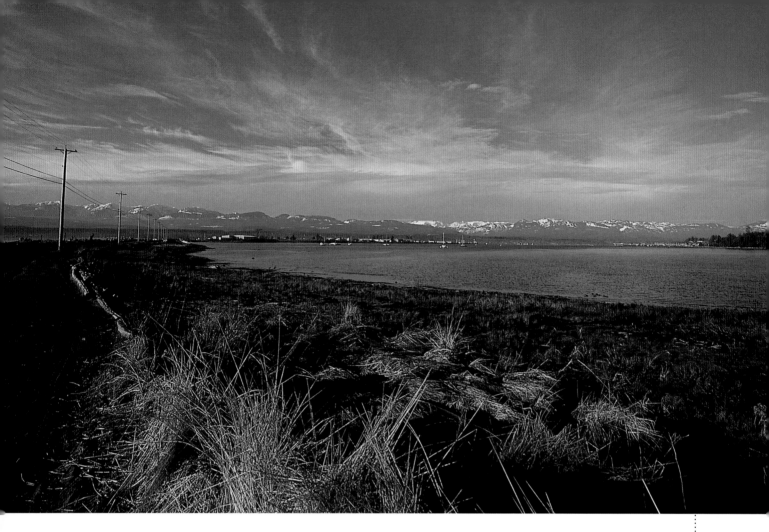

The dramatic sweep of Goose Spit curls inward toward the distant Courtenay shore.

The Comox Peninsula: A Recreational Paradise

The Comox Peninsula juts out into the Strait of Georgia like a swollen, work-worn thumb sporting a few knobby calluses here and there. Low-lying areas and sandy beaches give way to steep bluffs and a wide elevated plain. The population is concentrated around the Town of Comox with larger properties, farms and the Canadian Forces Base 19 Wing Comox taking up much of the outlying areas.

From earliest times, when water served as a highway and travel by canoe and ships was the standard means of transportation, Comox Harbour has been a gateway to the valley. Protected by the sandy curve of Goose Spit, the bay provides one of the safest year-round harbours on Vancouver Island. Early Royal Navy vessels including HMS *Egeria*, which surveyed much of the British Columbia coast, frequently took advantage of this protected moorage.

A trio of mallards takes flight. The Comox Valley is a recognized feeding area for resident and migratory waterbirds.

The local Hudson's Bay Company outpost called the area Comox, but early settlers rechristened it Port Augusta in honour of one of Queen Victoria's daughters. When the wharf was built in 1874 the adjacent area became known as the Landing. That changed in 1893, when, with no notice or consultation, the provincial government announced that the Landing would be called Comox, even though the entire valley was known as the Comox District.

While most settlers chose the relatively open land of the prairies, James Robb saw the potential of Comox. He knew the sheltered bay was a good place for a wharf, so he and a grown son preempted 280 acres. Eric Duncan described Robb, a Scotsman, as a "man of

masterful character, tall and bony, with work-bent shoulders and feet of thirteen inches." But Robb didn't have an easy time of it. His land was heavily timbered and Comox didn't develop as quickly as he had hoped it would. When coal was discovered near today's Cumberland, it became the economic hub of the valley and the coal was shipped out of Union Bay, not Comox. Still, Robb hoped to make a fortune and in 1922 advertised lots for $175 to $500 an acre. He had the right idea—Comox did become a prime commodity on the valley real-estate market—he was just ahead of the times.

Another prominent figure in Comox's early days was Joseph Rodello. An Italian, Rodello's dark eyes and hair, coupled with an oversize moustache made him one of the best-looking men in the district. He bought two lots from Robb just above the wharf and built a store on one side and the Elk Hotel on the other. He also served as postmaster, tax collector and constable, and later built some cabins to rent out. Although Rodello was an astute businessman, he wasn't much of a carpenter. Many of his structures had a definite slant, as well as numerous gaps. It's said that a building he donated to the community came with multiple water views—one through the walls, another through the roof and the third through the floor to a creek below.

Once the wharf was completed, a small business community including the Elk, Lorne and later the Port Augusta hotels began to take shape. Sometimes referred to as "whisky houses," the hotels also served as places to discuss business and wait for a CPR steamer with its load of mail, supplies and passengers. Although the Elk and original Port Augusta are long gone, the Lorne, built around 1878 and now operating as a pub, is the oldest free-standing licensed hotel in BC.

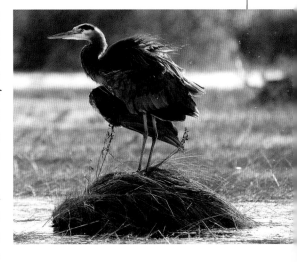

Great blue herons are plentiful in the Comox estuary.

Comox Valley residents seeing the 102nd Battalion off at the Comox wharf in June 1916. Comox Archives & Museum

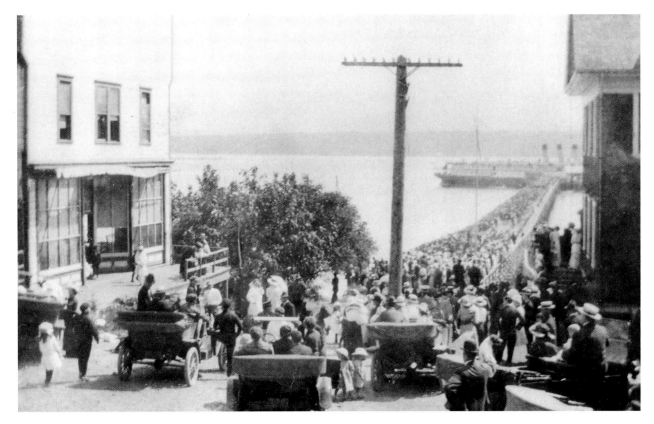

Opposite: The office of the Comox Harbour Authority (top) keeps watch over the expansive Comox marina, one of the busiest on Vancouver Island. It's a great place to watch July 1st fireworks (top, right) or to stroll along the promenade (bottom).

In late winter, commercial fishboats from all over the BC coast converge on Comox for the rich herring roe fishery.

Once they had a wharf, Sandwick farmers could ship their excess produce to other communities, but the rough trail to Comox made it difficult to get there. Everyone wanted a real road, but surveyor George Drabble favoured an inland route (today's Back Road), while most others preferred a beach road. Robb's waterfront orchard was an obstacle—the government could expropriate land for a road but couldn't disturb the orchard. Eventually a beach road was built, swinging inland to miss the fruit trees. Out of spite, Drabble surveyed this section up the steepest part of Comox Hill, making the journey to the wharf a hardship for the heavy, produce-laden horse-drawn carts coming from Sandwick.

But before the beach road could be used, a section just past the mouth of the Courtenay River had to be modified to prevent it from flooding at high tide. Twice a dyke was built and twice it was washed away by storms. On the third go-round, large box-like structures were installed in the worst spots and someone suggested adding virgin wool and cedar boughs to the rock and earth fill to "puddle it." It worked, and although the road is now officially named Comox, some old maps still bear the name Dyke Road.

In the early 1920s, Comox businesses began to cultivate the tourist industry. It all began with Sidney "Dusty" d'Esterre. Born in Plymouth, England in 1884, d'Esterre came from a wealthy family with ties to De Beers' diamond and gold mines in South Africa, as well as other business interests in England and Southeast Asia. d'Esterre's office was filled with 8x10 glossy photographs showing him shaking hands with an assortment of kings, prime ministers and other dignitaries. But what really made d'Esterre stand out was the attention he received from the Royal Navy.

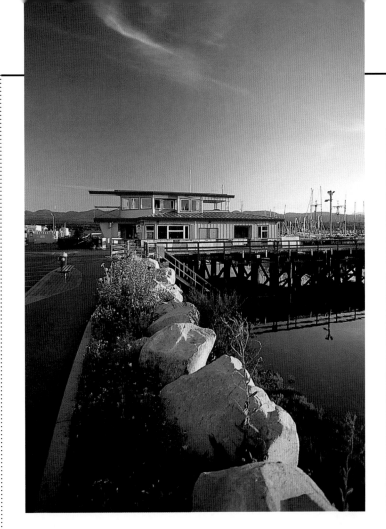

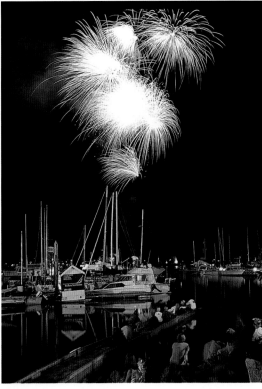

Early risers are sometimes rewarded with a magical view of Comox Bay.

"Comox Spit was once a Royal Navy base," said Comox resident Hope Spencer. "Whenever Royal Navy ships anchored there, they dipped their flags at the flagpole in Dusty's garden (near the present d'Esterre House Senior Citizens centre) as a mark of respect. Everyone suspected Dusty was involved in some sort of secret-service activity during World War I and II. He was the perfect invisible spy—tiny, sparse, no very distinguishing features. And he gave extraordinarily posh parties. You knew you were 'in' if you were invited to Dusty's New Year's Eve party in Dusty's Den or at the Union Club in Victoria."

Among his many business ventures, d'Esterre bought the Elk Hotel and, after a complete renovation, began advertising it as a tourist destination. Guests could swim, play tennis or tee off at a nearby golf course, and after supper in the dining room they could dance the night away. d'Esterre hoped to expand on a burgeoning tourist industry that had begun back in the mid-1870s when judges and lawyers from Victoria travelled up-island on a regular basis to hunt elk and deer and fish Comox Bay for giant tyee salmon. As Eric Duncan noted, "In those days the leisure classes of Victoria had a paradise in the Comox Valley."

Although downtown Comox has changed a lot since 1862, the bay remains a focus of the community. It's home to multiple marinas with a mix of commercial fishing, pleasure boats, sailing clubs, yacht charters and float planes making use of its sheltered harbour. A boardwalk skirts the breakwater providing views of the Comox Glacier and Royston, as well as an opportunity to purchase the

The annual Comox Nautical Days Parade is always fun.

catch of the day. Adjacent to the harbour is Marina Park with trendy coffee bars, shops and restaurants, including the historic Lorne Hotel, a short block away.

Two unique pieces of property lie along the outer edge of Comox Bay. The first is the Filberg Lodge and Park. Robert Filberg moved to Comox in 1916 and became a wealthy man after marrying Florence, the daughter of James D. McCormack, president of Canadian

Western Lumber Company. In 1929 the Filbergs built a one-of-a-kind house on nine acres of waterfront property overlooking Goose Spit. When Filberg died in 1977, he left his home and a multimillion-dollar trust fund to the Vancouver Foundation with a request that the interest be used to benefit the Comox Valley.

Once the home of logging magnate Robert Filberg, nine-acre Filberg Park now hosts the Filberg Festival every August.

A while later, alerted by Melda Buchanan that the property was in danger of becoming a subdivision, then town councillor Alice Bullen spearheaded a campaign whereby the Town of Comox bought the lodge and property to be used as a park. The lodge and grounds were granted heritage status in 2000 and since 1982 have been the site of the annual Filberg Festival, a showcase of arts, crafts, food and music that attracts visitors from all over the world.

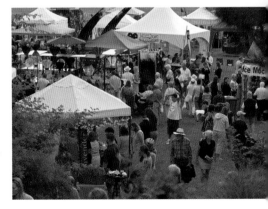

Within walking distance of the Filberg property is the Mack Laing Nature Park. Late in his life, Hamilton Mack Laing was known as the grumpy old man who walked to town a couple of times a week to get his mail. But throughout his 99 years, Laing was a respected naturalist, writer and scientist. A self-taught naturalist, Laing became one of the top field men in Canada, collecting over 10,000 birds, mammals and plants for various museums and universities. He also wrote more than 700 articles, as well as a biography of a friend and colleague titled *Allan Brooks: Artist-Naturalist*.

Although modern naturalists frown on shooting the creatures they study, Laing lived in different times, when specimens were used for teaching and to obtain scientific information.

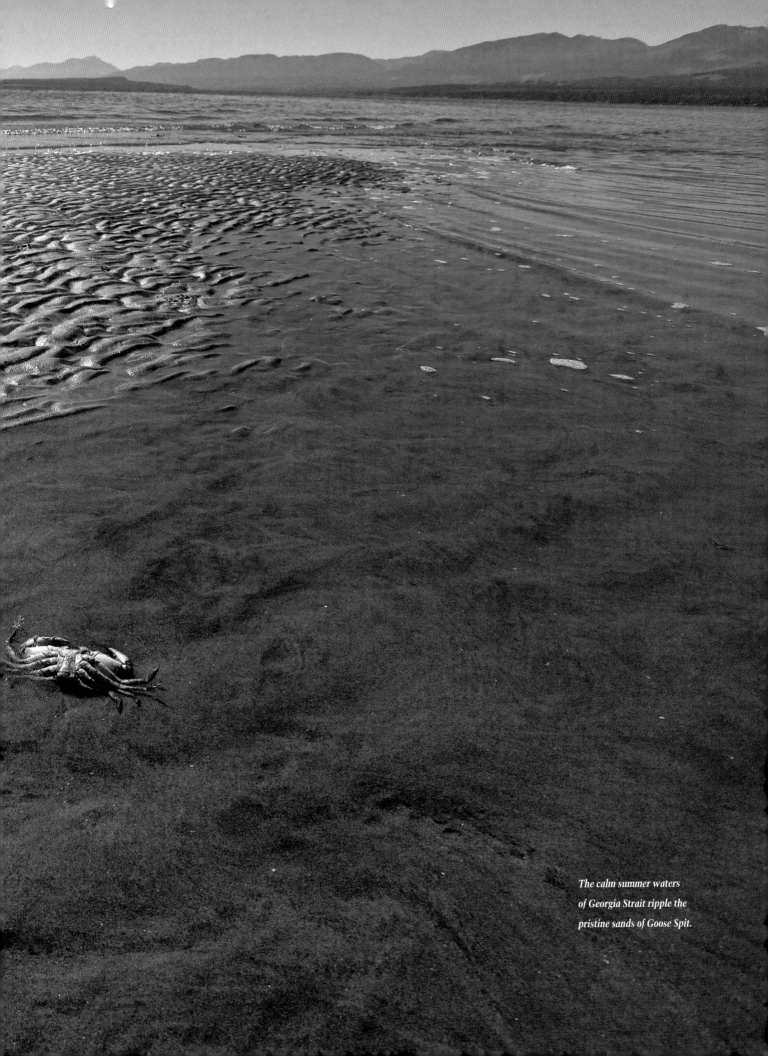

The calm summer waters of Georgia Strait ripple the pristine sands of Goose Spit.

A sunrise illumines the driftwood-decked shore of Goose Spit on the way to HMCS Quadra, a summer training centre for cadets.

According to Hope Spencer, "Mack built the windows in his kitchen and living room at a comfortable height to use binoculars so he could sit and watch his beloved birds coming and going. But he also believed in shooting birds for food or specimens and to get rid of the predatory ones." In *Hamilton Mack Laing, Hunter–Naturalist*, author Richard Mackie notes that Laing even went so far as to cut a trap door in his door so he could easily poke his rifle out to shoot pheasants.

Laing moved to Comox in 1922. After his wife Ethel died, he moved from their 900-tree nut farm to a house he called Shakesides. Profoundly deaf as an old man, Laing refused to buy a hearing aid and spent a lot of time alone at home, writing letters and repairing everything from clothes to shoes and tools. A frugal man, he would take a day to glue a broken plate together rather than buy a new one. Nine years before his death in 1982, Laing donated his possessions and waterfront property to the Town of Comox, the only stipulation being that the property remain in its natural state.

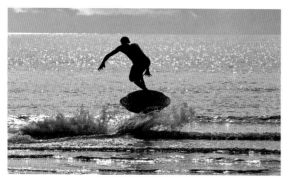

A skim boarder tests his skill.

Not far from Laing's place is Goose Spit, a skinny finger of sand that curves in toward Comox Bay. The far end of the spit contains the military site HMCS Quadra and a small First Nations reserve. The beach is frequented by the endangered sand verbena moth, as well as dog walkers and kite flyers. It's a particularly popular swimming spot in summer, when the tide flows in over sun-warmed sand. In the past, the view properties on Willemar Bluffs adjacent to the spit were known as Nob Hill, the ritzy place to live on the peninsula.

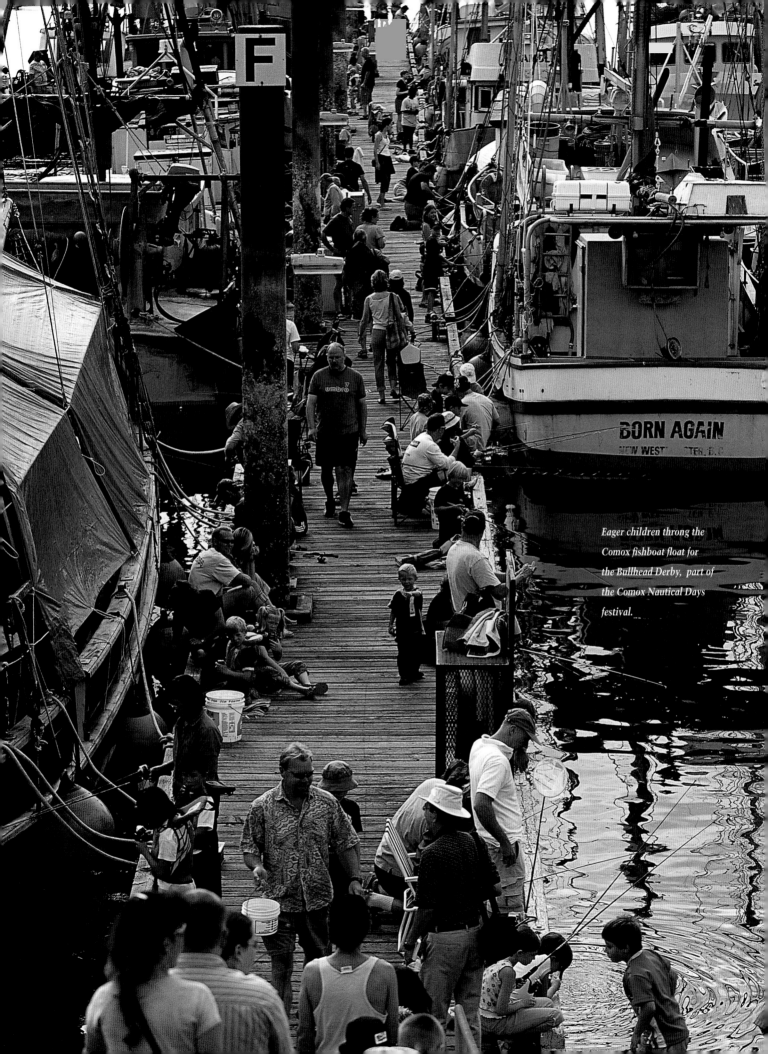

Eager children throng the Comox fishboat float for the Bullhead Derby, part of the Comox Nautical Days festival.

Goose Spit also serves as a temporary refuge where migrating birds can rest and fuel up before continuing their flights north in the spring. Toward the end of the spit is the small Indian Reserve No. 3. It's possible to walk all the way around the spit, but much of the land above the beach is military property and off limits. This is the site of HMCS Quadra—despite its name, not a ship but a naval shore establishment.

Back in the 1800s it was considered good for sailors to occasionally get away from the Royal Navy's main base in Esquimalt. Goose Spit was often used for onshore training and recreation and was known as Camp Comox. The main focus of the camp was musketry and small-arms drill, but what everyone looked forward to most were the after-hours R&R in Comox hotel pubs. Many old-timers recall that once the Naval Service of Canada was formed and the spit turned over to Canada's fledgling Navy, there was seldom a time between the two world wars when there wasn't a warship anchored in the harbour.

A rigorous training program at HMCS Quadra teaches cadets the fundamentals of sailing and marching, as well as other essentials of life in Canada's navy.

HMCS Quadra, which at different times has been called HMCS Naden III, HMCS Givenchy III and HMCS Naden II, was the training ground for combined operations in preparation for the invasion of Europe during World War II. The facility closed in 1947 and reopened in the early 1950s, when the Navy League of Canada invited the Vancouver Island Sea Cadet Corps to use the spit for, in the words of Commanding Officer LCdr Brown, "a summer of shooting, sailing and work." A few years later the site was commissioned as HMCS Quadra. When the sea-cadet training area in Esquimalt closed in the 1970s, HMCS Quadra became the training ground for all of Canada. Most summers, there are more than

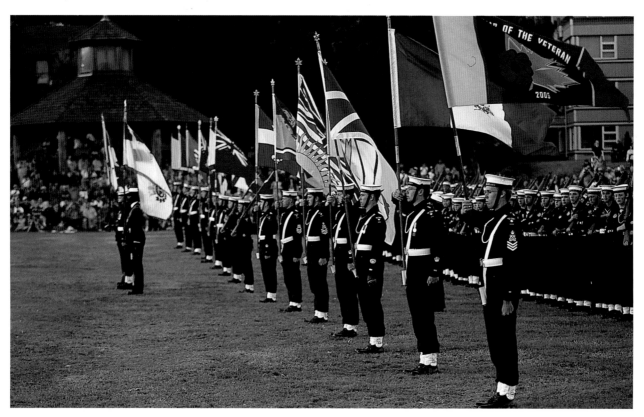

1,000 cadets at the camp. It's not unusual for the evening breeze to carry the sounds of the cadet marching band or to see the youngsters paying a visit to town in their sharply creased and freshly pressed uniforms.

If HMCS Quadra is the oldest military installation on the Comox Peninsula, it is not the largest. What is known locally as "the Base" covers 625 hectares of the Comox Peninsula and for many years has been the area's largest employer. Formerly known as Canadian Forces Base Comox, its official title is now 19 Wing Comox. People posted to the Base often enjoy life in the valley so much that they—or their grown children—return to become permanent residents, giving rise to the claim that there are more veteran licence plates in the Comox Valley than anywhere else in BC

Historically there's been some type of military presence in or around the Comox Valley since at least 1862, when the initial wave of settlers arrived on the Royal Navy gunboat HMS *Grappler*. Along with visits by HMS *Hecate* and *Egeria*, two Navy survey vessels, Comox Bay was frequented by Royal Navy warships of the Pacific Squadron. The commander of the Pacific Squadron was so impressed with the area that he obtained full control of Goose Spit in 1895. When the Royal Navy left Canada 10 years later, all facilities were turned over to

Canadian Forces Base 19 Wing Comox is home to the 442 Transport and Rescue Squadron (shown above practising free-falling) and a springtime training base for the Snowbirds, Canada's renowned precision flying squadron.

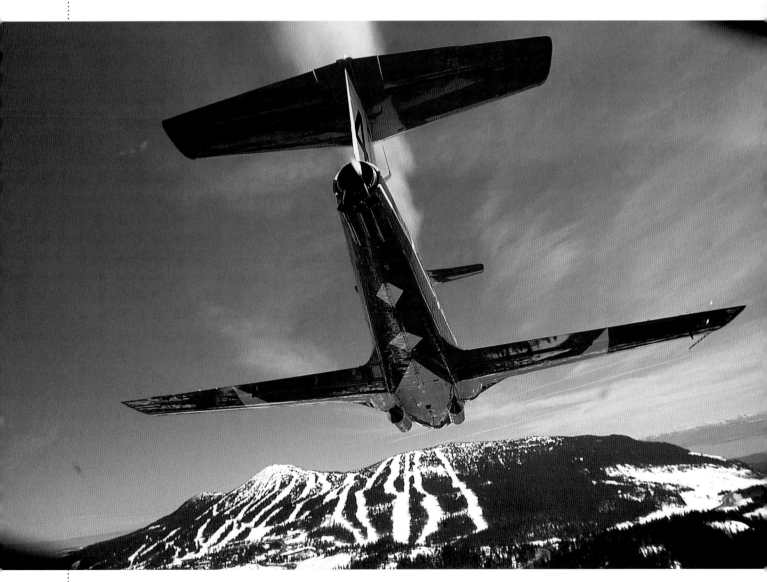

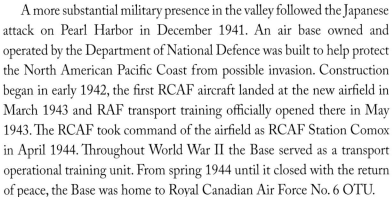

the federal government. The Royal Navy was eventually replaced with the Canadian Naval Service, later renamed the Royal Canadian Navy.

A more substantial military presence in the valley followed the Japanese attack on Pearl Harbor in December 1941. An air base owned and operated by the Department of National Defence was built to help protect the North American Pacific Coast from possible invasion. Construction began in early 1942, the first RCAF aircraft landed at the new airfield in March 1943 and RAF transport training officially opened there in May 1943. The RCAF took command of the airfield as RCAF Station Comox in April 1944. Throughout World War II the Base served as a transport operational training unit. From spring 1944 until it closed with the return of peace, the Base was home to Royal Canadian Air Force No. 6 OTU.

The Base was reactivated in 1952 during the height of the Korean War and became the centre of operations for 407 Maritime Reconnaissance Squadron. In 1954, as the Cold War intensified, 51 Aircraft Control and Warning Squadron and No. 409 Fighter Squadron were also formed at Comox. After unification of Canadian Forces in 1968, the base was renamed CFB Comox. Then, in the early 1990s, the Air Force re-established the use of numbered wings.

At the start of the 21st century the Base had two operational squadrons. The 407 Maritime Patrol Squadron, made up of five CP-140 Aurora maritime patrol aircraft in 2005, was originally formed to keep a close watch on Soviet subs and surface ships along Canada's Pacific coast. Today it primarily performs ocean surveillance missions, keeping tabs on suspicious or

Veteran World War II Spitfire fighter pilots Duke Warren and Stocky Edwards with the Snowbirds flying overhead.

Residents and visitors frequently see Search and Rescue Technicians practising various manoeuvres over local waters. The 442 Squadron responds to air and marine disasters and assists with ground search and rescue efforts and medical evacuations as needed.

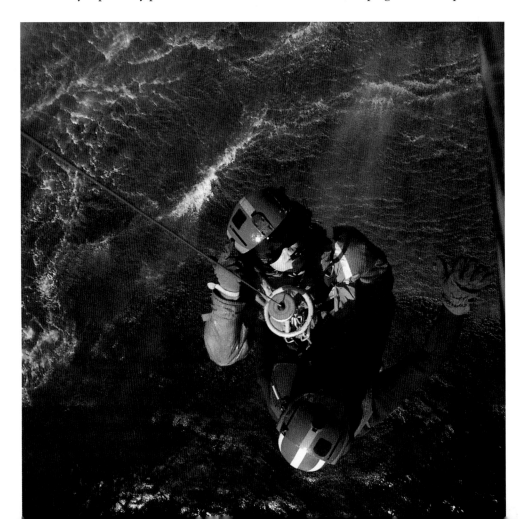

The air traffic control tower at Canadian Forces Base Comox coordinates the use of the CFB Comox runway by base aircraft and commercial aircraft flying in and out of the Comox Valley Airport.

Airplane enthusiasts restore a Supermarine Spitfire, Y2K at the air base. Photo by Rick James

The Comox Valley Airport is one of few in BC that accommodates national and international flights.

illegal activity such as drift-net fishing, the smuggling of illegal immigrants or drugs, or the at-sea dumping of pollutants by vessels of all flags.

The other squadron is the reactivated 442 Transport and Rescue Squadron with its CC-115 Buffalo aircraft and CH-149 Cormorant helicopters. This unit has aircraft on 24-hour standby to provide aviation resources in support of the Rescue Coordination Centre in Victoria. They respond to air and marine disasters anywhere from the BC–Washington border to the Arctic, and from the Rocky Mountains to 1,200 kilometres out into the Pacific, and they assist with ground search-and-rescue efforts and medical evacuations as required.

The Base is also home to 19 Air Maintenance Squadron and the Canadian Forces School of Search and Rescue, now the primary national search-and-rescue training facility in Canada. According to the 19 Wing web site, in 2006 it employed approximately 1,000 in regular forces, 120 reserves and 250 civilians who perform a variety of duties such as logistics, engineering and administrative functions. In addition, the Base supports the annual air cadet training at the Regional Cadet Gliding School (Pacific) and the HMCS Quadra sea cadet camp. Its operating budget was almost $100 million in 2006.

Since the 1950s the Base has been an integral part of Canada's air defence system. The sound of fighter aircraft is usually rare in the Comox Valley, but in the weeks following the 9/11 emergency in September 2001, valley residents heard it often as aircraft roared overhead en route to monitor incoming aircraft. CFB 19 Wing personnel have been involved in numerous United Nations and NATO overseas missions and as part of Canada's commitment to the international campaign against terrorism.

Unless they work at the Base, most civilians aren't familiar with the grounds. Of

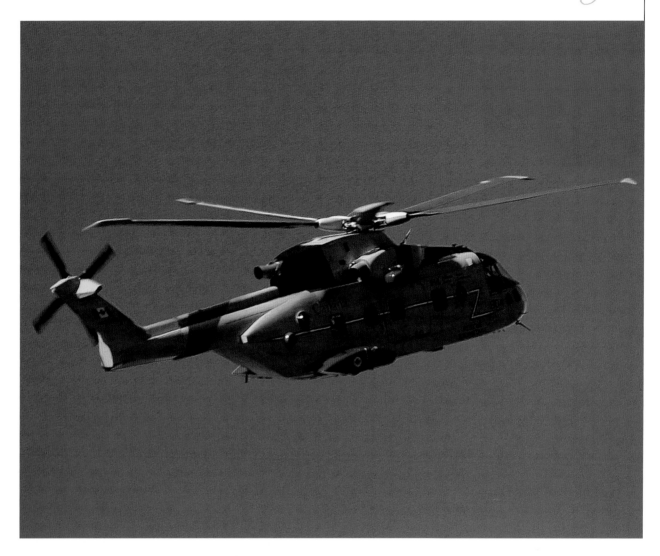

Cormorant Search and Rescue helicopters from Comox are a welcome sight to boaters in distress along the BC coast.

course, not just anybody can wander around in there; a guard at the gate monitors all comings and goings. However, many people visit the property without realizing it. The Comox civilian airport is located on Crown land at the Base and thus has access to the second-longest runway in BC.

Just outside the main entry to the Base is the Comox Air Force Museum, a large building crammed with artifacts and memorabilia relating to local and national military aviation history. Not far away is the outdoor component of the museum, a Heritage Airpark featuring four fighter jets, including the Avro CF-100 "Canuck" and the McDonnell CF-101B "Voodoo," as well as the multi-engined Douglas "Dakota," an MiG 21 "Fishbed" from the Czechoslovakia air force, a Grumman CP-121 "Tracker" and a Piasecki H-21 rescue helicopter sometimes called the Flying Banana.

Since 2000 the museum has owned another plane, the Supermarine Spitfire of World War II Battle of Britain fame. Volunteers started restoring the Spitfire, which bears the call sign Y2K, to flying condition in August 2000. "The Spitfire was our best defensive fighter in the war," RCAF Wing Commander (retired) and Comox Valley resident Stocky Edwards told journalist Susie Quinn. "There was no airplane like the Spitfire … there was always a toss-up who you liked best, your girl or your plane. And your plane won out every time."

Every second year, the general public has an opportunity to enjoy an air show at the Base as part of Armed Forces Day. The show is a huge production, featuring fly-pasts of various Canadian and US military aircraft, acrobatic stunt flying and an on-ground aircraft exhibit. The Snowbirds are a popular attraction at many of the shows. Snowbirds are members of the 431 Air Demonstration Squadron who fly CT-114 Tutor jets capable of speeds of up to 750 kilometres per hour. They're best known for flying in high-speed formation approximately 1.2 metres apart. Each April residents get an unofficial free show when the team visits the valley to take advantage of its varied landscape during a three-week training session.

Away from Comox Bay, people settled in little pockets here and there carving out farms and rural neighbourhoods. As in many parts of the valley, residents share the terrain with deer, bear and the occasional cougar. Nearby at Little River, BC Ferries makes regular crossings to the Sunshine Coast on the mainland. Just up the coast from the ferry terminal is the 650-hectare Seal Bay Regional Nature Park. The First Nations name for this area is Xwee Xwby Luq, which translates as "place of serenity and beauty." Hiking and mountain-biking trails lead inland through a dense forest and open swampy areas. On the water side, a steep path winds down through a fern-filled ravine to the beach, a favourite hangout for seals and sea lions.

One of the park paths has a plaque commemorating Melda Buchanan. Buchanan, Canada's first female meteorologist, gave up a career as a math professor at the University of BC to devote her life to conservation and was instrumental in establishing Seal Bay Park. "Melda had great respect for all living things great or small," noted her friend Hope Spencer. "She would stop her car to let a newt cross the road. But if talking with a developer or someone else she didn't approve of, she would call them 'the scum of the earth' and other unprintable words." Upon her death in April 2004, Buchanan left her property to the Land Conservancy of BC (with some restrictive covenants) for them to sell and use the money toward important Land Conservancy goals.

The Comox Valley is home to black bear, Roosevelt elk, cougar and much other wildlife, but black tailed deer are the most commonly sighted.

Another place in the park pays tribute to Jim Egan, who as an elected director of the Regional District of Comox–Strathcona, was actively involved in securing the land for park use. But Egan also played a role in the larger arena of life. From the late 1940s—before there was even a gay movement in North America— right up until the 1990s, Egan wrote extensively to defend the rights of homosexuals. A film, *Jim Loves Jack: The James Egan Story*, came out in 1996 and Egan's book, *Challenging the Conspiracy of Silence: My Life as a Canadian Gay Activist* was published two years later. Egan, who may have been the first openly gay politician elected in Canada, never gave up his battle to ensure equal rights for gay men and lesbians. A few years before his death in 2000, he launched a Supreme Court battle against the Canadian government in an effort to obtain spousal old age pension benefits for his life partner, Jack Nesbit.

A network of trails, as seen here at Seal Bay Park, provide access to forests and beaches.

Considered one of the Comox Valley's premier beaches, Kye Bay has lots of sand and a view of the mainland's Coast Mountains.

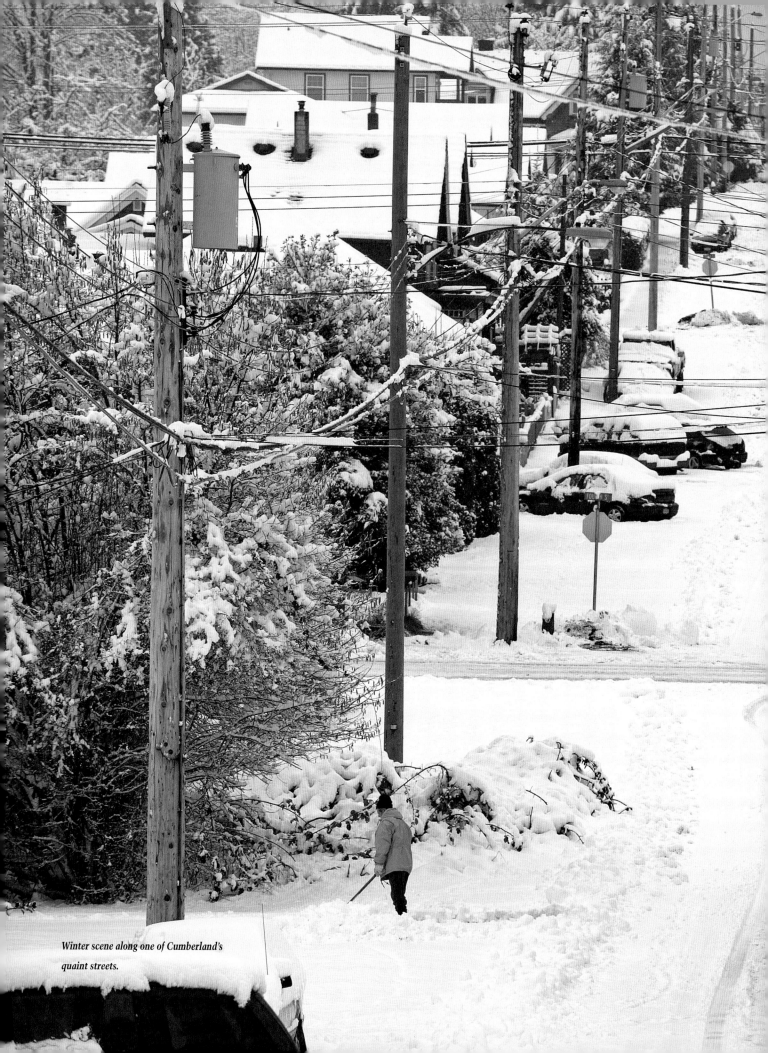

Winter scene along one of Cumberland's quaint streets.

Chapter 4
Cumberland, Union Bay & Royston

Cumberland: Dodge City

Entering Cumberland is like taking a step back in time. Heritage houses—modest miners' dwellings and a few upscale mine managers' dwellings—are interspersed with modern homes and, on main street, converted coal carts serve as benches. But the old-time feeling goes beyond weathered buildings and relics of the past. It has to do with the people, the way they call across the street to one another and take the time to chat.

For decades the village has been known as Dodge City. Some take the name as a slur; others consider it an affectionate term that captures the village's unique charm. Unlike other Comox Valley communities, Cumberland has managed to retain some of its Old West ambience, and that's a large part of its appeal. And even though you won't see any gunslingers strutting their stuff in the "downtown" core, in the early part of the 21st century it was still easy to make a U-turn on the main drag in the middle of a Saturday afternoon.

Cumberland is full of characters. It was, and still may be, the nickname capital of the island. There's even a list of 575 nicknames, including such oddities as "Flubadub," "Muckle" and "Two and a Juice." And there's a story behind every one. William Moncrief moved from the Cumberland District of England to Cumberland, BC, in 1928 at the age of 14 months. He was just a kid when his pal Harold Waterfield, a.k.a. Bucket, dubbed him Bronco Billy after the cowboy comic strip that appeared in the weekly *Sunday Mirror*. He's been called Bronco ever since.

Bronco accomplished many things in his 30-year career as mayor of Cumberland, but the story that's stuck in a lot of people's minds is the time he joined an impromptu posse at age 65. "I used to spend a lot of time at the village office," he said. "One day I was crossing the street to

Former mayor Bronco Moncrief stops for a moment outside Cumberland's historic Ilo-Ilo Theatre. Photo by Rick James

Harvey Brown, another former mayor, outside his Waverley Hotel, a Cumberland landmark.

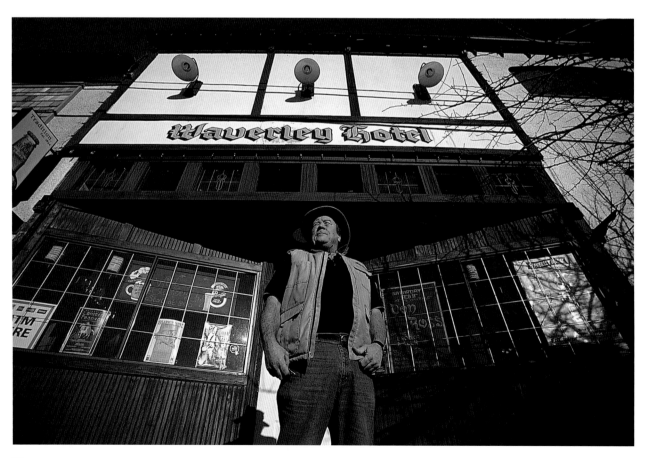

my truck when Bob Lemay yelled, 'Hey, Bronco, this guy just robbed the bank!' So I jumped in my truck, did a U-turn around to these apartments where the guy was just starting to back his vehicle out. I boxed him in but he got around me so I chased him all across town until I lost him on the way to Royston. By this time the robbery was big news and someone else caught him."

Cumberland lies a little over 6 kilometres southwest of Courtenay between the Inland Island Highway and Comox Lake. Because of its higher elevation and inland setting, it gets a bit more snow in the winter and perhaps some warmer days in the summer. But it was location, not climate, that made Cumberland the economic hub of the valley in the early years. Around 1864 rich coal seams were discovered. The Union Coal Mining Company moved into the area and a rough shantytown called Union Camp sprang up. When UCMC couldn't make a go of it they sold their interests and by the early 1880s the coal baron Robert Dunsmuir was owner.

Within five years, Dunsmuir's Union Colliery was a going concern. Since Union was built on a steep hill and not really suitable for the number of workers flooding into the area, Dunsmuir designated 100 acres just to the east of the settlement for a townsite. When incorporated as a city in 1897, Cumberland, named after a mining district in England, was booming. The community had a school, a newspaper and a hospital. Dunsmuir, the main street, was lined with false-fronted stores and a popular saloon named the Bucket of Blood.

A Cumberland Museum display shows a miner at work.

Cumberland's booming Chinatown once had a Buddhist temple, two theatres and a population of 500. It was bulldozed in 1968. Photo by Ed Brooks

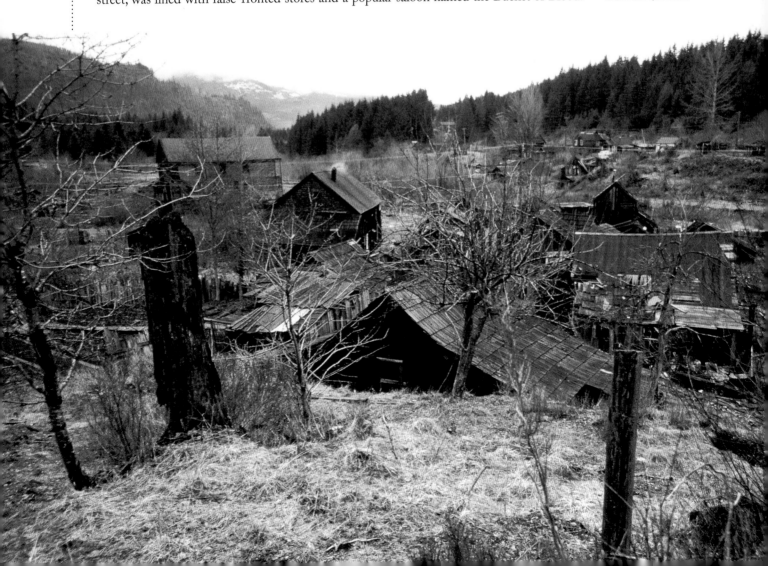

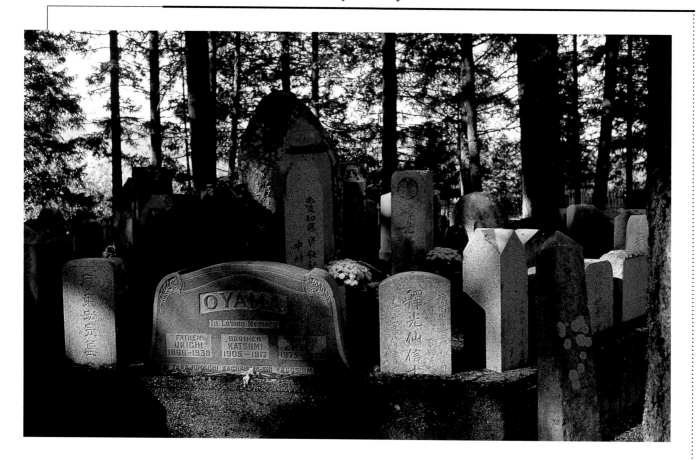

Headstones honouring Cumberland's Japanese pioneers repose beneath the trees at the old Japanese cemetery. Photo by Rick James

And a population of 3,000 supported a variety of clubs, such as the Fraternal Order of Eagles and the United Ancient Order of Druids.

The mainstay of Cumberland's coal industry was the men who brought years and sometimes decades of mining experience with them from England. But Cumberland was a multicultural settlement. Early on, an area near Union had been set aside for Chinese workers. They transformed the swampy ground into a dynamic community complete with shops, boarding houses, a Buddhist temple and two theatres, one with a seating capacity of around 250. There were also numerous benevolent organizations and societies that looked after business, political and personal aspects of life. As well as working in the mines, the Chinese operated laundries, stores and market gardens. Records for 1901 put the Chinatown population at just over 500.

There were also numerous Japanese in Cumberland. Like the other ethnic communities, they tended to live in segregated areas. But unlike the Chinese, who were mostly single men or men who had left their families in China because of restrictive immigration laws, the Japanese moved to Cumberland in family groups and had closer contact with mainstream society. Other immigrant communities in Cumberland included Blacks, Hungarians, Yugoslavians and a contingent of Italians out at Comox Lake.

When Numbers 7 and 8 mines opened, two small coal towns were built alongside the Puntledge River. The largest, Bevan, was its own little boom town complete with hotel, store, school and small Chinese and Japanese settlements. Eventually more than 100 houses were set among the giant stumps the loggers had left behind. A precursor of today's vinyl-sided subdivisions, the small, square houses were painted the same colour and wallpapered inside with one of three patterns. The train tracks ran right through town. Aside from memories and crumbling foundations, the original Bevan has disappeared. But its heritage lives on in

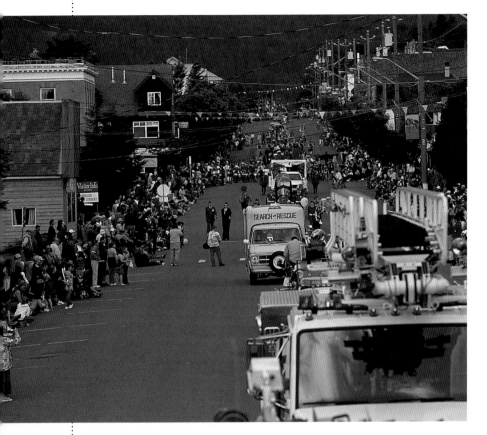

the many houses that were moved to other parts of the valley, and in the song "Are You From Bevan?" which tells the story of the two-year mining strike that began in 1912.

The second mining community built alongside the Puntledge River, and bearing its name, housed those working in No. 8 mine. This was the first of the mines to be run by electricity provided by a hydroelectric plant on the river. At one time Puntledge had 75 houses and a school. Although the mine has been closed for some time, a few families still live in the area.

The coal community was a close-knit one, but life as a miner was grim. Ten- to 12-hour shifts were common and the men worked underground with the constant threat of fire, cave-ins and death from afterdamp, the lethal gas created when coal dust explodes. It wasn't unusual for miners to work nearly an entire shift on their hands and knees, sometimes in shafts only half a metre high. Lynne Bowen quotes a Cumberland miner in *Boss Whistle: The Coal Miners of Vancouver Island Remember*: "Conditions were terrible, I was up to my waist in water lots of times … one place was on fire and another place was flooded … It was all on fire around there. It was burning for years down in the mine."

Finally the miners had had enough, and in September 1912 they went on strike. Those living in company houses were evicted; many spent the two-year strike camping out at what came to be known as Striker's Beach in Royston. While the miners agitated for a union and better working conditions, the company operated the mines with scabs. Families went hungry and fights broke out frequently. For a while, a group of 72nd Highlanders were stationed at Cumberland to keep peace and escort scab workers to the pitheads. With support and handouts of food from valley residents, the miners held out until 1914, when the United Mine Workers of America withdrew their support and World War I intervened.

The most famous name associated with the Cumberland strike is that of Albert "Ginger"

Above left: Cumberland's main drag, Dunsmuir Avenue, is the site of the Empire Day Parade.

Top: Old-time storefronts along Dunsmuir Avenue.

Above: Cumberland's Village Bakery is famous for its donuts.

Captain Len Banks shows his granddaughter, Mariah, around the Cumberland fire station. Cumberland has the oldest volunteer fire department in BC.

The sandy beaches of Comox Lake make it one of Cumberland's favourite recreation spots, though the glacier-fed waters are best described as "invigorating."

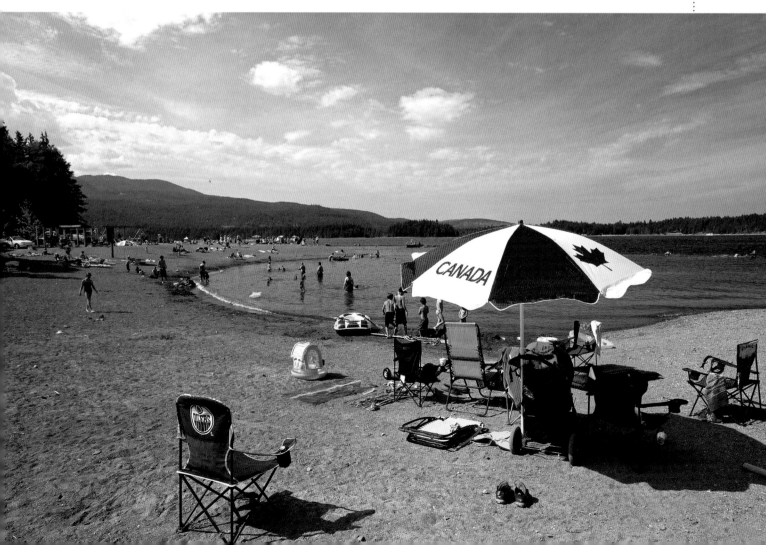

Goodwin, though he was not one of its main leaders. A short, frail man with red hair, a chronic cough and a mouthful of bad teeth, Goodwin's fiery oratory won him many admirers but resulted in his being blacklisted by mine owners. A series of jobs took him to Trail, BC, where he found work at the big lead-zinc smelter owned by Canada's most powerful corporation, the Canadian Pacific Railway. There, in 1917, he led Canada's first strike for the eight-hour day. Goodwin had been classified as unfit for military service due to poor health, but two weeks after the Trail strike started, his exemption was revoked. Goodwin, a pacifist, returned to Vancouver Island where he took shelter in the woods near Comox Lake with other war resisters.

Sympathetic miners delivered food and supplies but on July 27, 1918, 31-year-old Goodwin was shot through the neck by Dan Campbell, a disgraced former policeman hunting conscription evaders for the Dominion Police. Campbell swore he fired his gun in self-defence, but enough questions were raised to launch a grand jury investigation. The jury decided there wasn't enough evidence to take the case to trial, but questions still linger. None of the miners worked on the day of Goodwin's funeral, August 27, 1918, and the procession of mourners following the coffin to the cemetery was 1.5 kilometres long. Workers in Vancouver walked out in sympathy, precipitating what Labour historian Paul Phillips calls "Canada's first full general strike."

Every June on Miners' Memorial Day, Comox Valley residents and a variety of labour organizations visit Goodwin's grave to pay tribute to the slight man known as "the worker's

One of Cumberland's most visited sites, the gravestone of labour martyr Ginger Goodwin is always kept in good repair. Photo by Rick James

Its day as the backbone of Vancouver Island transportation long past, the E&N Dayliner still runs between Victoria and Courtenay.

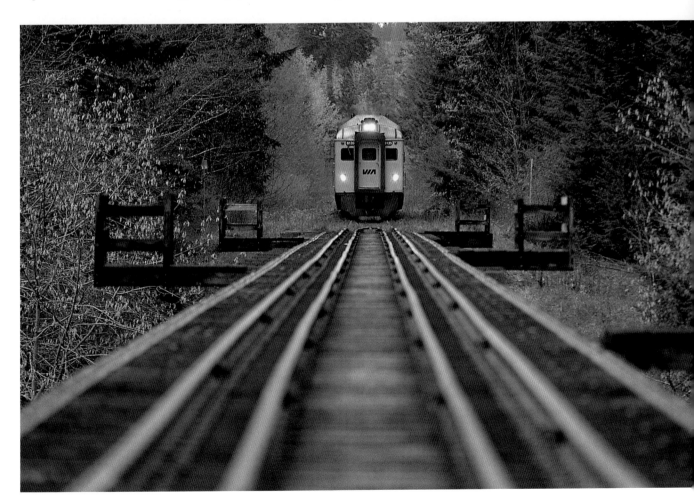

Cumberland has been celebrating Empire Days for over 100 years. It is a tradition for a member of the RCMP to escort the May Day Queen. Shown here is the 2005 Queen, Amanda Jones.

friend." Even though Goodwin died in 1918, his memory still stirs emotions. A stretch of the Inland Island Highway was called Ginger Goodwin Way when it was built, but when the BC Liberal government assumed power in 2001 the signs were removed. Efforts are still afoot to reinstate the labour activist's name. In the meantime, Ginger Goodwin Way lives on in bumper stickers and signs in shop windows. Goodwin's well-kept gravesite is one of Cumberland's popular attractions, but visitors should keep two things in mind: it gives the wrong date of death, and the brightly-painted hammer and sickle was added by later enthusiasts. Goodwin never belonged to the communist party.

In 1937, the City of Cumberland was the administrative centre of the entire Comox Valley. But the advent of the oil age signalled the end of the steam era and its primary fuel, coal. All residents of Japanese descent were forcibly removed from the coast during World War II, and as mines closed, other families drifted off in search of jobs. By 1958 Cumberland's status had reverted to village.

Around this time, buildings in the old Chinatown were starting to show serious signs of

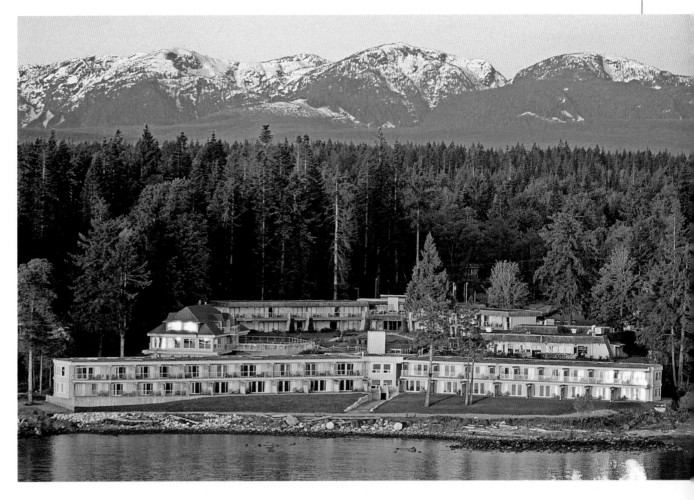

An early morning view of the spectacular Royston-area coastline with the Kingfisher Resort in the foreground.

decay. Only a few old men lived there and treasure hunters plundered the area, looking for opium bottles and other collectibles. In 1968 the village council declared the site a fire hazard and had it razed. Only one building, a cabin belonging to Mar Hor Shui, a large, old fellow known as Jumbo, was saved.

Out of all the communities in the Comox Valley, Cumberland retains the closest ties to its working-class roots. Many families there have generations of coal dust in their blood. "We had some tough times after the mines shut down," Bronco Moncrief acknowledged. "I've often said two things: we never had a problem that money wouldn't cure, and one of these days this place is going to blow apart [with growth] and I hope we can handle it. Whatever happens, I hope everyone works together to keep Cumberland's identity."

New folks are moving to Cumberland. They're attracted by the small-town atmosphere and the proximity of Comox Lake and other recreation sites. As well as being riddled with mine shafts and tunnels, the undeveloped land around the community is criss-crossed with hundreds of kilometres of trails used by hikers, horseback riders and mountain bikers.

These features, combined with the village's cultural history and heritage buildings, as well as a growing arts and culture scene, are raising outsiders' awareness of Cumberland. There's also a growing interest in preserving and protecting the community's assets. Jumbo's cabin, Chinatown and a former Japanese settlement are now heritage sites. And in 2000, a group of residents formed the Cumberland Community Forest Society with the goal of purchasing up to 260 hectares of forest adjacent to the village for recreational and aesthetic purposes.

Royston: A Seaside Retreat

Since Comox Logging & Railway's log dump and booming ground became inactive in the late 1970s, Royston has been a quiet, largely residential community. Situated between Courtenay and Union Bay on the Old Island Highway, it's also linked to Cumberland via Royston Road. Neighbourhoods line the southern edge of Comox Bay and continue inland. In 2006 there was only one traffic light along the Old Island Highway.

A few kilometres inland lies what is known as Happy Valley. When a railway line was punched through from the Trent River region to Cumberland, it revealed a large swampy area. It was drained, and farmers moved in to take advantage of the rich soil. The area was later named Minto after the Governor General of the same name.

It took a while for Royston's allure to be discovered. In fact, it was only after the prime prairie and delta land near the Courtenay and Tsolum rivers was developed that settlers looked to the more heavily timbered areas. As late as 1877, Royston was referred to as New Siberia because of its dense forest cover and lingering wintertime snow.

Royston, or Roy's Town as it was originally called, got its name from William Roy, who obtained land there in 1890. Oddly enough, the beachfront property along today's Marine Drive was not Roy's first choice. For some reason he preferred a swampy area near Cumberland. Although Royston was not directly involved with the coal industry, it always had close ties with Cumberland. Numerous Cumberland residents had summer homes in Royston. During

Fifteen historic ships were used to create a breakwater for the big Comox Logging booming ground at Royston. Above, the bow of the former Cape Horn windjammer, Comet *(photo by Rick James); below, the Royal Canadian Navy frigate,* HMCS Prince Rupert.

the strike of 1912–14 many miners and their families camped out on Royston beaches, and for years Roy's field was the site of the annual colliery picnics.

Around 1913, Bob Grant started the Royston Sawmill. It changed hands a couple of times and for most of its life was owned by a group of Japanese who renamed it the Royston Lumber Company. It became the first local firm to be involved in logging, milling and sales at the same time.

Throughout the 1920s and '30s, Royston was the place to be on a Saturday night. The Royston Pavilion, located just across from the water and a couple of blocks from the government wharf, hired a variety of local and out-of-town bands and served meals catered by the Isenor family. Even though the pavilion was extremely popular, when it was struck by lightning and burned down in 1940, it was never rebuilt.

Mary and Ted Grieg put Royston on the horticultural map when they opened the Royston Nursery in 1933. The Griegs were pioneer rhododendron growers who specialized in hybridizing Asian species with English hybrids. They were known throughout North America for their rhododendron collection, and Mary was frequently invited to speak at conventions. A garden in Vancouver's Stanley Park containing more than 4,000 of their rhodos is dedicated to the Griegs' memory. Upon Mary's death in 1990 at age 93, many of the rhododendrons in her yard were transplanted to the University of British Columbia Botanical Gardens. Many of

Below: A BC Centennial cairn in Royston marking the province's 100th birthday.

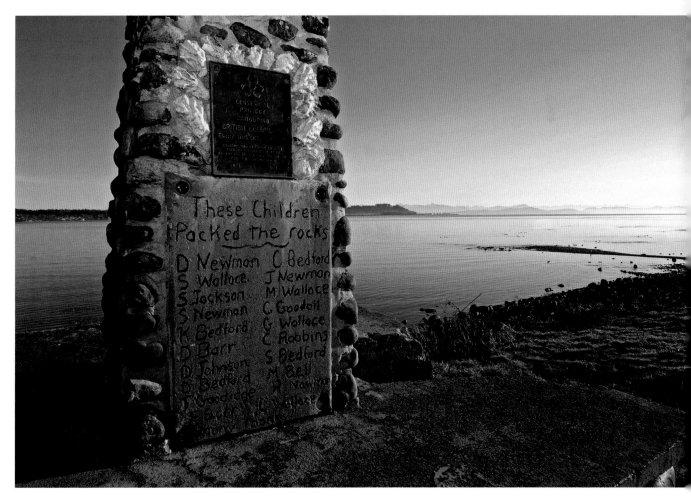

the Grieg rhodos—in particular the Royston Red—continue to bloom in the valley. And more recently they've been joined by what's known as the "Courtenay Five," hybridized rhododendrons, including the Courtenay Lady, Courtenay's official flower, created by former Courtenay Parks foreman Harry Wright.

Royston is also the site of what's locally referred to as the Royston Wrecks. Not wrecks in the true sense of the word, this collection of 15 historic ships was deliberately scuttled across from Comox Harbour to act as a breakwater for Comox Logging & Railway's log dump and booming ground. The logs were delivered from the woods, dumped into the water, sorted into booms and made ready for towing to Fraser Mills near New Westminster.

The log dump and booming ground was active from 1911 to 1978 and those who lived nearby either got used to the noise of steam trains or huge diesel logging trucks or found somewhere else to live. Although it is not unusual for ship hulks to be used as breakwaters, it is unique to find warships, whalers and tugs grounded next to a wooden-hulled barquentine, an auxiliary schooner and three Cape Horn windjammers. More than one expert has called the Royston Wrecks a "world class maritime heritage site."

One of the most spectacular hulks is the *Melanope*, a three-masted vessel that was launched in Liverpool in 1876 and that may still hold the record for the fastest passage under sail from Port Townsend to Cape Town, South Africa. Throughout her history, the *Melanope* suffered many mishaps, supposedly because a curse was put on her by an old apple seller who had been ignominiously removed from the ship. Although the Royston "wrecks" are in various stages of decay and many have broken apart, this site—easily viewed from the beach—still presents a fascinating cross-section of West Coast maritime history.

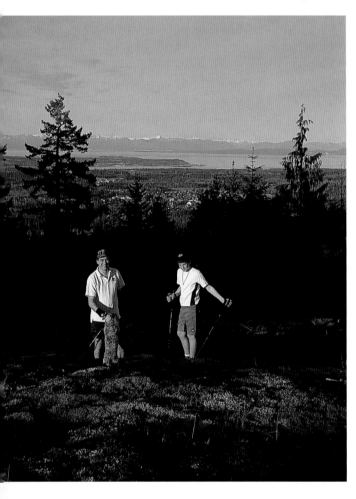

Photographer Boomer Jerritt and son Josh test the "Bike God" trail near Cumberland.

A very real wreck that happened in Royston took place not far from Gartley Point at Trent River. The canyon walls were so steep that a high wooden trestle had been built over the river. In August 1898, a locomotive carrying 21 loaded cars left Cumberland for Union Bay. But a short way across the river, the trestle collapsed and the locomotive plunged through it nose first with the loaded cars falling all around it. Seven of the 10 people on-board died as a result of the accident and others were seriously injured. One man escaped death by jumping from the train to hang from the swaying trestle. Although damaged, the Number 4 locomotive was repaired and back on the rails within a short time.

Royston has grown over the years, but most development has been residential rather than commercial. From time to time there is talk of developing the area along the waterfront, but most Marine Drive residents would probably prefer their neighbourhood to retain its undisturbed view of the Strait of Georgia. Although people no longer flock to Royston beaches, residents and visitors still enjoy the community's quiet rural atmosphere.

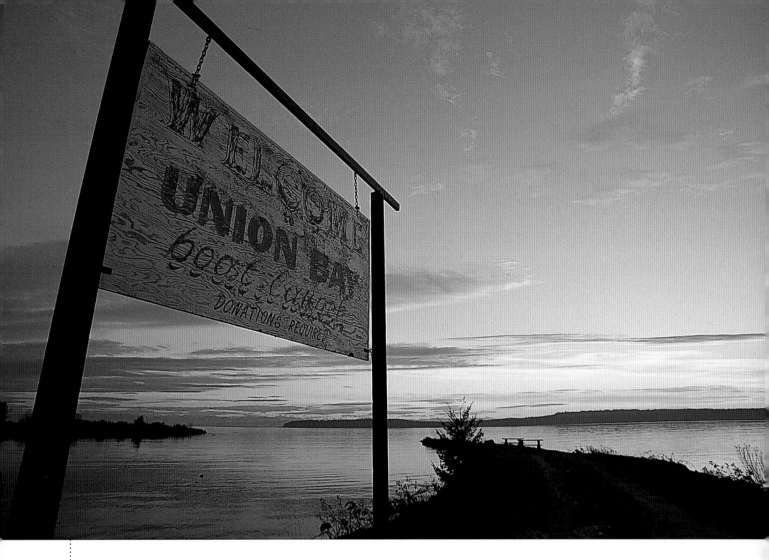

Union Bay: The Shipping Port

For much of the latter half of the 20th century, Union Bay's been a small blip on the Old Island Highway that could easily be missed in a fit of sneezing. During most of this time, a tiny commercial strip has bordered the highway with residential areas stretching along Baynes Sound and up a steep hill past the railway tracks to the plateau above. The actual bay, protected by the small bump of Union Point and the bulk of Denman Island, is about 15 kilometres south from downtown Courtenay.

As late as 2006, a visitor would never guess that this sleepy waterfront community was once a major shipping port. The tons of coal pouring out of Cumberland made a port a necessity. The original plan had been to build a wharf at Royston, but even at high tide Comox Bay was too shallow for deep-sea vessels. So Robert Dunsmuir extended a trestle and railway line to Union Bay and had an 18.5-metre-high wharf built out over the water that would hold a locomotive and train of coal cars and allow several ships to load at once. Thanks to the combination of Cumberland's high-grade coal and the wharf's reputation as one of the best in the world to load at, Union Bay was an extremely busy international port. In a 1975 interview, Tom Mumford, 98 years old at the time, said, "I heard a Blue Funnel captain saying down at Union Bay once that he would steam halfway around the world to fill his bunkers with Comox coal."

Workers at the port facility washed the coal (separated it from rock), stored it and loaded it. The washer was four storeys high and could wash 600 tons of coal in 10 hours. It ran on steam produced by water piped from nearby Washer (Hart) Creek to power the Pelton Wheel. Set

Early morning light along the scenic Oceanside Route (Highway 19A) shows Union Bay with the old train trestle site in the background.

Rolling hills of black coal slag bear testimony to Union Bay's past as a coke-making centre.

Photo by Rick James

back in the yard were 200 coke ovens. Coke is the fuel produced when coal is heated to high temperatures in ovens to remove gases. Cumberland coal produced great coke and was much in demand by BC's copper-smelting industry. The coke ovens ran 24 hours a day at an even 600 degrees Fahrenheit.

Union Bay was a dirty, noisy and very prosperous company town. Life was regulated by the sounds of the work whistle, coal cars being unloaded on the wharf and ships coming and going. Coal dust drifted in the air and huge smokestacks belched out a variety of pollutants from the coke ovens. But even though the work was dirty, it wasn't as dangerous as working in the mines—except for the Chinese.

Once a major coal port for ships of the world, Union Bay is now a quiet refuge for small pleasure boats.

Photo by Rick James

As in Cumberland, Union Bay also had a Chinese community. Charlie Mah June had a contract to provide Chinese workers, usually men he hired from Vancouver and put up in two-storey bunkhouses. Some lived independently in a cluster of one-room shacks near Washer Creek. The bottom floors of the bunkhouses were used for gambling, and tiers of bunk beds were installed on the upper floor. Huge vegetable gardens were cultivated out back, and a few men sold the excess produce.

Most of the Chinese worked as trimmers—men who made sure that the coal was loaded on a ship evenly to keep the vessel "trim." It was hard, dirty work that involved pushing coal around in the hold. As the hold filled up, the trimmer had less and less room and often finished the job lying down with less than 30 centimetres between his head and the top of the hold. When ships were in port, trimmers worked around the clock in 12-hour shifts.

Favourite ways of relaxing for the Chinese were gambling and smoking opium, and often the two pastimes were combined. No matter what was done to curtail the trade, a steady supply of opium came ashore at Union Bay, and much of it made its way to Cumberland. In an effort to halt the flow, customs officials routed most shipments of imported foods and goods through the Cumberland customs house and searched them there. Once a cache of opium was found hidden inside several heads of cabbage, with no sign as to how it had gotten there.

For Union Bay residents other than the Chinese, social life revolved around several hotels—the Nelson being the first—and the Fraser and Bishop store. Since Fraser and Bishop supplied ships loading coal, they were usually well provisioned. And Union Bay residents had an unusually good supply of exotic fruits such as lemons, limes and bananas, thanks to the generosity of those on-board the ships. One Union Bay man traded some of his detective magazines for an armful of coconuts.

Another area of social activity was the post office, where everyone gathered to collect mail and peruse any postcards, a relatively new way of communicating. Some postcard messages were read aloud even if the people they were addressed to were not present.

Because of its large selection of merchandise, the amount of cash on hand and its proximity to the water, Fraser and Bishop was frequently broken into. The most oft-told tale involves the Flying Dutchman. Thirty-nine-year-old Henry Wagner, a handsome rogue with many aliases, including Water Pirate and Flying Dutchman, was wanted by Washington State authorities

for various robberies and the murder of a postman. He was considered armed, dangerous and desperate.

One night in 1913, two young police officers interrupted Wagner and an accomplice while they were looting the Fraser and Bishop. A terrible battle ensued, with display counters and merchandise flying in the dark store. In the end, one officer was killed and Wagner's buddy escaped. Wagner was tried, found guilty and sentenced to hang. To avoid the gallows he tried to commit suicide, first by slitting his wrists, then by ramming his head against the cell wall in an effort to break his neck. The night before he was to be executed, he nearly succeeded in strangling himself with a blanket. Nonetheless, the Flying Dutchman never flinched when he walked up the gallows steps and the black hood was fastened over his head.

At the end of the coal era, Union Bay shifted to a residential community populated by retired people or those commuting to other areas to work. The wharf and coke ovens were dismantled, and all that remained of the once-bustling shipping port were the black coal slag hills of Union Point. When the Inland Island Highway was completed, the waterfront road through Union Bay, once a major thoroughfare, became quiet.

In addition to its long-time residents, Union Bay has several physical links to its past. The old post office still serves its original purpose and the tiny 1901 gaol has been moved next to it. Down the street are two distinctive prefab Aladdin houses built around 1906. Not far from the water there's a 30-hectare stand of 100-year-old trees, and a small remnant herd of Roosevelt elk still visit area gardens. For decades Union Bay has been a sleepy shadow of its former self, but as with Cumberland, it's only a matter of time before a growing valley population makes it a boom town of a different sort than it was in the past.

Union Bay's handsome post office, built in 1913 and meticulously restored in recent years, bears witness to the quiet village's busier past.

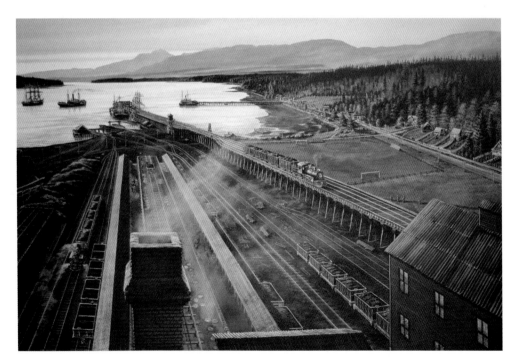

The port of Union Bay in its heyday around 1917 as depicted by local artist Bill Maximick. The state-of-the-art facility was large enough to hold a loaded coal train and to allow several ships to load at once.

Fanny Bay waterfront.

Chapter 5
Fanny Bay,
Denman & Hornby
Islands

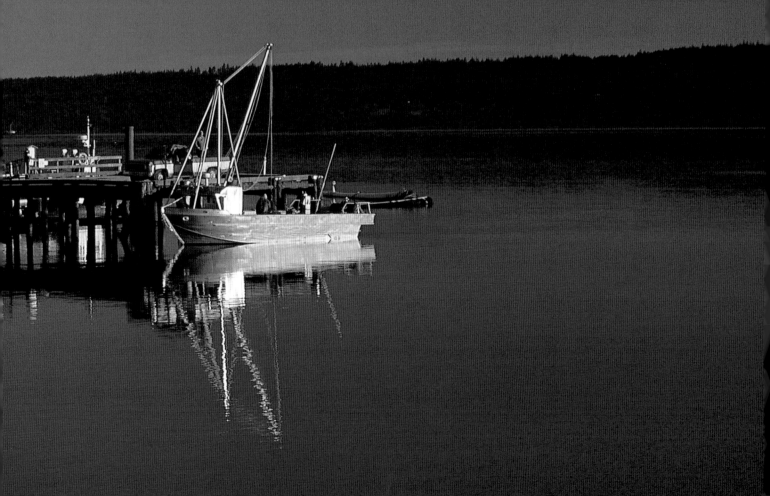

A juvenile Steller sea lion mugs for the camera at the Fanny Bay log tie-up, a favourite sea lion haunt. (Below) The Brico, former BC Telephone Co. cable-laying ship and erstwhile roadside eatery, is a Fanny Bay landmark. Photo by Rick James

Fanny Bay: The Oyster Capital

After the Inland Island Highway was completed, traffic through the outlying communities of the Comox Valley dwindled. What had sometimes been a white-knuckle, bumper-to-bumper drive along the Old Island Highway became a pleasant, scenic journey. For most of Fanny Bay the road hugs the low-lying coastline, providing views of Baynes Sound, Denman Island and gigantic mounds of oyster shells. The land adjacent to the old highway slopes gently upward and is dotted with alder, Douglas fir and bigleaf maple. One area, a boat-shaped peninsula called Ships Point, juts out into Baynes Sound.

The origin of the community's name is a mystery. Some claim it honours the wife of a British naval officer, others say it commemorates a First Nations woman who drowned or records the sighting of a naked woman frolicking on the beach. The actual bay starts at the estuary of the Tsable River and ends at Ships Point, but locals usually consider the term Fanny Bay to apply to the area between Hindoo Creek and Mud Bay.

Although it's quiet now, Fanny Bay had its share of large-scale industrial activity in the past. Coal was discovered near Tsable River in the mid-1860s, and later the Baynes Sound Coal Mining Company opened a mine. A wharf was built near today's Buckley Bay ferry terminal and the resulting community was called Quadra. When the mine closed after a few years, Phillip Buckley, a burly six-foot-six miner known for his patched overalls, decided to stay and buy some cattle

to run on the estuary. Even though he was only a squatter, the area is still known as Buckley Bay.

Not far from Buckley Bay is the site of what was once the largest shingle mill on Vancouver Island. Around 1916, Fanny Bay Mutual Mills Ltd. began operations, and by the early 1920s several local logging companies were supplying it with cedar. The mill had a 38-metre-high smokestack and, when it closed in 1962, was producing 8,000 squares of shingles per month. For many years the Old Island Highway passed beneath the conveyor belt carrying shingles to the drying kiln.

The mill is long gone and the *Brico*, a ship that laid and repaired cable for BC Telephone (now Telus Inc.), sits where the beehive burner used to be. Many people remember the old red ship as a seafood restaurant, but by 2006 it had been empty for years. During the spring herring season, the nearby log booms are a popular resting place for a large and raucous group of sea lions. The adjacent government wharf made headlines in November 1998 when authorities intercepted 12 tonnes of hashish as it was being unloaded from a fish boat.

One of the first settlers in Fanny Bay was Alexander Urquhart, who moved to Ships Point in the early 1870s and kept a mix of dairy and beef cattle on the Fanny Bay flats. Eventually Urquhart packed the family's belongings—complete

Baynes Sound is BC's leading oyster-farming centre, as the many shell mounds attest. (Below) Island people learn to shape their lives to the schedule of the local car ferry, which runs between Buckley Bay and Denman Island.

with a wood stove tended by his wife Margaret—onto a raft and poled it to the mud flats of Courtenay, where he established the GlenUrquhart farm.

Since the road into the peninsula was frequently under water at high tide, development at Ships Point was slow. Eventually a settler dyked the low spot, and residents no longer had to consult their tide tables before heading to Courtenay. The peninsula now boasts two parks, Ship's Point Park on the southeast tip at Little Bay and a 45-hectare marshland bird sanctuary and network of trails along Fanny Bay.

The population got a boost in the 1920s when numerous Japanese loggers moved into the area to work for Eikichi Kagetsu. A decorated Russo-Japanese War army veteran, Kagetsu left Japan in 1906 and logged on the Lower Mainland before moving to Fanny Bay and forming Deep Bay Logging. Some of his Japanese workers brought their families with them and lived in a small community along Cowie Creek near today's inland highway. Each house had a covered walkway complete with climbing roses that led to a steam bath. For many years, Japanese children were in the majority at the Fanny Bay school.

A well-known landmark is the Fanny Bay Inn. Jimmy Sturgeon built what locals call the FBI in the late 1930s. On opening night it was standing room only and customers were hard pressed to get a drink. Many residents still remember the New Year's Eve when Sturgeon, a champion bagpipe player, stood outside playing the pipes while enthusiastic patrons accompanied him with blasts from their shotguns.

In the 1950s Sturgeon sold the FBI to Fred and Anne Chalifour. When Fred had a serious heart attack, Anne—or "Fanny Annie" as she was sometimes called—began tending bar. She

Chrome Island, located off the south end of Denman Island, bears a number of ancient First Nations rock carvings, or petroglyphs.

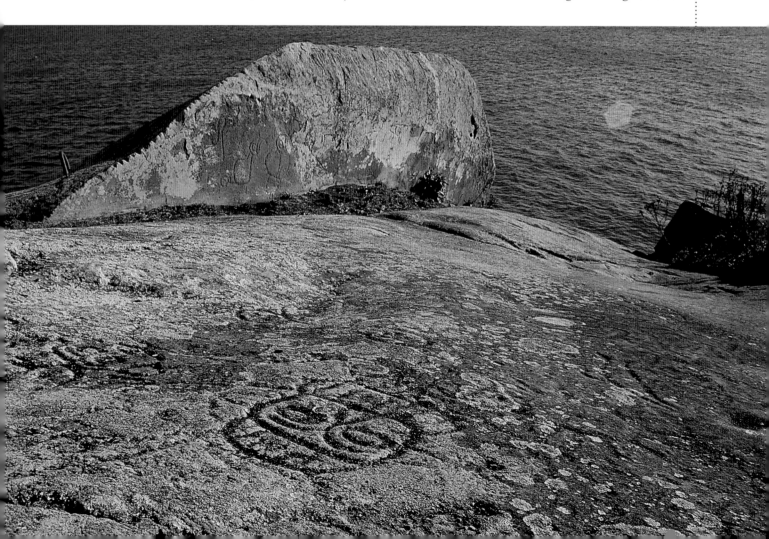

wasn't averse to handling a brawl or a drunk customer, but on busy nights sometimes employed Norm Davis, a 200-pounder nicknamed "Big Moose," to act as bouncer. Although she was firm, Anne always looked after her regulars. As noted in *Shingles & Shells*, by Arv Olson, she often wrapped layers of toilet paper around Donnie Stevenson so drivers could see him as he staggered home. In later years the pub became a convenient stop for down-island skiers to get a pint on their way home from Mt. Washington. Once the Inland Island Highway was punched through, the FBI reverted to a neighbourhood pub.

Fanny Bay's best-kept secret is the "Wacky Woods" that make up part of the marshland trails along Fanny Bay. Here, a turn in the path might reveal quirky wooden sculptures enhanced with found objects and cryptic political messages. This is the work of George Sawchuk, a former logger, fisherman and construction worker. In the article "Profile of an Artist," Francis Penny wrote that an associate called Sawchuk a "folksy communist.'"

Sawchuk decided to create some "real" Canadian art after an industrial accident sidelined his career. He moved to Fanny Bay with his partner Pat in the mid-1970s and started "fooling around" in the woods. Since then his one-of-a-kind sculptures have been exhibited throughout North America and he's been elected to the Royal Canadian Academy of Arts. A bit of a bureaucratic fuss occurred when Sawchuk's backyard creativity spilled over onto the Crown land behind his place. But an outpouring of public support led to a compromise, making it possible for visitors to continue enjoying Sawchuk's enchanted forest.

Today Fanny Bay owes its fame to the plump and tasty oysters that grow along its shores. A small variety of oyster is native to the Comox Valley, but it wasn't until the larger Pacific oyster was introduced in the early 1920s that the industry really took off. The imported oysters thrived in the nutrient-rich waters, and the first of numerous oyster leases was taken out in the 1940s. In 2003 the Baynes Sound area was responsible for about half of the shellfish production in BC by value. Fanny Bay oysters are now world famous and can be found on restaurant menus from New York City to San Francisco and beyond.

Chrome Island lighthouse keeper Chaz Thomson keeps a tireless lookout for boaters in distress.

The home of author and gardener Des Kennedy is a must-see on the Denman Island Home and Garden tour.

Denman Island: Back to the Land

"So this is where all the hippies went," California visitor Mary Lou Tracey said the first time she visited Denman Island. Indeed, the 10-minute ferry ride from Buckley Bay seems to journey further than a mere 2 kilometres. The pace of life is slower on Denman, and with

a winter population of around 1,000, the locals all know each other. Here no one strives to keep up with the Joneses. Instead, the primary goal seems to be for each person to follow one's own distinct vision of an alternative lifestyle.

Denman is about a 20-minute drive down-island from Courtenay and is separated from Vancouver Island by the narrow waters of Baynes Sound. The island is around 19 kilometres long, thin on one end and widening to about 5 kilometres at the thickest point. On the northwest end, the narrow crook of Longbeak Point stretches toward Comox Bay, and at the other side of the island the stub of Boyle Point looks out over the Strait of Georgia. The island is rimmed with sand and gravel beaches, as well as some steep bluffs and timbered slopes. Inland terrain features a high ridge and a couple of lakes and marshes.

The islands are known for the originality of their housing styles.

Many people's first introduction to the island is Denman Village, a bustling hub of activity complete with a school, craft shop, library, store and two community halls, at the top of the hill adjacent to the ferry terminal. To the left of the village, Northwest Road offers the option of turning toward Chickadee Lake or continuing along the coast with its views of Vancouver Island and the Beaufort Range. From Gladstone Beach it's possible to gaze across the water and up the Comox Valley or walk to Henry Bay, once the site of a logging camp and also a clamshell processing plant that produced grit for poultry. Just off Longbeak Point lies Sandy Island. Commonly known as Tree Island, this tiny piece of land contains a sensitive and unique ecosystem of rare and fragile plants.

Located off the northwest tip of Denman, Sandy Island Park is noted for its unique ecosystem and rare plants.

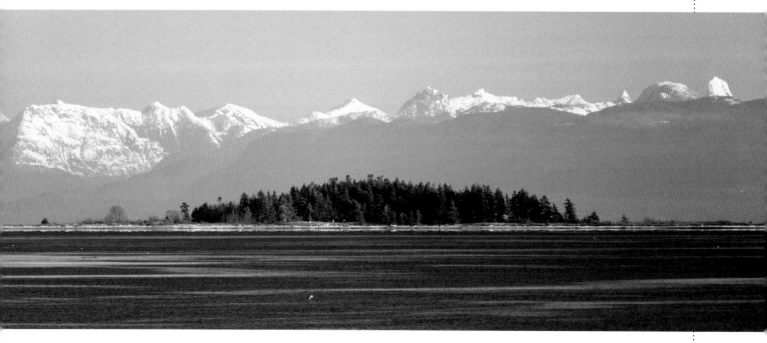

On the east side of Denman is George Beadnell's gift of Fillongley Park. Beadnell moved to the island around 1900 and developed his 23-hectare beachfront property into one of the most beautiful estates on the coast. A series of trails through an old-growth forest leads to a large meadow, once the site of Beadnell's home and bowling green. Fillongley Park is particularly beautiful in the fall, when many of the heritage trees turn colour.

At the southern end of the island, Boyle Point Provincial Park has several impressive lookouts, including one with a view of the lighthouse station on Chrome Island. Sometimes called Yellow Rock because of the tiny yellow blossoms that cover the ground in spring, the island was first used as a lighthouse around 1890. Its rocky ground holds an impressive array of petroglyphs.

It's believed that Peter Berry and William Robb, a couple of squatters who settled on the edge of a swamp in 1874, were the first non-Native residents of the island. When the mine across Baynes Sound folded a few years after that, several miners joined them. Most took up farming and raised some sheep or cattle as well. Tom Piercy arrived in 1876 and, after a quarter-century of clearing land, planted a 1,000-tree orchard that produced apples, pears and cherries.

Around the time Piercy was getting his orchard going, small-scale logging was beginning to harvest some of the island's heavy timber. But aside from farming and logging, the only

Wreck sites and rare six-gill shark habitat attract divers to island waters. Photo by Jacques Marc

Looking toward Denman from Mt. Geoffrey, Hornby Island.

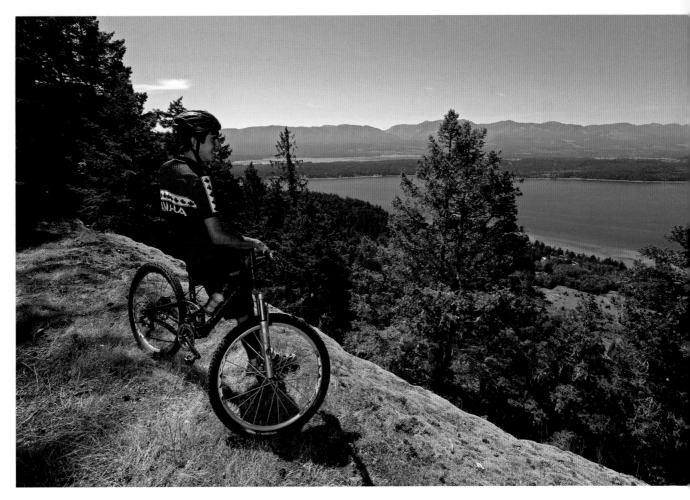

Winding roads overhung with trees give Denman a special charm.

Renowned Denman Island potter Gordon Hutchens tends his handmade anagma kiln. Photo by Paul Bailey

real industry on Denman in the early years was the opening of a sandstone quarry around 1907. The stone was used in buildings as far away as Vancouver and Victoria, and although the quarry was successful enough that men moved to the island to work there, the operation shut down around the start of World War I.

For many years, getting to Denman was awkward, especially if someone wanted to transport equipment or animals. Small animals crossed Baynes Sound by rowboat; horses and cattle usually had to swim. Alby Graham launched a water-transportation service in the early 1920s. With his small steamboat, the *Diane*, he pulled a cedar-log raft that could hold several vehicles. When the raft was nudged ashore, drivers had to navigate the beach and drive up onto some planks before they reached the road.

Around 1930 the Denman Island Farmers' Institute successfully lobbied for a government subsidized ferry. Alexander "Sandy" Swan got the contract and used two scows to transport goods and vehicles. In those days Denman Islanders often didn't bother to license their cars,

Experimenting with different glazing techniques over many years, Hutchens created the beautiful Denman Lustre.

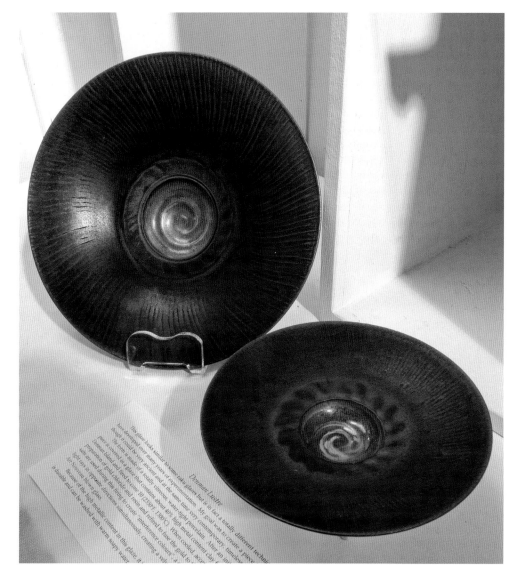

so if police boarded a scow, Sandy put out the alert. Everyone was on the same phone line and one long ring meant the cops were on the way. Today BC Ferries provides regular service to Denman from Buckley Bay on Vancouver Island.

Sometime in the 1950s, Denman became a popular place to holiday. Over time, to meet the demand for summer cottages, farms were carved into subdivisions. The rural nature of the island appeared threatened, and many residents welcomed the formation of the Islands Trust in the 1970s and the resulting slowing of development. But by that time, descendants of the pioneer farming families and summer residents were facing an influx of back-to-the-landers.

These Canadian and American newcomers were looking for a simpler lifestyle. And some were draft dodgers, not willing to be part of the United States' involvement in the Vietnam War. Although hippies, as many of these people were called, appeared in all parts of the Comox Valley, they seemed particularly attracted to island life. Some began their residency as squatters; others bought property communally. Big, lush gardens were common, and many people sold their crafts and artworks for income.

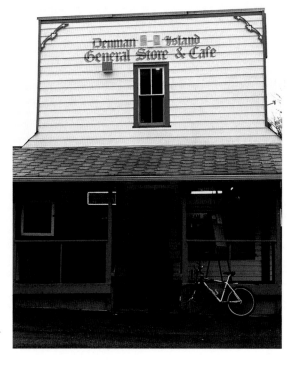

Perhaps because of the hippie influence, or maybe just because islands tend to attract unusual characters, the clothing and architecture on Denman tends to be as unique as its owners. There are still a few communally owned properties, and people continue to raise livestock and tend orchards. Thanks to a slightly warmer climate, crops often ripen three weeks earlier than in other valley communities, and organic produce finds a ready market in Courtenay and Vancouver. A little less than half of Denman's 5,150 hectares is farmland.

The island is also known for its vibrant arts community and is home to numerous well-known artists. Others earn a living from oyster leases, and a few operate B&Bs. A certain percentage of the population commutes off island to work and some, dismayed by the cost of ferry transportation, move away. In 1997, when a tree farm comprising approximately one-third of the island was sold and logged within a couple of years, a renewed interest in protecting and preserving the island was generated. Most residents are anxious to hold condominiums and large-scale development at bay and advocate ways of making a living that leave a light footprint on the land.

A short walk uphill from the ferry terminal, the Denman Island General Store is located in Denman Village, a hub of island activities. **Photo by Rick James**

Denman's heritage is readily visible in the community hall, cemetery, two churches and assortment of old orchards, barns and homes. Everyone seems to have a large garden, and the best bet for a behind-the-scenes glimpse of Denman life is to attend the annual home and garden show in June.

Beaches and accommodations are limited on Denman, so it doesn't get the heavy influx of tourists that nearby Hornby Island does. As Marilyn Jensen, a Denman Island resident and coordinator of the Denman Island section of *Islands in the Salish Sea: A Community Atlas*, said, "Denman's just a speed bump on the way to Hornby." But be forewarned: Denmanites get cranky when visitors treat the narrow, windy roads between ferry terminals as a high-speed expressway.

Hornby Island is famous for its fantastic rock formations.

Hornby Island: An Artists' Haven

To some, the limited number of ferry sailings would make Hornby Island an undesirable place to live. But residents prefer to put some distance between themselves and the rest of the world. Hornby lies to the east of Denman Island across the narrow waters of Lambert Channel. The island's approximate 2,900 hectares is roughly round in shape with a deep indentation at Tribune Bay and a long peninsula stretching out into the Strait of Georgia. Hornby is known for its sandy beaches, unique rock formations and high bluffs. Seventy-five percent of the island is classed as green space and a full 25 percent is officially protected in some way.

George Ford, one of the earliest settlers, moved to the island in the 1860s. A hearty, outgoing fellow, Ford acquired close to 800 hectares and is remembered by the tiny cove that bears his name. Another short-lived venture, a whaling station that started around 1871, also has a bay named after it. For the most part, however, growth was sporadic. Forty years after Ford's arrival the population was only around 30. Most residents took advantage of the good climate and farmed; around 1910 a few gyppo logging outfits began tackling the timber.

*Denman and Hornby
islands have always held a
special attraction for those
who seek the path less
travelled.*

*Hornby Island residents'
creative spirit is reflected
in the design of their
community hall.*

Award-winning potter Wayne Ngan finds inspiration in the Hornby Island landscape.

Ngan's graceful and elegant pottery has an international reputation.

Then, in the 1940s, artists discovered the beauty and serenity of the island. Jack Shadbolt and other instructors from the Vancouver School of Art were attracted to Hornby early on. Aided by his wife Doris, a well-known figure in the Vancouver art scene, Shadbolt became an icon of West Coast painting and is recognized for his exploration of abstraction and modern painting techniques. He was also generous enough to mentor and advise other artists who crossed his path.

Comox Valley painter Brian Scott began visiting Hornby as a child with his parents and built a summer studio there in 1984. "Every summer I would do an art show at the Hornby hall and to my delight (and often amazement) Jack Shadbolt would show up to 'critique' my new works," Scott wrote in his book *Brian Scott Book Two*. "Years later, I found out that my father would simply phone up Mr. Shadbolt and ask him to look at my work."

With the boost in population that the artists provided, Jimmy Loutets decided to open the Salt Spray Grocery. As Hilary Brown noted in *Hornby Island: The Ebb and Flow*, "They weren't making any money, and what he was really interested in was his home brew. He always had something brewing behind the stove." When Loutets took a tumble off a ladder and seriously injured himself in the mid-1950s, he encouraged a group that had been talking about a co-op to take over the store. "It was slow. Sometimes we had two customers a day," recalled John Richards, the first Hornby Island Co-op Store manager. "Twice a week I'd load goods into my car and circle the island, stopping wherever people lived." Often the co-op wasn't able to pay its bills until summer, when the tourists arrived. Luckily, the first official resort, the Hornby Island Lodge, opened in the late 1920s and ever since that time tourists have been a mainstay of the island economy.

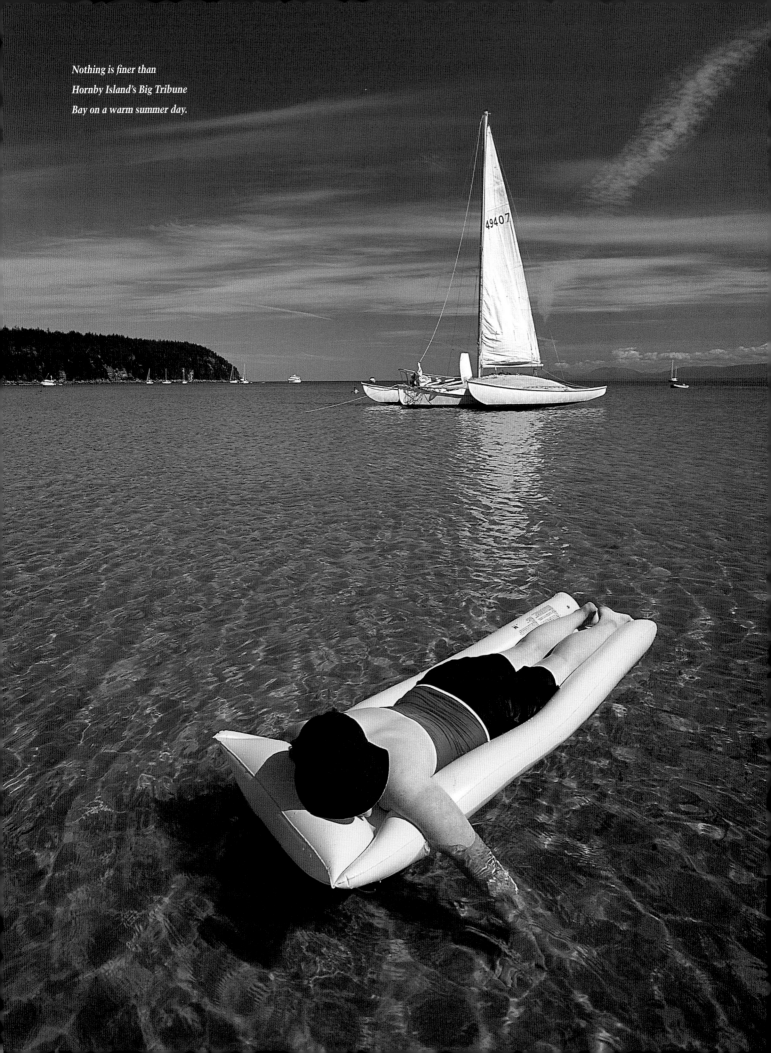

*Nothing is finer than
Hornby Island's Big Tribune
Bay on a warm summer day.*

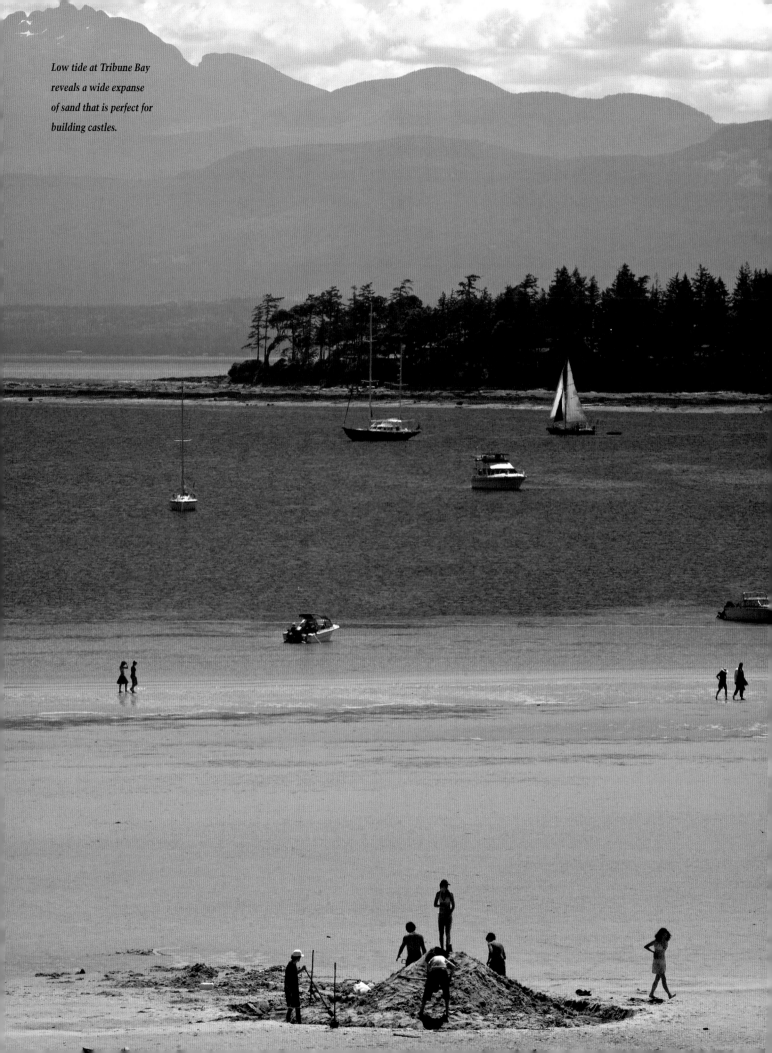

Low tide at Tribune Bay
reveals a wide expanse
of sand that is perfect for
building castles.

Access to Hornby was difficult for many years. With no suitable wharf, settlers had to row passengers and freight to and from ships anchored offshore. In the early 1920s Leon Savoie began making trips to Comox Bay in his boat the *Lipgig* and often agreed to take along passengers or freight. When ferry service was established between Denman and Vancouver islands, many Hornby residents left their cars on Denman and rowed across Lambert Channel. It wasn't until the mid-1950s that Hornby got its own government ferry.

Now regular ferry runs link Hornby and Denman. The ferry docks at Shingle Spit, the location of one of several buildings featuring thatched roofs. Not far away is Hornby's pride and joy, the Recycling Depot & Free Store. Garbage is often a problem on islands. Hornby's solution was to convert their landfill into a state-of-the-art recycling centre. Now, on a per capita basis, residents there produce less garbage than any other community in BC—in 2000 they recycled a whopping 47 percent of their garbage. And what was once a stinky dump has become a gathering place for locals and a must see for many tourists.

Near Tribune Bay, a spot known for its low tide, wide expanse of white sand and warm water, is the hub of the community. This focal point includes the Ringside Market, complete with café and designer coffee bar, as well as arts and crafts and numerous summertime open-air stalls. This is also the site of the co-op store. Once unable to pay its bills, the co-op is now an upscale grocery stocked with gourmet goods.

At the tip of St. John's Point lies Helliwell Provincial Park. Trails wander through a second-

The sandy beaches of Tribune Bay and the rocky bluffs of Helliwell Park (below) are prime Hornby Island attractions.

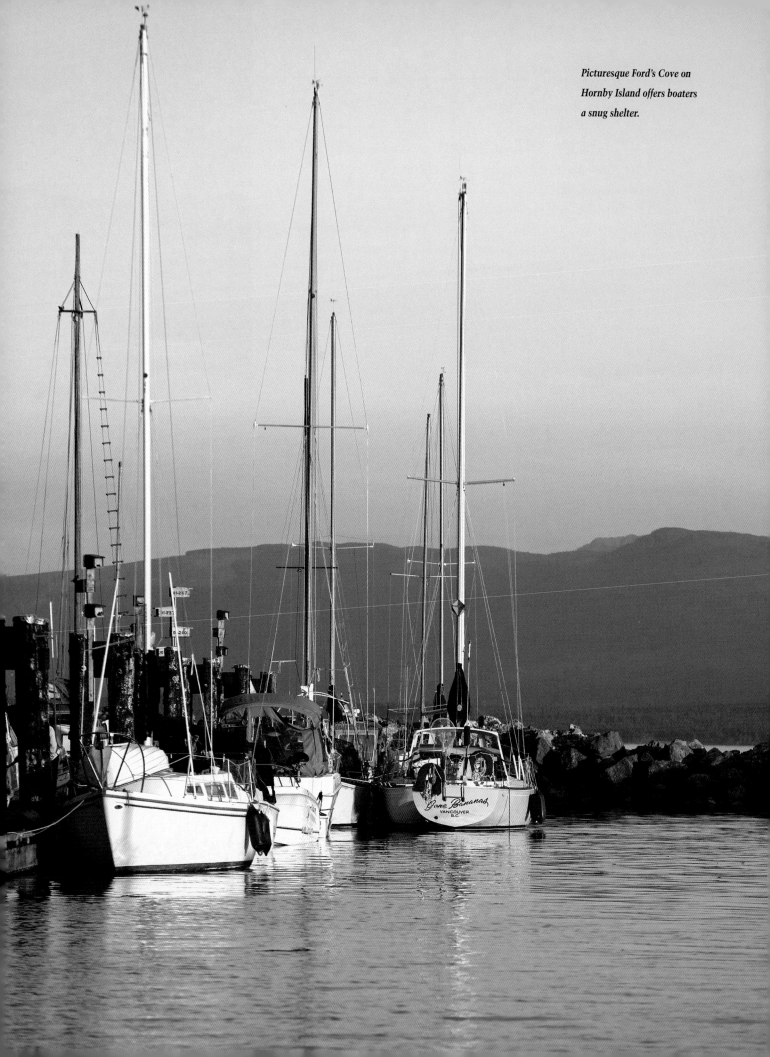

*Picturesque Ford's Cove on
Hornby Island offers boaters
a snug shelter.*

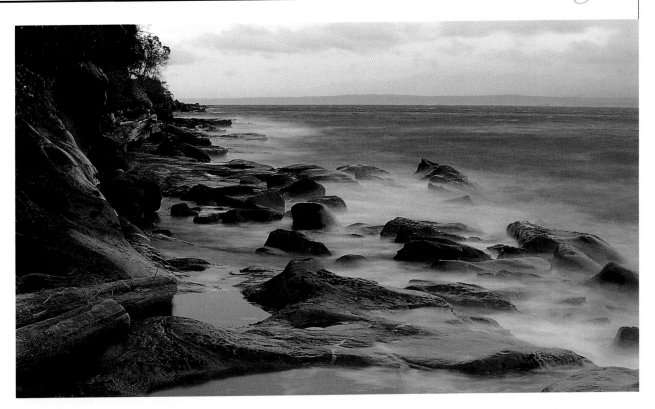

growth forest and a huge meadow bordered by a grove of Garry oak and arbutus trees. High bluffs provide a view over the water, and in winter, rafts of sea lions are sometimes seen taking a snooze in the sheltered coves. Just off the northeast corner of St. John's Point is Flora Islet. Every spring this rock is covered with tiny blossoms but it's best known as a midsummer dive site where lucky divers may catch a glimpse of elusive six-gill sharks.

On the southwest corner of the island, the high slopes of the Mt. Geoffrey Escarpment Provincial Park rise from the sea. The 174-hectare park contains an interesting mix of shoreline, orchard and two unique coastal bluff ecosystems with endangered Garry oak and arbutus trees.

The park is criss-crossed with hiking and mountain-biking trails, and various vantage points provide mountain and water views. Anyone who feels ambitious can hike through the park from Ford's Cove to the ferry landing at Shingle Spit.

Hornby's ambience changes with the seasons. Spring brings wildflowers on the bluffs and the herring run, which in turn brings boats, planes, a variety of birds and noisy sea lions. In the summer, the number of people on the island at any one time can rise to 5,000 or even 6,000. Ferry lineups tend to be long and water shortages require extreme conservation measures. Even though many Hornby Islanders make their living from tourism and selling arts and crafts—a 2006 statistical report by Hill Strategies Research Inc. rates Denman and Hornby as third in Canada's top ten artistic communities—permanent residents worry about the impact of so many people.

By fall, the grass on Helliwell's bluffs is yellow and the crowds of summer residents and tourists have begun to thin. In winter the population dips to just under 1,000, and most of the people sipping lattes at the Ringside Market are locals. Many of the large waterfront homes are battened down for the season and it's just the smaller, architecturally intriguing homes of full-time residents that have smoke curling out of the chimney.

A restless surf wears away at sandstone formations in Ford's Cove.

Wharf pilings at Hornby Island's ferry terminal.

An oyster skiff heads off to catch the morning tide.

Chapter 6
Working the Land

Working the Land

The landscape and nearby waters of the Comox Valley provide pleasing vistas and endless opportunities for recreation. But the importance of land and sea goes far beyond leisure activities. For thousands of years the environment has provided both food for the table and various ways to earn a living.

Emu farming is a new valley venture. *Photo by Rick James*

The Puntledge and K'ómoks were the first to take advantage of the bounty of land and sea. They harvested red cedar for building material and canoes and other implements necessary for daily life. Fish, clams, berries, herbs and edible bulbs were plentiful, as were geese and ducks. With the help of dogs, they hunted deer and elk. Early settlers led similar lives of subsistence, but once their farms were viable, they focused their energy on agricultural endeavours.

As the farms flourished, employment and business opportunities diversified. Soon merchants were opening stores and businesses to meet settlers' needs. Hotels provided gathering places for residents and later marketed the valley as a "sportsman's paradise." When coal was discovered in the mid-1800s, large-scale, capital-intensive industry was developed, and it was the dominant economic activity in the region for more than half a century.

Comox Valley *by E.J. Hughes 1953.* Courtesy E.J. Hughes

Other smaller industries also evolved into significant players in the local workforce. Shellfish

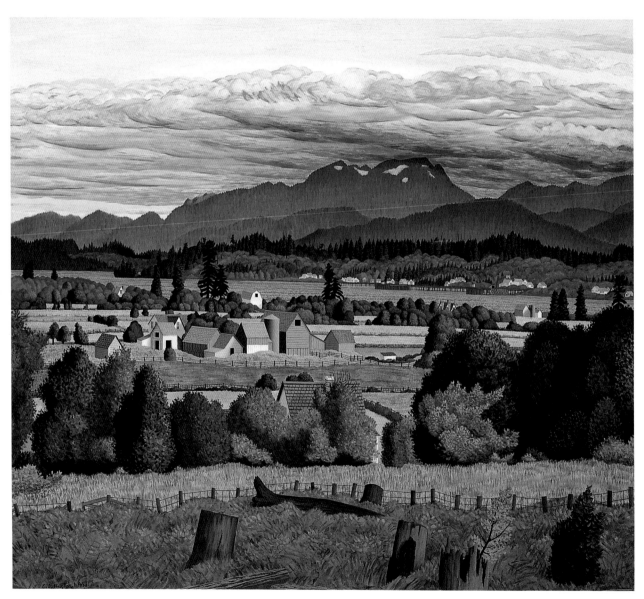

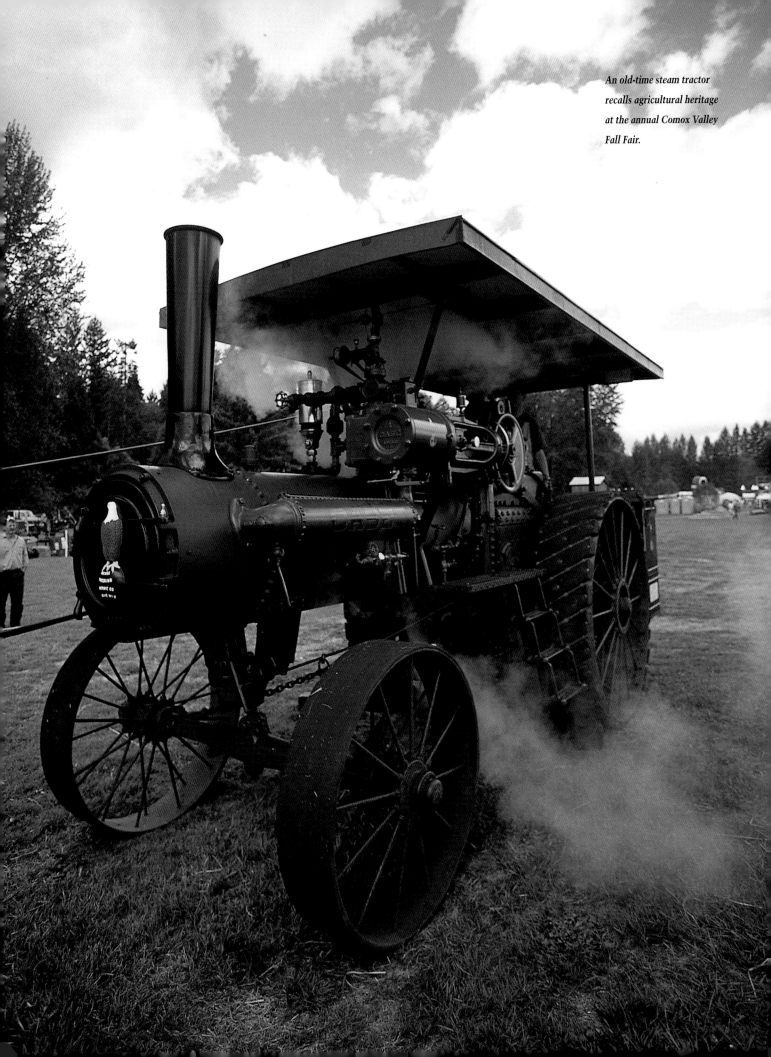

An old-time steam tractor recalls agricultural heritage at the annual Comox Valley Fall Fair.

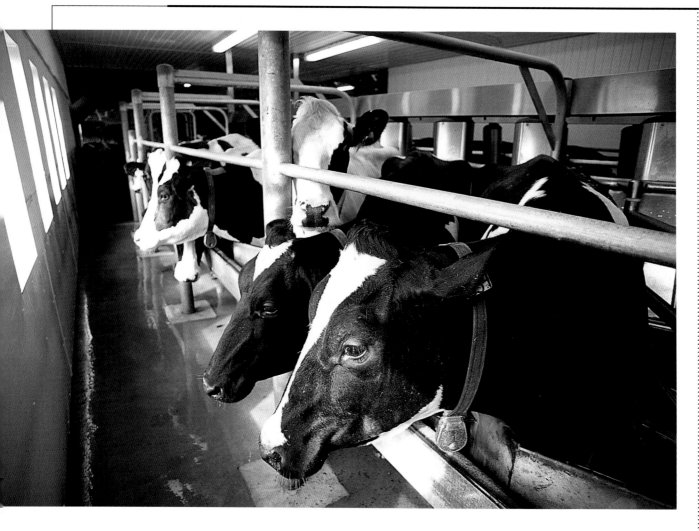

Dairy farming is the number-one agricultural activity in the Comox Valley.

harvesting, introduced in the early part of the 20th century, continues to be an important part of the valley economy. The commercial fishing industry evolved from handliners' small wood rowboats to a large fleet, which in the early 21st century consisted of about 150 multi-licensed commercial vessels whose home port was the Comox Marina. But aside from coal mining, the two industries that had the biggest impact on the valley's early development were farming and logging.

A Farmer's Paradise

As early as 1861, Lieutenant Richard C. Mayne of the Royal Navy commented on the valley's potential as an agricultural settlement. After a stop at Port Augusta, he wrote that it took a day and a half to walk over the land "through which a plow might be driven from end to end." Settlers were delighted to find good soil and a favourable climate, and those lucky enough to obtain land on the "prairies" had a relatively easy time clearing it. But prior to the building of Union (now Cumberland) in the late 1880s, it was difficult to market surplus produce. Farmers who were interested in shipping butter and eggs to Victoria and Nanaimo, for example, were hampered by the lack of a road and infrequent stops by steamers at Port Augusta.

Once the coal industry was firmly established, however, it didn't take long for the Comox Valley to claim its place as one of the largest agricultural areas on Vancouver Island. Most

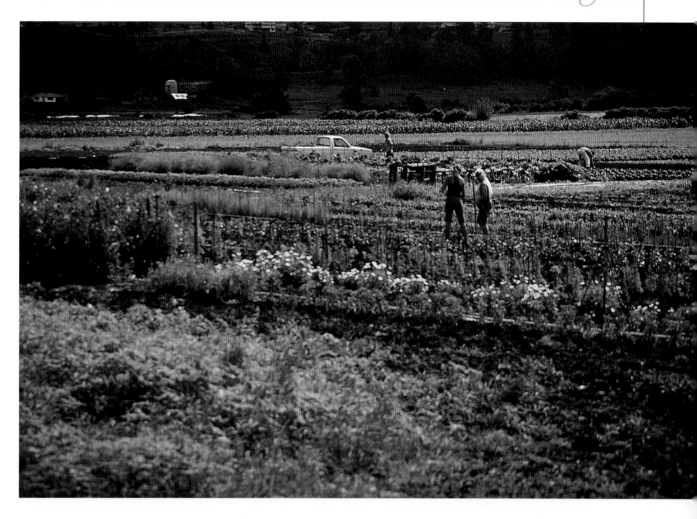

farmers went in for a mix of crops and some fruit trees. In the early days, the best farmland was located on the prairies along the Tsolum River flood plain and on the estuary flats of Comox Bay. At one time Merville was known for its strawberries and Denman and Hornby islands for their extensive orchards.

One of the best crops was potatoes. "Vancouver Island raises potatoes of unsurpassed excellence," Eric Duncan noted in *Fifty-Seven Years in the Comox Valley*. "Adam McKelvey owns 300 acres of the best land ... and raises potatoes as 'big as yer fut.'" During the boom days of coal mining, the Duncans regularly shipped 675 kilograms of potatoes at a time from their Sandwick farm to Cumberland. By the fall of 1921, Comox Valley potatoes were being shipped to points as far away as the Orient.

Comox Bay Farm (formerly Farquarson's Farm), a valley landmark, helps provide produce for a vibrant Farmer's Market. Photos by Rick James

Another kind of farming got its start in the early 1880s with the arrival of the first Jersey cows. The high fat content of their milk makes great butter, but initial attempts at marketing failed. "If I was in the oil business," one Victoria merchant commented, "I might handle it [butter] for axle grease." A few years later Alex Urquhart, known as the father of large-scale farming in the valley, had 45 Jerseys on his Comox Bay farm and was successfully selling his butter in Nanaimo.

Urquhart and other large dairy farmers could afford mechanical cream separators, but that wasn't practical for smaller operations. So in 1901 a group of them invested around $100

Agricultural activity includes many specialty items such as Middle Mountain Mead from Hornby Island.

each and, with a $1,000 donation from James Dunsmuir and a government loan, launched the Comox Creamery. The co-op had a rough go of it in the beginning. Cream was often delivered unseparated, and its quality and that of the water supply were dubious. Then William Carroll was hired as butter maker and the creamery started to make a name for itself. Victoria merchants began ordering it, and before long some of the larger dairies got involved. Eventually the facility became one of the four biggest creameries in British Columbia, producing such high-quality butter that housewives in Victoria were willing to pay an extra 5 cents a pound for it.

In 1919 Carroll blended ice from Maple Lake (near Cumberland) with some of the cream in an ice-cream maker, and Comox Jersey Ice Cream was an instant hit. A few years later the company began producing jam to take advantage of excess fruit. In the mid-1950s, when government regulations stipulated that all milk be pasteurized, the creamery took over small farmers' door-to-door deliveries, with trucks travelling as far as Port Alice. Gradually the milk business took over, and after 66 years of operation, the creamery part of the business was phased out.

For a short while the valley even had a milk condensory. The Courtenay Condensed Milk Company opened a plant on Anderton Avenue next to the Puntledge River. There they extracted 50 percent of the water from milk, packaged it in cans and sold it under their own label of Buttercup Condensed Milk. But the condensory couldn't get enough milk to make the operation profitable and closed after about seven years. Today the only hint that it even existed is the road and bridge bearing the name *Condensory*.

Another food processing plant, the Comox Valley Cannery, was built near today's 17th Street Bridge in the 1930s. A variety of fruits, berries and vegetables were processed by the company, which in its heyday employed 50 women plus a staff of mechanics and machine operators. For a short time the cannery even processed bacon and other meats, but the business was short-lived and closed before the end of the decade.

The fertile Comox Valley is one of the few places on the BC coast where it would be worth anyone's while to own a combine.

Farming changed after World War II as returning soldiers took jobs in a growing industrial sector rather than return to the family farm. But as active farming declined, property values increased. All of a sudden it was the land itself that was valuable. Many farms were subdivided into residential developments. This led to a problem that persists to this day—city folk purchasing their dream property next to a working farm and discovering that growing crops or animals can be a smelly business. The Agricultural Land Reserve established by the BC government in the early 1970s slowed the development trend and is most likely responsible for protecting much of the remaining green space in the valley.

A challenge for farmers since the late 20th century is the increasing number of trumpeter swans. These birds were once nearly extinct; now one-tenth of the world's trumpeter swans—50 percent of Vancouver Island's seasonal population—spend their winters in the Comox Valley before migrating north in the spring. And they've discovered that pastures, cover crops and harvested vegetable fields provide food that's just as tasty as what's found in coastal marshes. A

full-grown swan can eat up to 1.2 kilograms of grass a day, which translates into a substantial loss for farmers. Many farmers plant subsidized cover crops that lure swans away from their perennial grass fields.

A popular swan hangout is the Comox Bay Farm, which runs along the east side of the Courtenay River and estuary. In 1998 this oasis of green, which has been farmed for more than 100 years, was purchased through the Pacific Estuary Conservation Program, a partnership of government and non-government agencies, including Ducks Unlimited. The unique property now serves a dual role: working farm and habitat for waterfowl.

Farming is still an important part of life in the Comox Valley. In fact, the valley contains about half the agricultural land on Vancouver Island. Berry and vegetable fields, orchards, cows chowing down at the feed trough—all are only a short drive from the major urban areas. A number of farms have diversified into specialty products such as emu, wasabi, cheese and sprouts, as well as organic produce. Some farms have been passed down from pioneer families to succeeding generations. Dairy farming is the number one agricultural enterprise, and several potato farms carry on the tradition of the valley's early farmers. A wide range of fruits and vegetables are grown; beef cattle, pork and chicken are also raised. The local Farmer's Market, said to be one of the most dynamic on Vancouver Island, has provided a steady market for smaller farmers and meets the growing demand for fresh local and often organic produce. It's also become the place to see and be seen on a summer Saturday morning.

Once nearly extinct, one-tenth of the world's trumpeter swans now winter in the valley, bringing joy to birdwatchers but grief to farmers, who have had to explore innovative ways to keep swans from destroying crops.

A Garden of Eden for Loggers

It didn't take newcomers long to realize that their farms were located next to some of the best stands of virgin Douglas fir found anywhere in the world. In the 1870s, settlers struggling to clear their 64-hectare preemptions sold some of the timber to Reginald Pidcock's Courtenay sawmill. Over time, numerous sawmills were established throughout the valley. Later, larger

Harold Macy and his family employ enlightened forest practices on their 400-hectare woodlot near their Merville home. Photo by Rick James

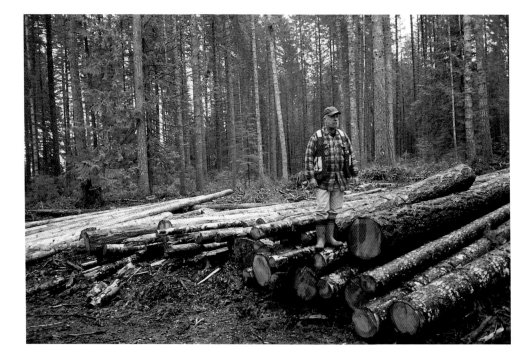

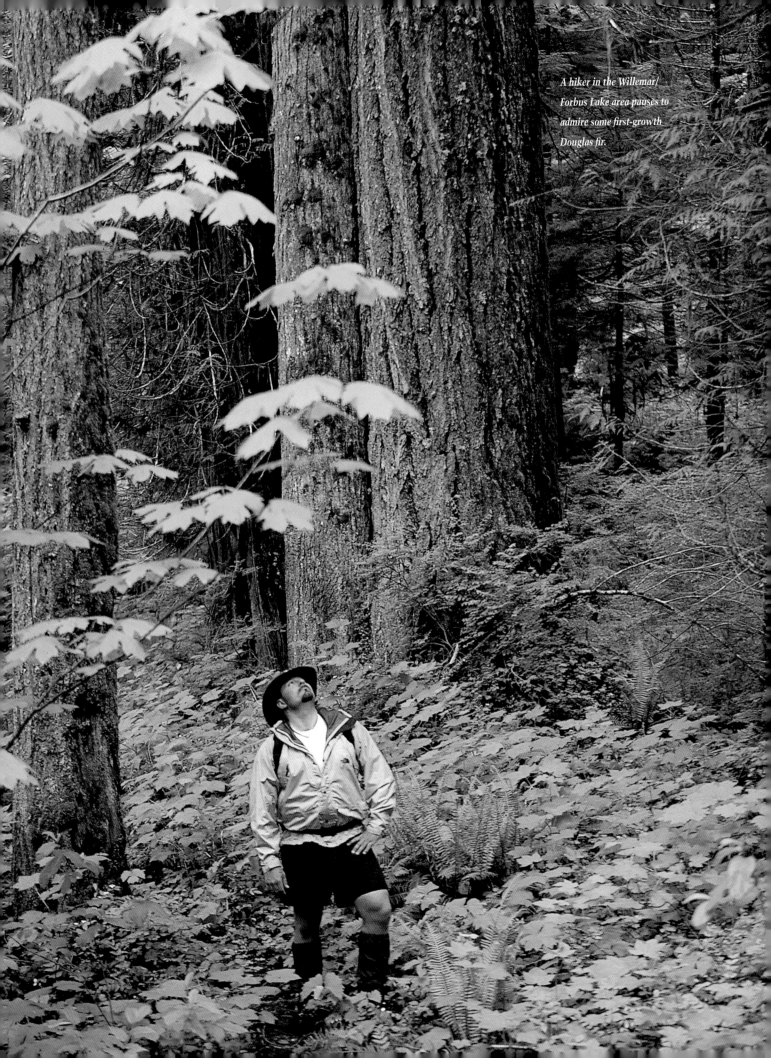

A hiker in the Willemar/Forbus Lake area pauses to admire some first-growth Douglas fir.

A veteran treeplanter airs his socks and enjoys a smoke after a backbreaking day in the logging slash.

Photo by Rick James

The equipment gets bigger as the logs get smaller (below). Huge first-growth trees of the past are but a memory as second and third growth reaches harvestable age.

mills that operated for long periods of time include the Fanny Bay shingle mill and Field's Sawmill, formerly located by the 17th Street Bridge in Courtenay.

Around the 1880s, as southern coastal mills demanded more timber, small-scale logging outfits began moving to the valley. John Berkeley started the first logging camp and used teams of oxen to skid logs out of the Dove Creek area. The logs, some nearly 2 metres across, were dumped into the Tsolum River, the expectation being that the current would float the logs down to Comox Bay so they could be boomed and towed south. Instead, colossal log-jams built up and floods often deposited the logs in farmers' fields.

By the early 1890s, most of the easily accessible timber was gone. The arrival of steam-powered equipment marked the beginning of a new era in logging, and soon large sawmills began buying or leasing tracts of their own forest land. Victoria Lumber & Manufacturing Company, which ran a huge export mill in Chemainus, staked out over 20,000 hectares of prime Comox Valley timber in 1899 and 1900. When their logging contractor, King & Casey, persisted in trying to drive logs down the Tsolum River, they plugged the river with huge fir logs for 9 kilometres back from Comox Bay. As a result, it wasn't until 1910, after the Canadian Western Lumber Company bought out the Chemainus company claim, that logging really got underway in the valley.

The company that played the largest role in the lives of Comox Valley residents was Comox Logging & Railway Company. It was created when some investors from central Canada, Britain and the US purchased an old sawmill on the Fraser River near New Westminster and bought the rights to the magnificent stands of timber in the Comox Valley.

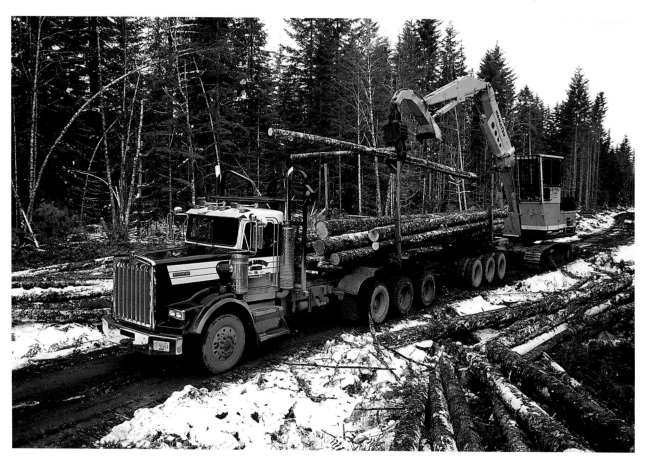

They organized their new holdings into the Canadian Western Lumber Company and renamed Comox and Campbell Lake Tramway Company the Comox Logging & Railway Company. A rail bridge was built across the Puntledge River and track laid out to a new booming ground at Royston. Since there was virtually no grade and no rocky outcrops, no blasting was required, and laying rail out into the timber stands was as simple as dropping track on the flat valley floor.

For more than 40 years, steam locomotives ran up and down the valley every day, blowing their whistles at each crossing. The company's mainline ran right through downtown Courtenay—the old railway bed is now the parking lot behind the Native Sons Hall and the Sid Williams Civic Theatre. It wasn't unusual for 50 flatcars filled with logs to pass through the city each day. But the only time anyone paid attention was if a log was so enormous that there was only one to a flatcar.

Comox Logging initiated several unusual practices for its day. The first was to introduce regular pay periods for loggers. Prior to 1910, men received money owed them only when they quit or wanted to take their "grubstake" to Vancouver for some R&R. From time to time, valley loggers got cash advances at their favourite bar, the Riverside Hotel. But when the total amount advanced reached several thousand dollars, the Riverside demanded that Comox Logging do something about it. Major Arthur Mansfield Hilton, the office manager, settled the problem by adopting a monthly pay schedule; eventually other logging companies on the coast followed suit.

Comox Logging also built Headquarters Townsite as a permanent home base for its workers. This was not a logging camp: it was a full-fledged company town complete with

The new economy encounters the old: a kayaker explores crumbling hulks that provided shelter for a long-vanished log dumping ground at Royston.

Photo by Doug Tracey

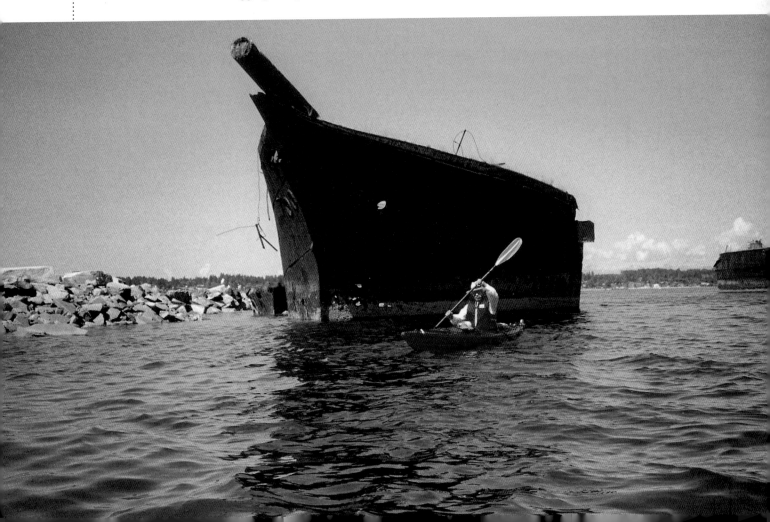

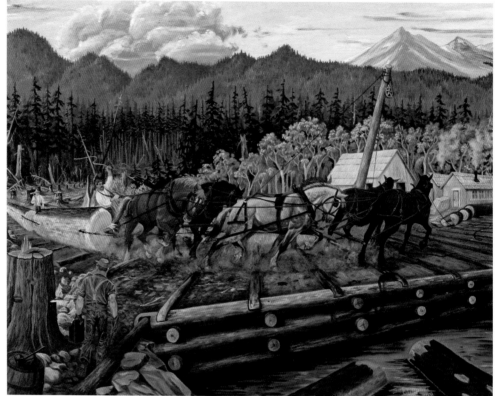

Real Horse Power, a painting by logger artist Bus Griffiths, shows how logging was done before the coming of machines. A six-horse team yards big first-growth logs down a skid road to a dump. The skids were greased to make the logs slide better.

Below: Fanny Bay logger-artist Bus Griffiths' series of logging history paintings is held by the Comox Valley museum. His illustrated book Now You're Logging *is a regional classic. Photo by Rick James*

homes, school, store, hotel, dance hall and tennis court. For most men, especially the married ones, it was a huge improvement over staying in a logging camp.

Another unique aspect of logging in the Comox Valley was the Homeguards. At the start, Comox Logging had two types of employees: loggers and other tradesmen hired from Vancouver labour halls who came and went, and permanent employees, mostly in management, who lived at Headquarters. In the 1920s Jack "Greasy" McQuinn, a short, powerful man with a prodigious appetite, ignored management's reservations and began training local men as loggers.

Most of the men came from nearby farms and were glad to have the extra income. There was a learning curve, of course, and for a while whenever anything went wrong, "Oh you farmer!" would be spit out in a derogatory tone. But the homeboys learned quickly and were content to work on their farms during summer and winter shutdowns. Eventually management recognized the advantages of employing Homeguards. So, unlike most logging companies, which had a constant flow of workers coming and going, Comox Logging had a stable workforce that was always at hand.

Robert Filberg first worked in the Comox Valley as a surveyor and later as engineer in charge of Comox Logging's railway. In 1916 he married Florence McCormack, the boss' daughter, and a few years after that he became superintendent of the company. "This [Comox Valley] was the Garden of Eden for loggers," he reminisced in his later years.

Because of his position and eventual wealth, Filberg became an influential person in the

community. It was said that he was an aloof man to work for and had a temper. But once he'd said his piece, he considered the incident to be over. After witnessing the success of the Homeguards, Filberg encouraged the hiring of local employees and gave workers access to cabins on his Williams Beach property. The Filbergs' former waterfront home in Comox is now a heritage park and lodge.

A number of smaller railway-logging companies worked south of Comox Logging's claim. Bloedel, Stewart & Welch at Union Bay and Victoria Lumber & Manufacturing and Deep Bay Logging in Fanny Bay all ran a few kilometres of track back into the hills to access timber. When Jack Fletcher, a truck logger from the Lower Mainland, took over Deep Bay Logging at Fanny Bay in the 1940s, he brought Bus Griffiths with him.

Griffiths' extensive experience with all aspects of handlogging and his skill at painting have resulted in a unique documentary of old-time logging techniques. His most significant works—a series of eight logging paintings complete with detailed captions—were featured in a one-man show at the Royal BC Museum in Victoria and thanks to a donation from the BC Truck Loggers Association are now part of the Courtenay & District Museum's permanent collection. And Griffiths' pictorial book, *Now You're Logging*, originally published by Harbour Publishing in 1978, is a collector's item.

In the 1950s new machinery made logging easier, and gas and diesel vehicles started to

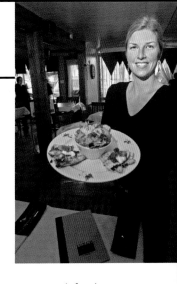

As resource industries decline, valley residents find work in the service sector (above) while others like Andy Everson forge careers in the arts (below.)

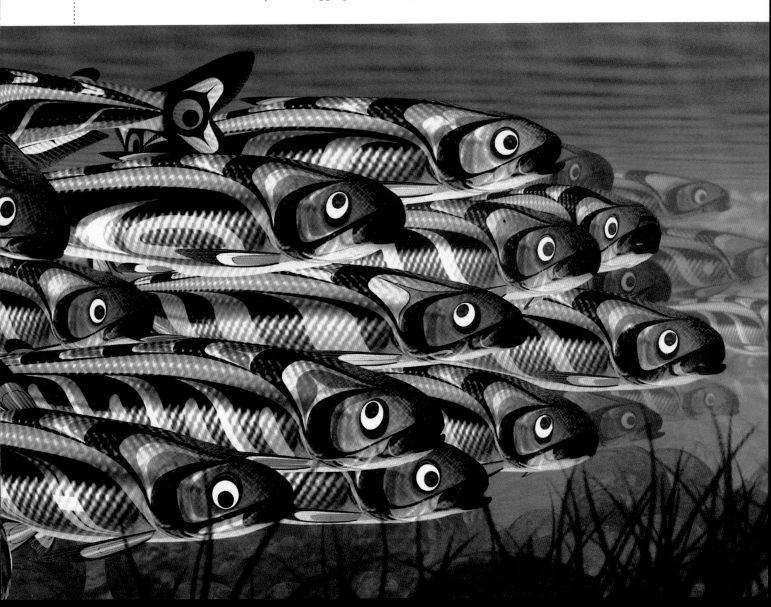

Chemist-turned-treeplanter Tony Berniaz has a unique formula for blue-ribbon rhubarb: bury a dead chicken under it! Photo by Rick James

With the valley's surging popularity as a recreation and retirement community, construction has become a leading employer.

replace the old steam locomotives. Toward the end of the decade, Headquarters, home to many for more than four decades, closed. A few remnants of old-time logging serve as reminders of the bygone era. The old railway mainline along Condensory Road is now a trail, and the historic Two Spot locomotive is on display next to the Visitors Info Centre in Courtenay. The remains of the Headquarters Mill built in 1912 are readily visible from Farnham Road, and a stroll though the woods might reveal a huge stump bearing springboard notches. (Early handloggers chopped notches into stumps a metre or more above ground, jammed planks into them and stood on the planks to saw through the tree at a point high enough to avoid the swell of the stump and pitch.)

Most of the first-growth timber is long gone, and newer residents may not even realize that much of the valley was once filled with massive trees. But the valley still has an active core of forest-industry workers. Some spend weeks or months at a time bent over among the logging slash, planting trees to replace those that have been harvested. The first organized planting of trees took place after the big fire of 1938, when Mennonite farmers from Black Creek were hired to re-seed the area.

Tree planting is dirty, physically demanding work involving long hours on rough terrain. There's a knack to planting trees correctly, and it's piecework: a planter gets paid for what he or she gets into the ground. An experienced planter working in good conditions can make $300 or more per day, but not every day, and most workers make much less. A common image of treeplanters is young people filling in time between university semesters or working as a stopgap measure while deciding what to do with the rest of their lives, but for a significant number of valley planters, some now 50 or older, tree planting is a lifelong career. Many of them are members of the Million + Trees Club. Tony Berniaz, a treeplanter and supervisor for more than 30 years, obtained a doctorate in chemistry at Simon Fraser University in the early 1970s. But instead of pursuing a promising—and potentially lucrative—career in the sciences, Berniaz moved to Merville, and that's where he and wife Lauren raised their three daughters.

As the valley entered the 21st century, big forest companies were harvesting second-growth timber where Comox Logging had worked 60 to 100 years before. And new, sophisticated methods of obtaining timber, such as heli-logging, give them access to stands of prime first-growth that earlier companies couldn't reach.

Some valley residents, however, are taking a different approach to traditional forestry practices. Harold Macy, his wife Judy Racher and their four sons manage a 400-hectare woodlot. By selectively logging single trees and clearing small areas, they are able to earn a living while leaving the forest in a largely natural state. Instead of clearcutting an area and waiting for new trees to grow, they can continuously harvest trees from this forest forever. In his spare time Macy gives talks on agro-forestry, or what he calls the "four-storey forest." He believes it's possible to combine agriculture with forestry, and he points out that a thinned forest with some small meadows can support sun-loving conifers as well as shade-tolerant trees, berry bushes and a variety of mushrooms. Macy is also responsible for bigleaf maple syrup becoming a gourmet market item.

Although some residents still earn a living from logging, farming, shellfish harvesting and fishing, the primary source of employment in the valley has shifted away from resource extraction. By the early 21st century, the Canadian Forces Base 19 Wing Comox and School District #71, along with Mt. Washington Alpine Resort and St. Joseph's Hospital, had become the major employers in the area. The construction industry goes through periodic boom cycles, and a growing population and increase in visitors has resulted in more service, retirement and tourism-related industries.

While valley resource industries may be down, they are far from out, as this concentration of commercial fishing vessels in Comox indicates.

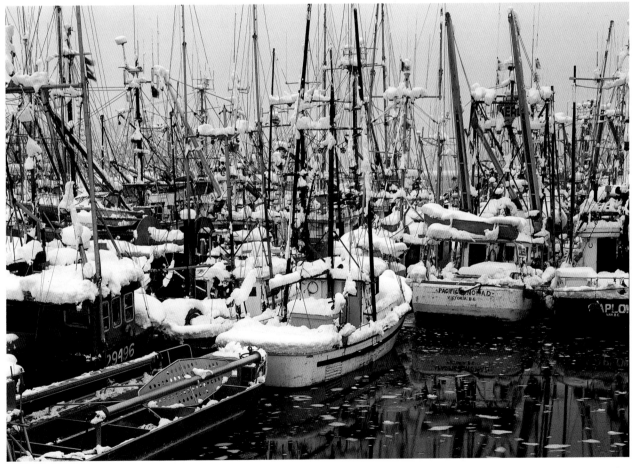

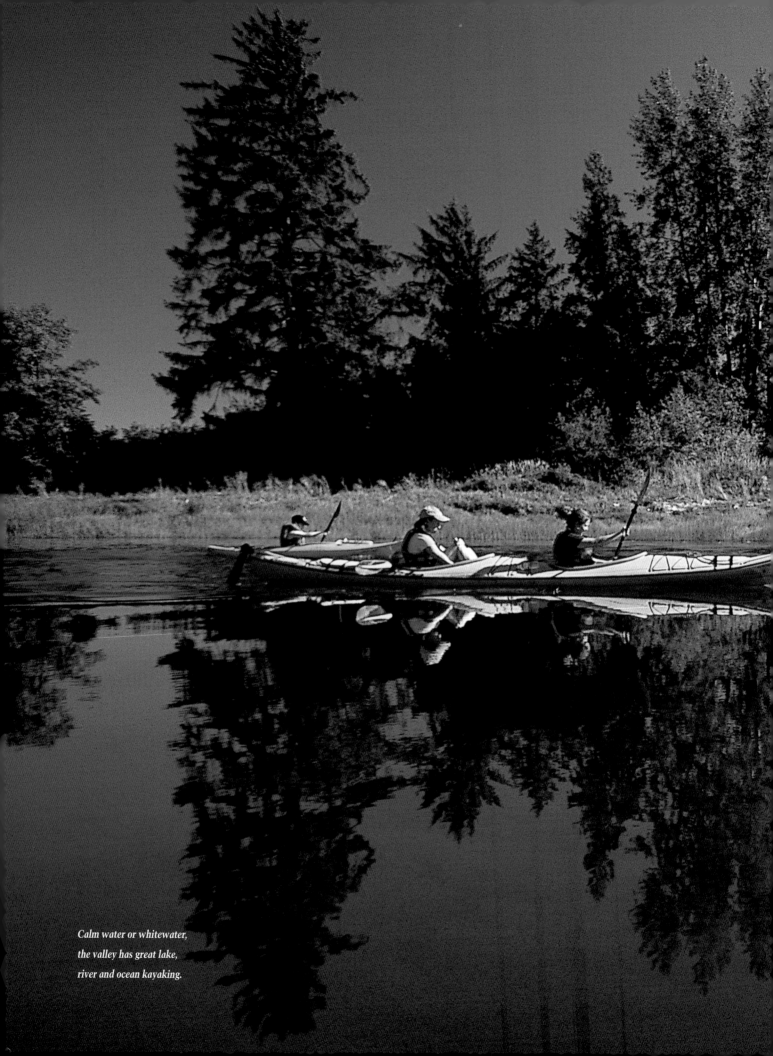

*Calm water or whitewater,
the valley has great lake,
river and ocean kayaking.*

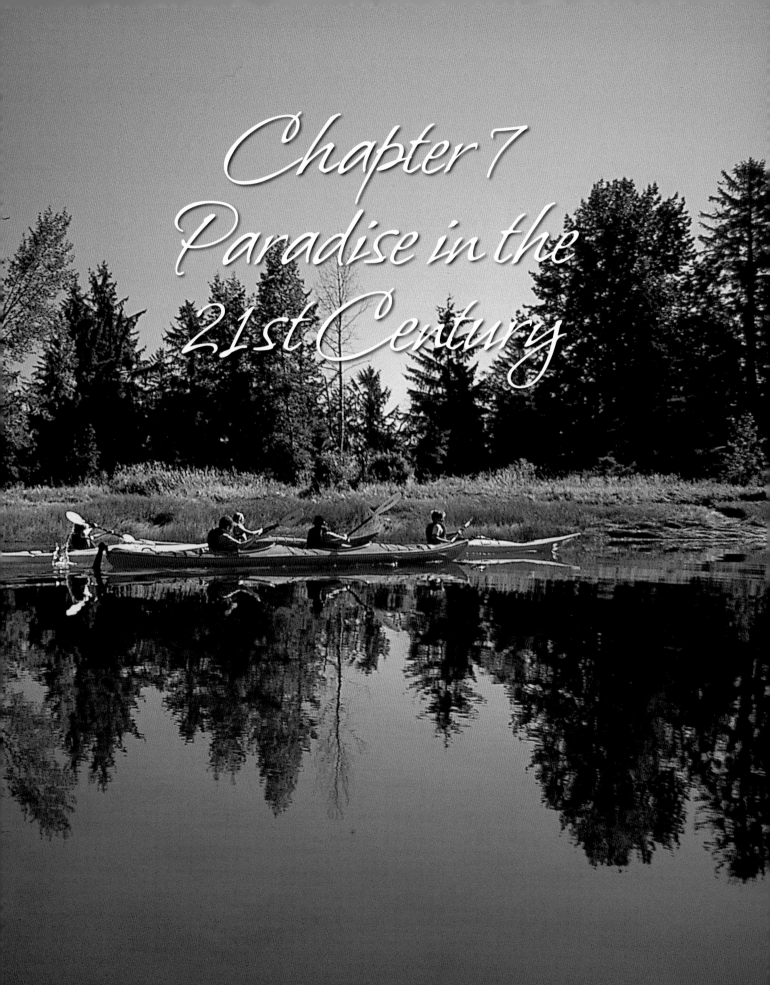

Chapter 7
Paradise in the
21st Century

Stunted alpine vegetation and sparkling mountain tarns make the Forbidden Plateau an unforgettable hiking experience.

Photo by Rick James

As far back as the late 1870s, people were visiting the Comox Valley to shoot deer, elk and ducks and to fish for trout and salmon. Fifty years later, local hotel owners were promoting the area as a tourist destination. In addition to hunting and fishing, they enticed visitors with tennis courts and golf courses, as well as grand places to dine and dance. They knew that if people came once, they would be captivated by the valley's natural beauty and would want to return. And it wouldn't matter if they preferred mountains, forests, rivers or beaches, because snow, salt water and everything in between was all within a short distance of their lodging.

Although the valley is no longer the sportsman's paradise it once was, people are still drawn to its natural attractions. They come to play on sandy beaches, swim in sun-warmed water and explore sheltered coves by kayak, sailboat and yacht. And even though few tyee salmon remain, there are still fish to catch and birds to watch. People from Calgary sometimes fly into the valley just for a weekend of skiing or golf—and, if the conditions are right, a little bit of both. One of the first things many visitors to the valley notice is the Comox Glacier, visible from various vantage points and appearing extraordinarily close when seen from downtown Courtenay. Although most people are content to admire the ice cap, some long to climb it.

Early settlers first explored the mountains rising from the valley floor as hunters, trappers

Whisky-jacks (a.k.a. grey jays) love the subalpine meadows. They're also not shy about asking for handouts! Photo by Rick James

A captive breeding centre for the Vancouver Island marmot, Canada's most endangered species, is located on Mt. Washington.
Photo by David Reid

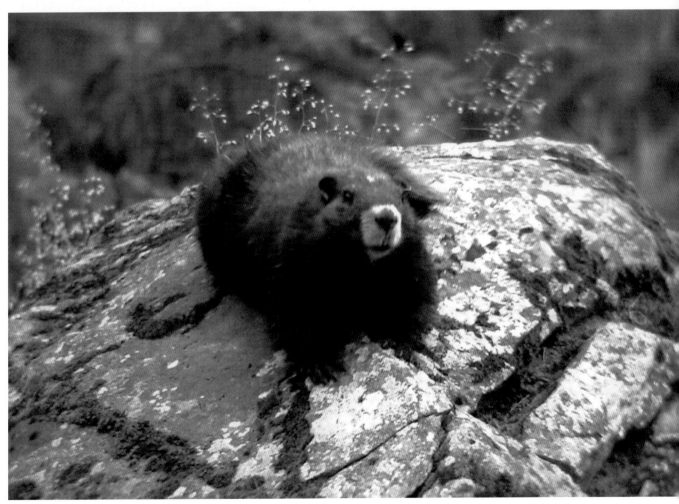

and prospectors. Between the valley and the high ridge of the Vancouver Island Mountain Range they found a subalpine plateau with rolling hills and numerous ponds and lakes. Over time the routes of trappers and prospectors became trails, and others ventured into the area. By the late 1920s the Comox and District Mountaineering Club was hiking Forbidden Plateau in summer and skiing its slopes in winter. A few cabins were built, and as word got around, people from outside the valley began visiting Forbidden Plateau and the wilderness of nearby Strathcona Provincial Park.

A well-known figure on the ski hills was Herb Bradley. He moved to the valley in 1947 as the first full-time director of the Courtenay Recreation Association and is credited with teaching many valley residents how to swim and ski. Kids nicknamed him the "bone shaker," as he was always willing to drive them up the rough gravel road to the ski lodge on Forbidden Plateau. It was there that Bradley founded the Vancouver Island Skiing for the Disabled Society (now the Vancouver Island Society for Adaptive Snowsports), an organization that has gained national recognition for the skill of its skiers.

Even after he retired, Bradley could often be found up the mountain lending a hand and encouraging skiers. To honour his community service, Bradley was awarded the Freedom of the City by Courtenay and twice named the Comox Valley Citizen of the Year. In 2001, two years before his death at age 84, the annual disabled skiers' race that Bradley initiated was rechristened the Herb Bradley Coca-Cola Classic.

Well before the ski lodge at Forbidden Plateau collapsed under a load of snow in 1999, the majority of snow activities had moved to nearby Mt. Washington. Privately owned since 1979, Mt. Washington Alpine Resort has expanded into a centre for winter sports that includes

Exploring the mountains can be as easy as a walk in Paradise Meadows (above) or as strenuous as a climb to Mt. Albert Edward. Photos by Rick James

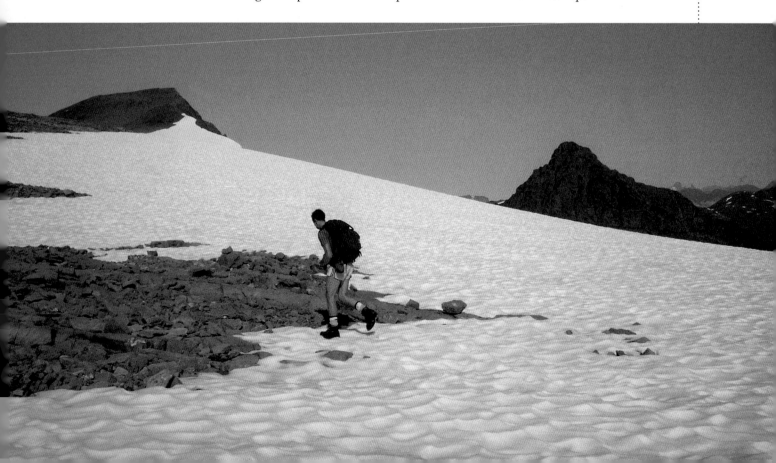

downhill and cross-country skiing as well as snowboarding, tubing and other white weather activities. In the old days, valley skiers trudged up hills on skis covered with snow-gripping sealskins before they could begin their descent. Now people can practically drive to a chairlift and find everything they need to enjoy their après-ski time at the alpine village.

Over time, Mt. Washington Alpine Resort, about a 30-minute drive from Courtenay, evolved into a year-round playground where summertime visitors can hike, mountain bike or take a ride on the chairlift for stunning views of the surrounding mountains, Strait of Georgia and Comox Valley. When the snow melts, delicate subalpine plants are revealed in the cross-country ski area of Paradise Meadows. This is a gateway to Strathcona Park, over 250,000 hectares in size, and the oldest and largest provincial park on Vancouver Island. The Paradise Meadow Loop is an easy walk for most people and provides an opportunity to get up close and personal with the park's biggest moochers, whisky-jacks.

The Mt. Washington ski lift does double duty carrying skiers in the winter, then hikers and mountain bikers throughout the summer months.

Mt. Washington is also home to Canada's most endangered species, the Vancouver Island marmot. Full grown, one of these furry brown rodents is about the size of a well-fed house cat. A distinct Canadian species, this marmot is found only in alpine meadows on Vancouver Island. At one time there were an estimated 350 marmots, but as logging clearcuts attracted

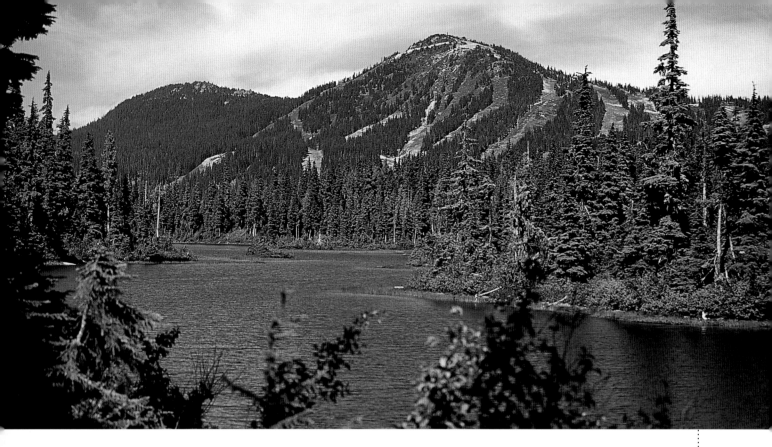

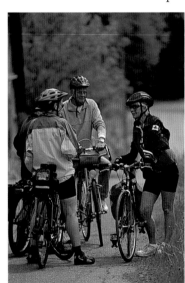

A summer hike to Battleship Lake provides a view of the extensive ski runs on Mt. Washington.

Cycling is also a good way to explore the valley.

them into the open, predators took their toll. Once the number of wild marmots dropped to about 20. The good news is that four captive breeding stations located at Mt. Washington, Calgary, Toronto and Langley, BC, may prevent the marmots from becoming extinct. Early in 2006 there were around 120 marmots in captivity, over half of them being cared for at the Tony Barrett Mt. Washington Marmot Recovery Centre. The Mt. Washington facility is important as many marmots lived in the area in the past, and it is currently the site of the second-largest wild colony. And no matter where the marmots are bred or released on Vancouver Island, they all spend nearly a year at Mt. Washington adjusting to the alpine climate.

From the mountains a complex network of rivers and streams flow down to the valley. First Nations groups and early settlers fished these abundant waterways for food; over time they became popular hunting, fishing and swimming spots. But here as elsewhere, human activities such as mining, logging, urban development and overfishing have taken a heavy toll.

Since the early 1970s, numerous organizations throughout the valley have worked to protect watersheds and return them to a sustainable state. One ongoing project is to restore the Tsolum River to its original condition after being contaminated by acid rock drainage leeching into the water from an abandoned mine. Although fish numbers are nowhere near their historic runs, thanks to the dedication and hard work of many volunteers, aquatic species and associated wildlife are beginning to return.

The Tsolum and Puntledge rivers come together to create the short tidal waters of the Courtenay River. The section of river near downtown Courtenay is a recreation hot spot during the summer. Lewis Park is a popular swimming area, and it's not unusual to see kids dripping with water lugging huge inner tubes up the main drag to Puntledge Park for another journey downriver. A few blocks from downtown, Condensory Bridge provides a convenient jumping-off place for teens, and sport fishermen crowd the banks each fall. Fishermen aren't the only ones tracking the fish upriver, however. Local seals

Mountain biker Jeremy Grasby launches off a root system on the "Shaker" trail near Cumberland. The valley has bike trails to challenge even the most dedicated thrill-seeker.

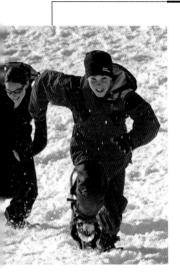

Mt. Washington offers a full range of activities including snowshoeing, skiing and snowboarding.

often cruise the water, and many are clever enough to use the lights at the Fifth and 17th Street bridges to aid them in their nighttime troll for salmon.

The Puntledge River, the site of a hydroelectric station since 1912, experienced a drastic decline of chinook salmon in the early 1950s. To remedy the problem, the Puntledge River Hatchery was opened in 1981. As well as successfully increasing salmon runs, the two-site hatchery also provides an opportunity to view various stages of salmon enhancement and an underwater window view of salmon migrating upstream in the fall. Easy access to Stotan Falls and the 55-acre Nymph Falls Nature Park have made the Puntledge River a prime recreation area. From Nymph Falls it's possible to walk or mountain bike along the river on a series of interconnecting trails that lead to the dam at the outlet to Comox Lake.

Not far from the lower Puntledge Hatchery is a 7-hectare piece of paradise called Masters Greenway and Wildlife Corridor. A path winds along a steep bank overlooking the Puntledge River, and in spring trilliums bloom undisturbed beneath the tall firs. After placing protective convenants on the property to ensure it remains in its natural state, Ruth Masters deeded the property to the Regional District of Comox–Strathcona in trust.

A lifelong valley resident except for a two-and-a-half-year stint of service in World War II, including the last 15 months of the London bombings and a few years travelling, Masters worked for 40 years as a legal secretary and spent her leisure time hiking and skiing Forbidden Plateau with the Mountaineering Club. In the early 1950s she joined author and BC naturalist Roderick Haig-Brown in the fight to save Buttle Lake from being dammed, and an environmental activist was born. A self-professed shit disturber, Masters has saved a bear from trophy hunters, protested logging in Clayoquot Sound and dared a developer to fall

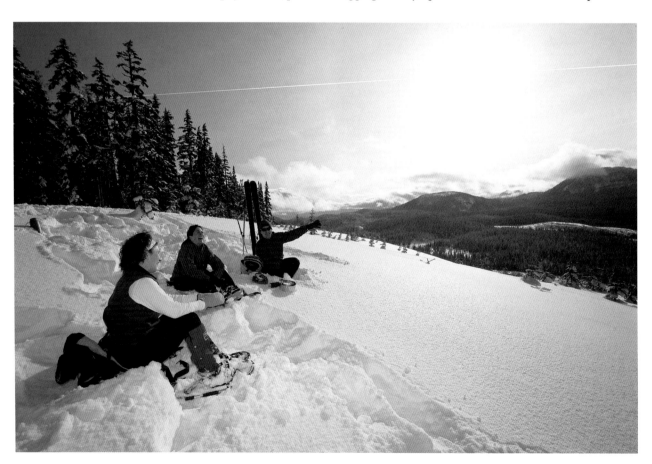

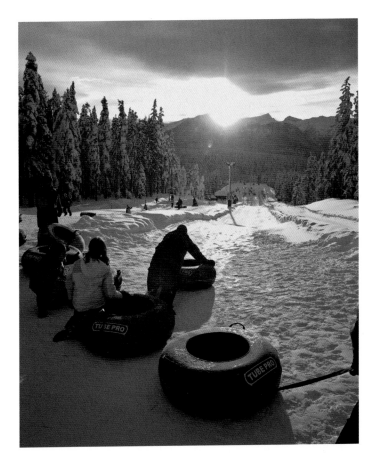

Left: Snow-tubing at the Mt. Washington tube-chute makes great family sport.

Below: Cross-country skiers reconnoitre outside Mt. Washington lodge.

Bottom: A nordic skier traverses one of Mt. Washington's cross-country loops in fading light.

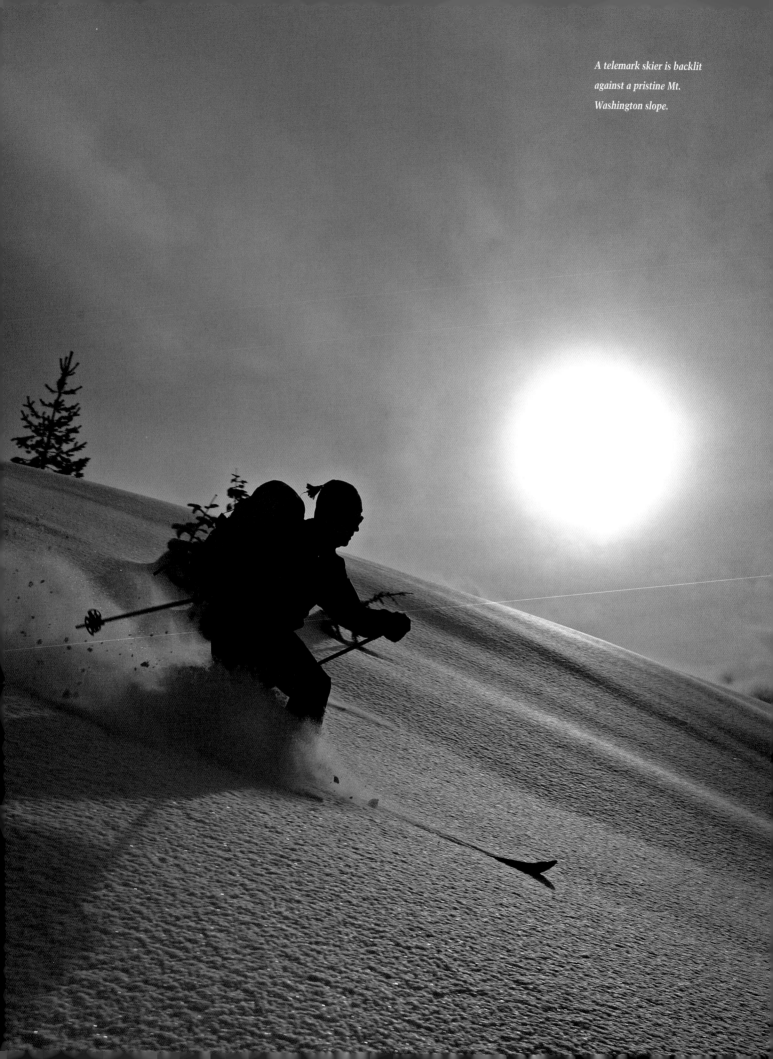

A telemark skier is backlit against a pristine Mt. Washington slope.

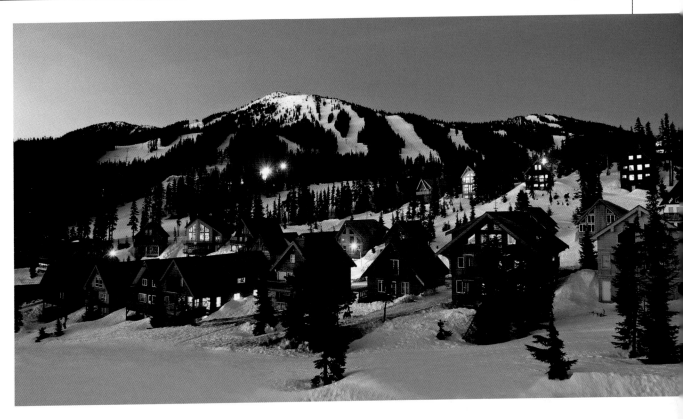

Mt. Washington Village at night.

a tree on her. With a garage full of protest signs, she's ready to join the fray on a moment's notice. In 2005, at age 85, Masters estimated that she supported some 80 organizations, and only regretted that she's spread too thin to do much good. "I'm not a spear carrier," she said. "I just back up the heroes."

For much of her life, Masters has fiercely defended animal rights and protected sensitive valley ecosystems. Although her opinions and letters to the editor are not welcomed by all, she has received an award from the Ministry of Environment, Lands and Parks for her "efforts to protect, preserve and enhance the environment," and twice has been voted Comox Valley Citizen of the Year. Her greatest sense of accomplishment, however, is knowing that the land she has given to the regional district will always remain in its natural state. The Comox Valley has been blessed with people like Masters—people who are willing to donate their time, energy and sometimes property to preserve the natural beauty of the valley.

Activist Ruth Masters (far right) has been tireless in her efforts to save the valley's environment for the enjoyment of future generations. Photo courtesy Ruth Masters

The Comox Valley has changed a lot since the first settlers arrived in 1862. But one thing that hasn't changed is the appeal of the place. New "settlers" continue to arrive, but instead of staking out prairie pre-emptions, many favour condos with a water view and choose to spend their time on the golf green rather than cultivating crops. As in the past, some come and go, but these days there seem to be more stickers than quitters. And, as more people discover the area, whether it be for a day or a lifetime, the pressure for development will only increase. The challenge—for long-term residents, newcomers and politicians—is to find ways to accommodate growth, yet retain the attributes that attract people to the Comox Valley in the first place.

Discovering the Comox Valley

Having fun in the Comox Valley is as easy as waking up in the morning. A temperate climate and easy access to mountains, beaches and everything in between provides an amazing number of options for enjoying the outdoors. Hiking, skiing, mountain biking and horseback riding are all popular activities, as are swimming, diving, kayaking, fishing and sailing. Golfers can tee off at a deluxe course complete with a full-service clubhouse and restaurant or take the kids to a miniature course that offers fun for the whole family.

As well as outdoor recreation opportunities, the Valley is also known for its diverse arts and culture. Work by local painters, potters, sculptors and other artisans can be viewed in many shops, as well as at private studios. And an impressive array of festivals and annual events include the **Filberg Festival**, **Vancouver Island MusicFest**, the **Air Show** and **Courtenay Youth Music Centre**. Contact one of the local Visitor's Centres to tailor an outing to your interests.

Getting here:

Situated on the east coast of central Vancouver Island, the Comox Valley is accessible by land, sea and air. BC Ferries has regular runs linking the British Columbia mainland to Vancouver Island travelling from Horseshoe Bay to Nanaimo, Tsawwassen to Duke Point and Swartz Bay, Powell River to Little River and Prince Rupert to Port Hardy. Blackball Transport also has a ferry service between Port Angeles and Victoria.

From Nanaimo, visitors have the choice of taking the scenic oceanside route (19A) or driving the four-lane, high speed, Inland Island Highway (19). Several airlines provide direct daily flights to Comox Valley Airport and various marinas provide a range of amenities for boaters. It's also possible to enjoy a leisurely train ride between Courtenay and Victoria on the E&N Dayliner (VIA Rail).

A young fossil-hunter shows her find during a supervised tour of one of the valley's rich fossil beds.

Accommodation:

Accommodation in the Comox Valley ranges from rooms at a deluxe oceanside resort to hike-in campsites where the night sky is a mass of stars. Other options include renting a ski-in, ski-out chalet, staying in a villa overlooking a golf course or relaxing in a cozy B&B. The choices are endless.

Courtenay:

Plan to spend an afternoon exploring downtown Courtenay. Located within a few blocks of one another is the **Native Sons Hall**, numerous art galleries and the **Sid Williams Civic Theatre**. The **Courtenay & District Museum** offers history and paleontological exhibits, as

well as hands-on fossil tours. Walk across the Fifth Street Bridge to enjoy **Lewis** and **Simms** parks and watch salmon and seals in the **Courtenay River.** Near the city's southern entrance, the **Courtenay Airpark** is a pleasant place to observe birds. For some fresh-from-the-farm produce, visit the seasonal **Farmer's Market.**

Merville and Black Creek:

The rural nature of Merville and Black Creek encourage relaxation. Merville's **Kitty Coleman Park** is a blend of beach and mature forest, while **Tsolum Spirit Park** borders the river of the same name. Black Creek is known for the white sand beach and old-growth forest at **Miracle Beach.** A little farther north lies **Saratoga Beach** and the action-packed **Saratoga Speedway**.

Comox Peninsula:

The Town of Comox offers many amenities including the historic **Lorne Pub** and the **Comox Archives and Museum.** A block away is the marina promenade, which offers views of pleasure and working boats, as well as a chance to buy the fresh catch of the day. The marinas are a great place to paddle out to **Sandy Island** or launch a sailing expedition further afield. **Goose Spit** is a popular place to swim and watch birds and **Seal Bay Park** is known for its wooded trails and the numerous seals that congregate offshore. The **Filberg Heritage Lodge and Park** and the **Air Force Museum** and nearby heritage aircraft are also popular. For work by local First Nations, visit the **I-Hos Gallery** on the Comox reserve, just outside Comox.

Cumberland, Royston and Union Bay:

The quaint charm of Cumberland is best experienced by a leisurely stroll along Dunsmuir Avenue and adjacent streets. The **Cumberland Museum** is a treasure trove of mining and cultural history. **Comox Lake**, the **Japanese Cemetery** and the many hiking and mountain biking trails are all worth checking out.

Highlights of Union Bay include the **historic post office** and **old gaol.** In Royston, a drive

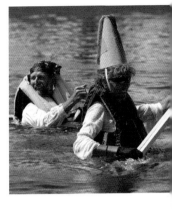

Two game participants come to a sticky end in the Build, Bail and Sail Race during Comox Nautical Days.

A low-stress way to cool off and enjoy the scenery is by tubing down the Puntledge and Courtenay rivers.

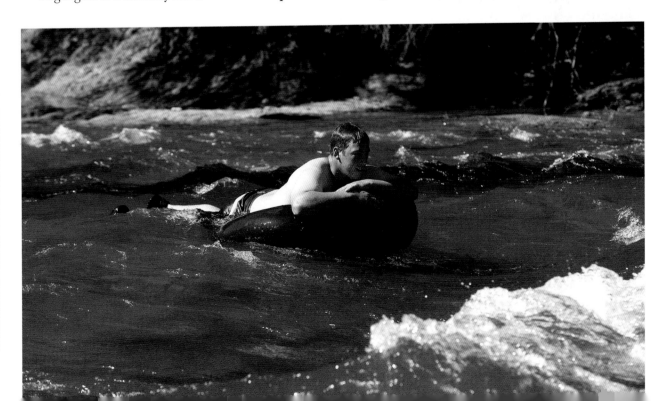

or walk along **Marine Drive** with a stop to look at the remains of the **"Royston wrecks"** is well worth the time.

Fanny Bay, Denman and Hornby islands:

No stop in Fanny Bay would be complete without purchasing some freshly shucked oysters at one of the numerous outlets. And around late February or early March it's amusing to watch enormous sea lions at their resting spot near the **Brico**. A walk through the bird sanctuary accessed from Tozer Road on Ships Point leads to George Sawchuk's uniquely landscaped woods.

Highlights on Denman Island include **Denman Village**, visiting individual artist's studios and visiting **Boyle Point Provincial** and **Fillongley** parks.

Spots of particular interest on Hornby are **Helliwell Provincial Park**, **Tribune Bay** and **Mt. Geoffrey Escarpment Park**. Make a point to stop at the **Hornby Island Co-op**, **Ringside Market** and, for something out of the ordinary, the **Recycling Depot and Free Store**. Many artists' studios are open to the public and, for the adventurous, it's possible to dive with six-gill sharks.

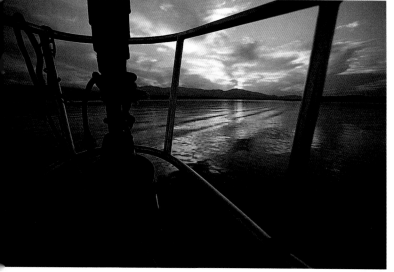

Discovering the Comox Valley can be an endless adventure.

Backcountry Exploring:

There are many unique areas to experience further afield. **Mt. Washington Alpine Resort** offers year-round recreational activities, and numerous trail networks provide limitless possibilities for exploring. Some of the main areas of interest include **Forbidden Plateau**, **Strathcona Park**, and **Nymph Falls Nature Park**.

Contacts:
Comox Valley Visitor's Info Centre: 1-888-357-4471 (toll free), 250-334-3234, www.tourism-comox-valley.bc.ca.
Cumberland Tourist Info Centre: 250-336-8313, www.cumberlandbc.org.
Mount Washington Alpine Resort: 1-888-231-1499 (toll free), 250-338-1386, www.mountwashington.ca.
Denman Island Visitor Info: www.demanisland.com.
Hornby Island Visitor Info: www.hornbyisland.com.

Transportation:
BC Ferries: 1-888-223-3779 (toll free within North America), 250-386-3431 (outside North America), www.bcferries.com.
Blackball Transport: 250-386-2202 (Victoria), 360-457-4491 (Port Angeles), www.cohoferry.com.
Comox Valley Airport: 250-897-3123, www.comoxairport.com.
Comox Valley Harbour Authority: 250-339-6041, www.comoxfishermanswharf.com.
VIA Rail: 1-800-561-8630, www.viarail.com.

Selected Sources and Further Reading

Annand, Betty. *Growing Up in the White House: Meandering Memories of the Whites.* Pitt Meadows BC: Rising Sun Publications, 1998.

————. *Voices from Bevan.* Pitt Meadows BC: Rising Sun Publications, 2002.

Baikie, Wallace. *Rolling with the Times.* Campbell River BC: Kask Graphics, 1985.

Bowen, Lynne. *Boss Whistle: The Coal Miners of Vancouver Island Remember.* Lantzville BC: Oolichan Books, 1982.

Carroll, Leila. *Wild Roses and Rail Fences.* Comox Valley: E.W. Bickle Ltd., 1975.

Comox Valley Naturalists Society. *Nature Viewing Sites in the Comox Valley & Environs.* Courtenay BC: Plateau Publishing, 1997.

Corrigal, Margery, et al. *The History of Hornby Island.* Courtenay BC: Comox District Free Press, 1969.

Duncan, Eric. *Fifty-Seven Years in the Comox Valley.* Courtenay BC: Comox Books, Division of Eric Duncan Literary Properties, 1979.

Eugene, Marjorie. *100 Flaming Years: The Cumberland Volunteer Fire Department.* Courtenay BC: Plateau Publishing, 1995.

Feely, Jean, and Margery Corrigal. *A History of "Tle-Tla-Tay"(Royston).* Royston Centennial Committee.

Fletcher, Olivia. *Hammerstone.* Hornby Island: Apple Press, 1989.

Glover-Geidt, Janette. *The Friendly Port: A History of Union Bay 1880–1960.* Union Bay: Douglas R. Geidt, 1990.

Hagen, Judy. *Comox Valley Memories, Reminiscences of Early Life in Central Vancouver Island.* Courtenay BC: Courtenay & District Museum and Historical Society, 1993.

Hames, Jack. *Field Notes: An Environmental History.* Courtenay BC: Gertrude Hames, 1990.

Harrington, Sheila, and Judi Stevenson, eds. *Islands in the Salish Sea: A Community Atlas.* Surrey BC: TouchWood Editions, 2005.

Hodgins, Jack. *Broken Ground.* Toronto: McClelland & Stewart Ltd., 1998.

Hodgins, Reta Blakely, ed. *Merville and Its Early Settlers 1919–1985*. Merville BC: Merville Community Association, 1985.

Hughes, Ben. *History of the Comox Valley, 1862–1946*. Nanaimo BC: Evergreen Press Ltd., 1962.

Isbister, Winnifred A. *My Ain Folk*. Comox Valley BC: E.W. Bickle Ltd., 1983.

Isenor, D.E., W.N. McInnis, E.G. Stephens and D.E. Watson. *Land of Plenty: A History of the Comox District*. Campbell River BC: Ptarmigan Press, 1987.

Isenor, D.E., E.G. Stephens and D.E. Watson. *One Hundred Spirited Years: A History of Cumberland 1888–1988*. Campbell River BC: Ptarmigan Press, 1988.

James, Rick. *The Ghost Ships of Royston*. Vancouver: Underwater Archaeological Society of BC, 2004.

Johnstone, Bill. *Coal Dust in My Blood: The Autobiography of a Coal Miner*. Lantzville BC: Oolichan Books, 1993.

Kennedy, Des. *The Garden Club and the Kumquat Campaign*. North Vancouver: Whitecap Books, , 1996.

Krause, James Allan. *The Life and Times of the Comox Valley Region of Vancouver Island, British Columbia, Canada*. Courtenay BC: SOTEL Ltd., 1997.

Mackie, Richard. *Hamilton Mack Laing, Hunter–Naturalist*. Victoria: Sono Nis Press, 1985.

——————. *Island Timber: A Social History of the Comox Logging Company, Vancouver Island*. Victoria: Sono Nis Press, 2000.

——————. *The Wilderness Profound: Victorian Life on the Gulf of Georgia*. Victoria: Sono Nis Press, 1995.

Mayse, Susan. *Ginger: The Life and Death of Albert Goodwin*. Madeira Park BC: Harbour Publishing, 1990.

The *19 Wing Comox*. Comox, 1999.

Olsen, Arv. *Shingles & Shells: A History of Fanny Bay*. Fanny Bay BC: Fanny Bay OAP (Association) II, 2004.

Schulz, Henry. *A New Frontier: The Canadian Chronicles of Henry Schulz*. Campbell River BC: Ptarmigan Press, 1984.

Scott, Brian. *Paintings and Stories of Cumberland, British Columbia*. Black Creek BC: Brian Scott Fine Art, 2000.

Smith, Elizabeth, and David Gerow. *Hornby Island: The Ebb and Flow*. Campbell River BC: Ptarmigan Press, 1988.

Stubbs, Dorothy I. *All About Us*. Courtenay: Glacier Press, 1975.

Index

Index